浙江青瓷與海派書画展

Zhejiang celadon and Shanghai Painting Exhibition

精 选
Selections

主 编

Chief Editor

杜正贤　沃明东

Du Zhengxian　Wo Mingdong

展 品

Exhibition Works

君苑文化

Jun Yuan Art

浙江省文物考古研究所

**Zhejiang Provincial Institute of
Cultural Relics and Archaeology**

－杭州博物館－

上海书画出版社

目　录
Contents

前言

　　三千多年前，在浙江北部传统制陶业中初露头角的原始瓷便以其旺盛的生命力跨入中华文明的殿堂，此后浙江青瓷不断发展，出现了越窑、瓯窑、婺州窑、龙泉窑、南宋官窑等一系列重要的青瓷品种。从饮食器、贮存器、卫生器、寝具、照明具到文具、陈设品、乐器、祭器、明器、玩具等等，应有尽有，其历时之久、种类之繁、适用面之广在中国古代物质文化史上是无与伦比的。

　　越窑是浙江地区的瓷器烧造的先驱，自东汉开始生产，经三国、两晋、南朝、唐，一直到北宋后期衰落，延续千余年，经历了创烧、成熟、稳定、鼎盛和衰落几个大的段落，它是中国南方青瓷生产的重要产地，在国内外享有盛誉。

　　浙江南部的龙泉，农业不发达，而林木繁水上交通十分便利，是北宋以后我国青瓷的主要产地。靖康之难后，北方汝窑工匠被迫弃窑南迁，龙泉窑由于受汝窑制瓷工艺的影响，突然出现了一路与传统青瓷并行发展的厚釉产品。经化学分析，这类厚釉产品釉中的助熔物质除了氧化钙（CaO）以外，还有较多的氧化钾（K_2O）和氧化钠（Na_2O），故这种釉的高温粘度大，可施得较厚，通常施二三遍，釉层大多乳浊不透明，宛如碧玉。

　　龙泉瓷业的勃兴当始于北宋，据《处州府治》云"会稽人，元佑中以左朝散郎，知栝郡，多滩汇能覆舟，景晖命疏凿以利往来"。明确记载了北宋元佑七年底治滩成功，使龙泉与外界的交通获得了极大地改善，由此开始，龙泉逐渐由农业转换成以制瓷业为中心的生产方式。

　　宋室南渡后，带来了大批北方的能工巧匠，同时随着南宋政局的逐渐稳定，京城对高品质瓷器的需求与日俱增，这些都促进了南宋龙泉窑的发展，使得这一时期的龙泉窑产品达到了前所未有的高峰。

　　除了少量黑胎瓷器，南宋龙泉窑大量生产的是一种白胎厚釉瓷，品种有碗、碟、壶、水丞、炉、觚、砚滴、瓶等，釉色以粉青和梅子青为代表。粉青釉光泽淡雅柔和，可与碧玉媲美。梅子青釉丰盈滋润，像雨水淋过的青梅。南宋以后，这类白胎厚釉瓷器继续大量生产。元代龙泉窑的白胎厚釉青瓷虽不及南宋时那样雍容华贵、精巧玲珑，但它以浑厚古朴的造型和丰富多彩的装饰而别开生面。

　　元代龙泉窑白胎厚釉瓷不仅遍销全国各地，而且还被源源不断地输往海外。明代，龙泉窑青瓷的销售范围已超出亚洲和非洲，开始向欧洲延伸。在欧洲，龙泉窑青瓷颇受人们欢迎，当它在法国出现时，人们为它那美丽的釉色所倾倒，一时找不到合适的词语来形容如此怡人的神色。便以法国小说家杜尔夫的长篇小说《牧羊女亚司泰

来》中穿着美丽青色衣服的牧羊人雪拉同来命名，于是，"雪拉同"便成为龙泉青瓷的代名词。后来"雪拉同"在欧洲成了对中国青瓷的统称。

海派书画在中国美术史上，尤其在近代中国美术史上是一个创新求实的创新风格，与江浙一带现代画派的发展直接相关。这个流派不是以风格、语言来划分的，它的形式与发展和上海新城市的崛起直接相关。自1840年开埠，上海成为了中西文明的交融点，在短短40年间，上海已经吸引了不同阶层、领域的人才到来，艺术家当然也不例外。总体上海派书画家划分为三代，第一代以赵之谦、任伯年为领袖，主要成员有张熊、任熊、任薰、胡公寿、虚谷、蒲华、钱慧安等，均是清末中国画坛的一流名家；第二代"海派书画"的领袖是诗书画印四绝的吴昌硕，主要成员除高邕、陆恢、王一亭、黄宾虹等人外，还有一批相当重要的"大师中的大师"即发展和打造大师的人物，如：沈曾植、李瑞清、曾熙等先后培养了于右任、张大千、吕凤子、王蘧常、李仲乾等，康有为栽培及扶植了刘海粟、徐悲鸿等；第三代到了20世纪二三十年代以"三吴一冯"即吴湖帆、吴待秋、吴子琛、冯超然为代表的"海派书画"则处于全盛时期，主要成员有赵叔孺、刘海粟、徐悲鸿、张大千、潘天寿、陆俨少、谢稚柳、程十发、唐云、贺天健、来楚生、江寒汀、张大壮等。海派书画一方面个性鲜明，重视书画、印诗方面的修养，另一方面从民间艺术中吸取营养，雅俗共赏，形成兼容并存的格局，使绘画更加符合社会审美需要，真正意义的走向市场。海派书画借鉴吸收外来艺术凸显出"海纳百川"，从而成为中国绘画史上的又一高峰。

海派书画是上海文化艺术的重要标志，海派书画主要表现形式为笔墨、线条、诗书、意境，倾向于意识形态；龙泉窑是地处浙江的名窑，龙泉青瓷是浙江文化艺术的"四宝"之一，龙泉青瓷主要表现形式为造型、瓷釉、工具、工艺，立足于物质形态。尽管它们表现形式的侧重点不同，其实在本质上是相同的，都属于文化艺术与伟大创造。此次上海君苑文化发展有限公司联合浙江省杭州博物馆举办"浙江青瓷与海派书画展"对于跨地区、多形式、多内容的文化交流必将产生深远意义，也是对海派文化和浙派文化的弘扬。

杜正贤　沃明东

2017年8月1日

Foreword

About three thousand years ago, the emerging proto-porcelain in the traditional ceramics in the north of Zhejiang Province made its appearance with vigorous vitality into the treasure house of Chinese civilization. Thereafter, Zhejiang Celadon thrived with a series of important celadon varieties including Yue kiln, Ou kiln, Wuzhou kiln, Longquan kiln and the official kilns in the Southern Song Dynasty, covering utensils, containers, sanitary fixtures, bedding, lighting devices, stationery, furnishings, musical instrument, sacrificial utensil, funerary wares and toys. Its long history, rich variety and wide application are unparalleled in the ancient Chinese material cultural history.

As a pioneer of porcelain manufacturing in Zhejiang area, Yue kiln can be dated to the Eastern Han Dynasty. It thrives through the Three Kingdom Period, the Jin Dynasties, the Southern Dynasties, the Tang Dynasty and declines in the late Northern Song Dynasty, lasting for over thousands of years and experiencing the major phases of emerging, maturing, stabilizing, prospering and fading. It is an important producer of celadon in the southern China enjoying prestige at home and abroad.

Despite of the undeveloped agriculture, Longquan in southern Zhejiang is endowed with luxuriant forest and convenient water transportation, making it a major supplier of celadon after the Northern Song Dynasty. After Jingkang Incident, craftsmen from Ru kiln were forced to abandon the kiln and moved southwards. Under the influence of porcelain workmanship of Ru kiln, Longquan kiln introduced a series of over-glazed products evolving in parallel with the traditional celadon. Chemical analysis indicates that the fluxing materials used in the over-glazing products also include potassium oxide (K_2O) and sodium oxide (Na_2O) in addition to calcium oxide (CaO), which contributes to the high viscosity of such glaze under high temperature and allows double or triple glazing. The glaze layer is as opaque as jasper.

The flourishing of Longquan ceramics can be traced back to the Northern Song Dynasty. The description that "Jinghui is Born in Kuaiji and appointed as Zuo Chao San Lang in 1092. After taking office, he ordered to dredge the mudflats to improve traffic" in "Governance of Chuzhou" explicitly documented the improved traffic connection of Longquan with the outside world after the successful governance of mudflats in 1092 of the Northern Song Dynasty, which gradually transformed Longquan from an agricultural land into a porcelain manufacturing center.

The Southbound Retreat of the Song Regime brought a large number of craftsmen from the north. In the meantime, with the gradual stabilization of the political situation in the Southern Song Dynasty, the demand of the capital for high-quality porcelain grew, which boosted the development of Longquan kiln and drove its products reaching an unprecedented peak.

In addition to a small amount of black porcelain, Longquan kiln churned out white over-glazed porcelains during the Southern Song Dynasty, including bowls, saucers, pots, water containers, furnaces, Gu (drinking vessel), water dropper and bottles mainly glazed with

lavender grey and plum green. The lavender grey glaze shows an elegant and tender lustre that is comparable with jasper. The plum green glaze is as rich and plump as a green plum after a rain. The mass production of the white over-glazed porcelains continued even after the Southern Song Dynasty. By the Yuan Dynasty, although the white over-glazed celadon manufactured in Longquan kiln were not as graceful and exquisite as that of the Southern Song Dynasty, they broke a new path with their simple and vigorous shape and colorful decorative patterns.

The white over-glazed porcelains manufactured in Longquan kiln were not only widely sold across the country but also exported overseas during the Yuan Dynasty. By the Ming Dynasty, the sales territory of celadon of Longquan kiln went beyond Asia and Africa and extended to Europe. People were infatuated with its beautiful glaze color and left speechless when it made its debut in France. They referred to the shepherd Celadon who wore pale green ribbons in L'Astrée by French novelist Honoré d'Urfé to name the porcelain. This is how "Celadon" became the synonym of Longquan porcelain. Later, "Celadon" became a general term for Chinese porcelain in Europe.

In the history of Chinese art, Shanghai painting represents an innovative and realistic style, especially in modern Chinese art history. It has a direct impact on the development of the modern painting in Jiangsu and Zhejiang, and in its essence is the extension of the style of the Southern Dynasties. The school cannot be divided by style or language, and its form and growth bear a close relation with the rise of Shanghai as an emerging city. Since 1840 which marked its opening as a commercial port city, Shanghai had become a hub of the contact between Chinese and Western civilizations. In a short period of 40 years, a lot of talents from all walks of life had come to the city, including artists. Overall, the painters of this school fall into three categories. The first generation of them, led by Zhao Zhiqian and Ren Bonian, include Zhang Xiong, Ren Xiong, Ren Xun, Hu Gongshou, Xu Gu, Pu Hua, Qian Huian, all the first-class masters of Chinese painting field in the late Qing Dynasty. The second generation, include Wu Changshuo who was good at poetry, calligraphy, painting and seal as the leader, include Gao Yong, Lu Hui, Wang Yiting, Huang Binhong, and master of master such as Shen Zengzhi, Li Ruiqing and Zeng Xi, whose famous students include Yu Youren, Zhang Daqian, LvFengzi, Wang Juchang, and Li Zhongqian. As for Kang Youwei, he cultivated Liu Haisu, and Xu Beihong. As for the third generation in the 1920s and 1930s, the school, represented by Wu Hufan, Wu Daiqiu, Wu Zichen, and Feng Chaoran, reached the prime. And its chief members include Zhao Shuru, Liu Haisu, Xu Beihong, Zhang Daqian, Pan Tianshou, Lu Yanshao, Xie Zhiliu, Cheng Shifa, Tang Yun, He Tianjian, Lai Chusheng, Jiang Hanting, Zhang Dazhuang. Shanghai painting placed importance on distinct personality, and a good mastery of all kinds of art, while drawing on the folk arts, so as to continuously expand its landscape, and cater better to the aesthetic needs of the society and achieve commercialization in the truest sense. Further, by staying open to the foreign art, it finally establishes itself firmly as another peak in the history of Chinese painting.

Du Zhengxian Wo Mingdong
1 August 2017

序一

浙江青瓷——龙泉窑

此次"浙江青瓷与海派书画展"展出了非常丰富的海派书画作品与浙江青瓷。在瓷器方面共展出八九十件浙江地区青瓷，时代包括从晋到清，每个时代都有其代表作品。除了一件造型丰硕线条优雅的晋朝越窑青瓷羊型器之外，其余皆为龙泉青瓷。展品中书房文具、香道用具，都相当特殊、精巧。香道中的七八件炉具，时代包括了宋、元、明、清，釉面温润，都富有时代特征。四件五管瓶姿态、风采互别，以莲瓣五管瓶最为端庄秀丽。三件龙虎瓶在瓶颈所贴塑的行龙表情生动，北宋的龙虎瓶形态锐利，南宋则显得温和，其盖钮各以不同兽形饰之。原本龙虎瓶，以龙瓶与虎瓶成一对，据称是龙虎斗，将灵魂斗拱上天。刻花十棱执壶，花刻纤细，器形明确显张力。刻花三连碟盖盒，盒面印花清楚，盒身及盒盖线条确实，盒子盖起来应是很密实的。元朝象耳衔环瓶，器形虽不大，器颈、肩、身三段釉面都很均匀、温润，象耳衔环强而有力，显得大方。而刻花爵杯，绝妙无比，以起线花卉纹饰满全器，青釉清澈中透出胎的淡红润色，可是难得之物。此次的展品虽不多，但也可略窥龙泉窑的时代系列。

浙江地区由越窑近千年的烧造，转承于龙泉窑，使得这个地区青瓷能绵延烧造将近二千年，并且是一枝独秀的烧造青瓷，世上唯独此处有。龙泉窑在承继越窑之后，产品精细，产量大，远传四海。一提"龙泉窑"，即使不见其影，也可知所指为"青瓷"，这给予人们很明确的印象。这就是从长久传承下来而产生的珍贵概念。借此次的展出，将龙泉窑的背景及发展经过在下文中做一个概要的介绍，希望能增加对展品观赏的兴趣。

唐朝时处州峻山险水

自商周以来，原始青瓷的烧造，历经千年原料与燃料的使用，终归资源罄尽而趋于没落，随着余姚上林湖烧造的没落，渐而转移到蕴藏瓷土丰富的龙泉，承其脉络烧造青瓷。龙泉位于浙江南面，为山峦绕峰之地，北宋中期之前陆路交通不便，虽有溪流经丽水出温州，但洑急之处特别多。由宋龚原的《治滩记》一文中可知其艰险的情形："……旧传缙云、丽水间苦水怪，有恶名，唐太守段成式至，害遂息，更称好溪……"这条水路属现在的瓯江，在唐朝段成式任缙云太守时，治平缙云这一段水路之水怪狷獗。段成式（生年不详，唐德宗贞元十九年（803）或稍后），他在唐大中年

间（九世纪五十年代）出守浙江处州，他治平缙云部分的溪滩，对地方有很大贡献。[3]但同属处州的龙泉，亦是滩多急流，山峻水险地区，却不见有段成式着手治理的记录。这时龙泉仍较封闭，还未开展通路，因此地方产业未能兴盛。

宋人提及龙泉青瓷

进入北宋时，社会繁华之际，瓷器渐为上层人士所用，元人所著的《南村辍耕录》中，录有宋人叶寘之文，云"……处州龙泉县，窑质颇粗厚"（与顾文荐之《唝暄杂录》内容相似）。由文的上下接来看应是指着北宋时的龙泉窑而言，评语为"质颇粗厚"。在笔记小说著作里如孟元老的《东京梦华录》记述北宋的事，但未言及龙泉窑。南宋的周密著《武林旧事》等一类宋朝笔记小说都没提及龙泉窑青瓷。直到南宋才有一位宗室子弟赵彦卫在他的《云麓漫钞》[4]中记载："青瓷器，皆云出自李王，号秘色，又云出钱王。今处之龙溪出者，色粉青，越艾色。唐陆龟蒙有《进越器》诗云：九秋风露越窑开，夺得千峰翠色来。好向中宵盛沆瀣，共稽中散斗传杯。则知始于江南与钱王皆非也。近临安亦自烧之，殊胜二处。"[5]

成书于南宋中期的《云麓漫钞》，终于出现了"处之龙溪色粉青"之记载，此文中将越窑、龙泉窑、官窑浙江的三个青瓷名窑全都提及，并将越之艾色、龙溪之粉青，二者不同火焰所烧造出来的青瓷色泽，非常明确地指出来。也因他是皇家弟子，对于同时代的"官窑"有所知悉(《云麓漫钞》书中只称"临安亦自烧之")，记载了临安亦自烧官窑青瓷。也透露着13世纪初，龙泉青瓷釉"粉青"已达成熟期，是龙泉窑的精品。《云麓漫钞》比周辉的《清波杂志》成书只不过晚十年，而《清波杂志》虽提及其他窑器，但未提及龙泉窑。唯独赵彦卫在其书中能以青瓷专条述及。对于未能列入贡瓷的龙泉窑而言，弥足珍贵。在实物方面而言，南宋时龙泉窑虽然已进入盛期，但在优质精致的龙泉青瓷产品中一直没见到圈足底面满釉的产品。

在考古发掘资料中，金村与大窑遗址中已证明有精美产品遗址层的存在，考古人员先后在大窑乙区和金村分别发掘到相同的三迭层。乙区的堆积以y_2为代表的上层发掘到最精美。在金村以中层的产品最丰富。[6]

唐朝龙泉县外围的瓷器生产

在唐乾元二年（759）之前，龙泉本是一个"乡"，此地由"乡"升格为"县"。在地方志上记有龙泉县名的由来："本括苍黄鹤镇其地有剑池湖，又号龙渊，唐避高祖

讳，改龙泉。乾元二年（759）越州刺史独孤屿请以括苍龙泉乡置龙泉县。宋宣和四年（1122）天下县镇凡有龙字者皆避，因改剑川。绍兴元年（1131）复为龙泉，明仍宋旧。"

唐代，越窑的外围有龙泉窑及丽水县吕步坑窑及庆元县的黄坛窑等。在行政地区，由"乡"改"县"时也是《茶经》成书的时期，也是顾况（约757年）、孟郊（约785年）等文士们对饮茶用器越碗赞赏的时期。由于江南饮茶之风兴盛，越窑优质的青瓷渐受重视，也渐渐带动周围的烧造。而这二地所发现的情形是：

"丽水县吕步坑南朝晚期至唐代青瓷窑址，和庆元县黄坛唐代瓷窑的发现，……1959年进行了局部发掘，出土品以碗、钵为主，胎壁较厚，釉色青黄，质量不高，黄坛村东北、龙（泉）庆（元）公路以南的地方，窑址已遭到严重的破坏，原有的堆积只留下不大的一块，但窑具和窑砖散布面很大，而且夹杂着碗一类的残片。两窑所出的青瓷质量低下，远远不及同时期的越窑、婺州窑和瓯窑的产品，……这种生产状况，到五代末宋初时，尚未有大的改变。"

乾元二年龙泉由乡改县人口渐增，由于龙泉水、陆两不便，生产事业并不发达，虽有优质的瓷土蕴藏，但此时发展时机仍未成熟。但乡改县，是刺激龙泉县烧造业开始进展的一个讯号。

宋朝元佑七年（1092）水路开通后的龙泉县

龙泉地区山峦迭起，交通不便，虽然在唐朝时段成式治了缙云一段的水路，但真正使龙泉与外界通往较便利的水路，则要到北宋元佑七年底，这一条水路的开通，对龙泉而言，才可以说是产业道路的开启，也是一个转折点。在《浙江通志》、《处州府志》、《龙泉县志》等几本地方志中，艺文记述的部分都录了一篇宋龚原的《治滩记》，在文中我们可以找到龙泉何时与外界开始方便通往的重要讯息：

"栝属县大溪三，皆会于丽，由芝达瓯入海。暗崖积石相愬成滩，舟行崎岖动辄破碎益尝变色而惴栗，失声而叫号，冀得万一无它以讫所济，然为上者，每闻覆溺事则曰：此险也，殆非人力可施，恬不为怪。元佑六年冬左朝散郎会稽关公来守是邦，视事之暇，披诸邑图而观之曰：嘻！奚滩之多也，……于是欲去害兴利，顾有甚于是耶。使俯有力仰有余，余不敢后言。一传旬浃四境，闻者欣然，曰：吾州滩会平矣，明年春（元佑七年-1092）龙泉民出钱，愿治其事，闻他邑亦继有请冀与龙泉比公以上部使者，且愿农隙行下及期，按图以事，……起七月戊申逮以十二月壬申毕，合百六十五滩，龙泉居其半。缙云亦五之一，凡昔所难，尽成安流。舟尽夜行无复激射

覆溺之。虞郡人相与语曰：遗此险几百千年岁，败舟几百致以溺死者又几何人，……今滩治功利实宏较勤，昔人异世，齐声我为公歌亦助斯旴形容本末与后作程。"[9]

上文内所提的关公即"关景晖，会稽人，元佑中以左朝散郎，知栝郡，多滩汇能覆舟，景晖命疏凿以利往来"[10]。在此明确地指出元佑七年底治滩成，共治了滩险处一百六十五滩，龙泉占半，被治平后的龙泉与外界的交通获得了最大的改善。治滩时，以"农隙"时动工，表示此时应是农业为主体的环境，由治滩成后开始，应该是龙泉由农业逐渐转换成制瓷业为中心的社会，因此在元佑七年应是龙泉瓷业开展的一个节点。

南宋龙泉县进入产瓷盛期

元佑七年治滩成，到宋朝南迁（1127），共三十五年，在窑业逐渐开展基础之际，北宋节节退至南方，后来高宗以杭州为京城，此时浙江境内的越窑已没落了，定窑、汝窑之地入金人版图。等南宋政情安定下来后，为了皇室日用、祭器之需，在临安皇城西南二公里附近，郊坛处开窑烧造官窑器。在京城人口日增，人民生活日由安定入侈，京城成了消费中心，也促进了对龙泉窑产品的需求。

自北宋末，水路滩头整治后，通往产瓷之地的龙泉也没昔日那般艰难，各地商贾往来频繁，是促使龙泉瓷业更上一层楼的好契机。金村与大窑便是二处龙泉西区的青瓷主要产地。由大窑翻过一个崎峻山岭便是金村，这两处瓷土矿脉相同，蕴藏丰富，所产的都是细质青瓷，胎质相当接近，是南宋最高质量的制瓷区。此外，贸易品的输出需求，也是促使龙泉窑量产的另一个因素。京城之地、经济繁荣、贸易需求，这三个因素的集合，使龙泉迈开了步伐，走向了质高量多的瓷业生产。

这些瓷器，以陆路搬运则翻山越岭，巅簸易碎，自元佑七年滩水治平后，溪与川的畅通方便了运载货品，出售到海内外四方各地。由府、志中所记载的水道溪流来看："秦溪在县南五里，蒋溪在县西六里，大溪在县南一里，合秦溪、蒋溪二水东流于郡。"[11]在龙泉县境内，利用这两条主要水道，然后"西自龙泉北自缙云，西北自遂昌、松阳皆会于丽水道，于青田东趋永嘉，以入于海"，瓷器就沿着瓯江这条水路到温州出海销售。

在《浙江通志》内有更详细的记载：

"灵溪在县治前，一名嵯溪又名大溪，大溪之上流则与秦溪、蒋溪合而为一，中阻槎州广袤约一、二里，上有济川桥，有留槎阁，溪因分为二，下后合流以达于海。"[12]

那么，利用这些水溪通道所运的正是大窑与金村及其水域地区所产的瓷器。在乾隆的《龙泉县志》记载得更为详细，在南边的溪流，除了这三溪之外，另有蜚溪、俞溪，在东边的则有铁杓溪、道泰溪、安仁溪（在东二十二都安仁东出安仁口，合流以趋武溪）、安福溪、大石溪、武溪、杜郊溪。另有甸川、梧桐川、豫章川、小梅川、锦川（在西十一都锦旦东出牛头岭下合流以趋蒋溪、石川）。[13]与这些在东边与南边的溪流对照，由现今发掘的龙泉、庆元县等古窑遗址分布图来看（附图1，录自《龙泉青瓷研究》），两旁正是满布了瓷窑的地区。由于有水路的通往方便，因此在山路方面利用渐少，直到近几年才有比较好的道路完成。这些主道、支道水路的通畅正是带给龙泉窑瓷器兴盛，畅销四海的原因。而与生产相关的窑烧造情形是："在几十座龙窑的发掘中，说明龙泉窑是用龙窑烧瓷的，其中南宋前期的龙窑最长，多数龙窑长在六十米以上，最长的达八十余米，南宋后期为了烧造厚釉的高档瓷器，龙窑缩短，长在三十米到五十米之间，到了明代，出现了分室龙窑。经过发掘和综合分析，历代的工匠对于龙窑的结构和装烧方法了如指掌，我们可以在废弃堆层中，了解装烧方法，也是提供了部分鉴定瓷器的年代依据。同时龙窑的长短大小合作坊的规模，也可探讨烧造是业是主业还是副业生产。也提供了明代顾仕成等窑业主雇工生产的瓷窑生产资料。"[14]在牟永抗先生的《龙泉窑调查发掘的若干往事》文章中，可以看到遗址堆栈层次及西区与李德金先生的《安福地区龙泉窑的有关问题》述及东区产瓷地区，生产盛期的情况。

"南宋时，烧造青瓷的地点，在龙泉境内的有……其中瓷窑最多，分布最集中，产量最高的要推大窑和金村两地。在大窑一带，有这时期遗物的窑址多达二十四处以上。次之为金村，在那里发现的十六处瓷窑遗址，主要是南宋前期的遗物堆积，而且窑址范围都很大，瓷片和窑具的堆积层甚厚。"[15]在长期的考古工作中，南宋龙泉窑大窑与金村的精品，我们注意到这些精品也没发现圈足底面有满釉的烧制品。

由处州境内窑冶税课看龙泉青瓷的生产情形

虽说南宋龙泉窑盛产，送出了数以万计的青瓷，供应给国内外各地，龙泉窑的精品件件运出远门，但据称龙泉本地人却是怕出远门。[16]龙泉多山，龙泉本地人惮于远出商旅。而山多则是道士修炼的好地方，其九姑山、凤凰山、琉华山、棋盘山等皆是名山。在唐时或更早时是一个可修炼成仙之地。[17]另外、龙泉又是一个炼名剑的地方，有一处古迹名为"剑池湖"，相传欧冶子在此处铸剑，"剑成，号龙渊，就湖淬之仕龙而玄。欧冶子乃吴王阖闾大夫，子有庙祀"[18]。自春秋，此处出名剑，直到现在龙泉宝

剑仍闻名中外。炼仙道与铸剑术都需要静寂的环境。龙泉炼剑对"炉火纯熟"已有高度的知识与掌握，这与浙江烧出最早的青瓷应是相关联的。这个渊源也带出了唐越窑以釉封匣钵而烧造出"秘色瓷"。南宋龙泉窑以还原焰烧出了温润的粉青瓷，所以(炼剑)与(烧瓷)想来并非偶然在一地可成之事，这两件事都是与"炉火"的掌握有着密切的关系。这两项都是地方政府课税的对象。

龙泉的窑业是重要课税财源之一，宋、元课税数目情况不知，现就以成化年间成书的《处州府志》所留下来的数据看，记录窑冶税，在处州境内有五个县：

丽水县：碗碟窑28处、缸窑4处、砖瓦窑11处。窑冶等项课钞约一千三百九十四锭。（成化《处州府志》，卷三，土产，十九页）

松阳县：缸瓶砖瓦三十处。窑冶等钞约三百八十一锭。（卷九，土产，坑冶，十七页）

龙泉县：盘碗窑八处、缸瓶窑四处、砖瓦窑九处。窑冶等项课钞约一万三千七百七十七锭。（卷十三，土产，十六页）（注：明代"钞"为纸币，明代一锭为钞五贯）

庆元县：碗窑一十二处、砖瓦窑二处。窑冶等钞约七十一锭。（卷十五，土产，十二页）

云和县：碗窑二十一处、砖瓦窑四处。窑冶等钞约一千二百九十锭。（卷十六，六页）

这个资料所记的调查窑数与课税金额、时间应是方志(成化年间刊版)成书之前，或更早的数据。因为地方志有时候会承袭前刊之旧志数据抄录。由这几个县比较可看出税金收纳最多的是龙泉县。另外，在记课税时会考虑到一些税额问题，如所记的税课数字大，后来的年岁，课税额都会以此为据，在商业日益兴盛的岁月里，是可以承担的，但生产不及之年，课税额目也照前例，就形成苛税。因此方志特别写上："贡赋惟据旧所定制，纪其常也。因时随事或有增加者，恐为他日取盈之故不书。"[19]龙泉之外，另记有四个县的窑冶税，这四县总共加起来，其税额只是龙泉的四分之一。龙泉县窑数没其他县多，但税金却高过数十倍，之所以如此，究其原因，可推测为龙泉县有大型的窑作坊存在，生产高级产品。在专业作坊制作方面，常是采用分类、分工生产，例如烧造碗、盘与缸、瓶等，各属不同作坊的分工，有利于生产线的流畅。龙泉县所产的除了有类别之分外，也有采取生产高级、高价的产品。因此龙泉窑数虽然没其他县多，但税额却高过它县数十倍，这也是必然的结果。方志所记的课税情形，暂且不管是南宋或成化之前的数据，但在考古累积层方面出现盛产丰厚的时代层—南

宋时期层，这应是一个税收丰富的时期。就如朱伯谦先生在《龙泉窑研究的回顾和展望—代序》中称"……对于历代龙窑的结构和盒装烧方法了如指掌，在瓷器中普遍留有装烧的痕迹，在了解装烧方法后，为鉴定瓷器的年代提供了部分依据。同时龙窑的长短大小合作坊的规模，为探讨是几家农民和烧的副业生产，还是像明代顾仕成等窑业主雇工生产的瓷窑性质提供了资料"[20]。有些学者认为以窑业为专业生产，才能有如此大规模的生产，由龙泉遗址积层的广厚看来，如以几家农民合烧的副业生产的方式，应无法达到如此大的规模。事实上，这应是随着生产时代的盛衰变化，及小农、大商各种不同形式经营的组合，会有各种情况产生。初始农业社会与手工业，因供需的关系，比例相当均衡。其后，农与工的比例也会随时代需要而有自动消长的调整。

以上这个课税资料是成化年出版的《处州府志》所记的，所记的应是明朝成化时期或之前的情况，因为其计算单位为"锭"，在洪武时有"给饶州等府工匠一千九银锭"及"给苏州府工匠钞四千九百七十锭"[21]，但宋朝则以"贯"为计。[22]

那么，这个税额说明成化或成化之前的明朝龙泉窑生产情形，这时期的生产应该仍然相当兴盛。以此来推想南宋、元时期的龙泉窑，生产盛况或更胜于明朝。而这个税是属于贡赋中的赋与课程里的房地、茶、酒醋一起，应属于正规共同课程的课税运作。如果要找瓷器单项目的课税额，或宋、元的瓷器生产盛期课税资料，则无从找到。但是在龙泉县方志里，可以找到一个与课税实务有关、很特殊的名词，即是"检税亭"。

唯独龙泉县设有"检税亭"

在方志上唯有龙泉县才有的"检税亭"，这个"检税亭"在成化《处州府志》被列在"古迹"之条内："检税亭，在尉司之西数步。"[23]而与"检税亭"同并列的有"手诏亭，在县画锦坊内"。

都被列为古迹应是前朝之事迹，在此书古迹之列，记有可见年号的大都属宋朝的年号，此条虽没记上年号，此处或为宋、元朝之遗址或使用到明朝永、宣时期，这个"检税亭"应是龙泉瓷器大量出口时期而遗留下来的迹址。

这个资料在雍正十一年（1733）版的《处州府志》（卷之一三十七页下古迹）则记为"简税亭"。乾隆二十七年的《龙泉县志》（卷之二建置、桥渡十二页），亦记为"简税亭"，其后多了"以上今俱废"的文字。这是一个令人感到兴趣的机构，"检"与"简"发音相同，但使用时或有意义的不同，按时间排最早的成化版本方志，以"检税亭"而论，应是一个课税专属的机构，但却是以"亭"设之。"亭"有

"驿"的含义也即是现在语的"站",如此一来,这个"检税亭",即是一个"课税站",货物在此经过、课了税放关出货。如是,则是为了因货物流量很大而设置的课税站。因此这个"检税亭"推测应是自南宋有大量青瓷出货时的出货税关口,经过这个"检税亭"抽税后出关,就成为国内的生活商品或出口贸易瓷,但无从确定是何时设立、何时才停止。

就宋朝贸易货品而言,瓷器占相当重要的角色,如日本、埃及、东南亚等地,有些遗址都有相当量的龙泉青瓷片出土,打捞沉船中也出大量的龙泉青瓷,韩国新安木浦沉船打捞出来的大量龙泉青瓷即是一例。再加上国内各地南宋、元遗留的龙泉青瓷器与瓷片来看,可知其各地的需求量之大,烧造量自然也就大。产量大、征税多,因而处州之龙泉窑税也比其他地区要高出许多,因而有"检税亭"之设立,应是合理的。所以"检税亭"在成化版的《处州府志》内已被列为"古迹"之条内,这个古迹也是龙泉窑兴盛繁忙之时所需要的机构,是南宋、元或到明初这一段盛产期所设立的机构吧。

综合"检税亭"、贸易瓷交易利益抽税及窖藏内容品的情况来看,南宋龙泉青瓷量产应是相当多,也受到了重视,在南宋、元当是一种高级又相当多量的产品。虽然高质量,但没有列为贡瓷名窑,但在南宋皇城遗址中有不少的龙泉窑产品破片出土,这也说明,南宋的龙泉窑圈足没有满釉,不成为贡瓷,但是皇城内用龙泉窑品应是不少。

翠绿滋润的釉色与器物面装饰的融合

时代所产生的共同性就是一种流行,就丽水、庆元、龙泉整个地区情况来看,唐朝、五代时所烧造的青瓷与越州青越造型相类似,都具有共同的时代风格。北宋早、中期这三地的产品,与景德镇造型等大都相同,在胎上面刻画的装饰比较多。到了南宋时的龙泉窑独步于高级青瓷的生产,其器面的装饰则开始变少,呈现较安静素雅的风格,这应是与龙泉窑厚釉产品相关联,因釉厚则刻花、印花纹饰在釉下被盖住不易显现出来,釉厚烧成的时间不能太久,如前所述的"北宋的龙窑长多数在六十米以上,最长的达八十余米,南宋后期为了烧厚釉的高档瓷器,龙窑缩短,长在三十米到五十米之间",窑身如太长,又以还原炭烧,光素胎面上的厚釉,烧造时间一过久,釉容易流淌脱落,因此南宋"龙窑缩短,长在三十米到五十米之间",是匠艺智慧结晶的呈现。南宋龙泉青瓷粉青色的烧成与龙窑长度有绝对的关系,不但烧出滋润的粉青色釉,一次烧造的数量也相当可观。

这类的高级青瓷，主要的产地为龙泉西区的大窑、金村二处，生产厚釉高档龙泉青瓷。南宋的龙泉青瓷为了显现其粉青翠绿釉色之美，在制作方面必定以釉积厚为考虑的重点。如日本大阪府久保惣纪念美术馆所藏的龙泉青瓷双凤耳盘口瓶(附图2)，被日本指定为国宝级之物。另一件，日本阳明文库所藏的也是龙泉青瓷双凤耳盘口瓶，被指定为重要文化财产。这个造型以素面无纹取胜，肩、腹将器面分割为几个较小单位，可以防止釉厚面积过大，烧造时釉容易脱落的缺点。其厚釉之美，可以在双凤耳盘口瓶的盘口面观察到，就是在盘口修坯时，盘口内缘挖得比较深，较深的地方积釉就厚，这个挖深的区块也形成了翠绿滋润的釉色，这是最值得欣赏之处。龙泉素面无纹的产品，有很多地方有细巧的处理。

另外还有盘口长颈弦纹瓶，在长长的颈部及瓶肩的地方，修胚时，却留有等距的凸弦纹，这个凸弦纹是一种装饰，也是为了使平滑过长的器面，起了阻止釉流的功用。这种凸弦纹，在汉朝时浙江一带所烧造的自然釉硬陶壶、罐之类中便出现。在制作上，往往在器肩上修出几条双凸弦纹，这是为了窑火停后，灰降下覆盖在器面时，灰与胎面结合成釉，釉积厚会垂流，所设的双凸弦纹，便可一段一段阻止它往下流。这种凸弦纹有此功能外，也成为一种装饰纹。在汉唐之间青瓷长石釉易流的系统里，常出现有这种凸弦纹的装饰。

器面凸弦的装饰法，也流传到南宋官窑及龙泉厚釉青瓷，一方面器面分成几个较小面积单位的平面处理，一方面凸弦纹也成简雅的重点装饰。这种厚釉的南宋官窑及龙泉青瓷，上釉时，不是一整器里外全上厚釉，我们常可观察到器物正常静置定放时，看得见的器面部分，釉上得厚而均美。在器物正常置放，视线较不及处，或圈足底内、小口瓶、罐等器内处，有时往往只上一次釉，甚至不上满釉，一部分少上釉，甚至瓶之类只上到器物内壁上半部而已，不但可以省工，也可减少器胎承受过多的釉量，而造成烧造的失败。也可能是因器口小，不容易施釉。而在壶、缸之类口大者，视线可马上看到壶、缸内，釉的处理就仔细多了，有时会将器内与器表面施一样厚釉，以求整器的完美。

与北宋相较下，南宋龙泉窑以厚釉为美之表现重点，几乎很少使用阴刻细线纹的装饰手法，因为厚釉会盖住细刻线。有时会以简练的半刀泥划花卉，在碗、盘、洗外壁一周作纹饰。瓶之类则以各种立体造型的双耳来做装饰，或以半模印制成贴花片，这种装饰法要比其他窑来得多，这些是以不碍厚釉之美为考虑而创造出来的装饰手法。因此南宋龙泉青瓷高级品应是以如何发挥青瓷釉与器形配合之美为制作的最大重点，这个时期的胎与釉都很均匀(到元中期胎与釉逐渐变厚)。这类高级品，价位高，应

该也是高课税的对象。

"元代早期器形特征和装烧方法与南宋晚期基本相同。但到元代中、晚期以后，制瓷工艺有明显区别，不如南宋制瓷工艺精细，器物胎壁逐渐增厚，胎灰白，釉色青中泛黄或灰，釉层变薄。刻划纹饰又增……"[24]在元朝中期，龙泉窑胎与釉变厚了。胎厚上厚釉，釉色呈翠青。元代瓷器品种有所增加，但还是以烧各式碗、盘、洗为主。与宋朝相比，器物尺寸也变大，器壁就需增厚，大件厚胎的器物在烧造上，比较容易爆裂。如元、明时代的海会壶及大瓶等大件器物，这一类器物在制作时，只成形器身壁下半身，器底成空，再用另一片似盘状的垫成器底，如此器壁与器底分开另件处理再接合，可以避免器底烧制时爆裂，这种处理手法在元中期到明中期是一个特色。

关于龙泉窑足下满釉的器物则要到元后期、明洪武时才出现。从2006年到2007年的挖掘调查，发现了大窑的枫洞岩窑是烧造元、明朝官窑。一些出土的器物在造形、纹饰、尺寸都与明朝洪武、永乐景德镇清宫旧藏的官窑及景德镇珠山出土的明代早期官窑是一样的形制、纹饰。[25]说明龙泉窑与景德镇窑都是受宫中指定烧造的官窑。

日本"七官手"青瓷名称的由来

在贸易瓷方面，韩国新安木浦海岸所发现的这条船，是到现在为止最令人震惊的发现，不但量多，而且质好。1976年沉船的打捞物中，瓷器高达近两万件，青瓷的部份以龙泉窑占很重要的部分，是13至14世纪中叶最好的窑产品参考数据。[26]韩国新安沉船打捞出一万多件的中国陶瓷中有一件龙泉青瓷大盘，在圈足上刻有"使司帅府公用"，这件在制作上，圈足上满釉，圈足内底留一圈没上釉，以垫圈烧。这时的圈足满釉青瓷，应是与唐、宋一样的具有为公家所用贡瓷的性质。

日本自宋以来便陆续输入龙泉青瓷，其中有特别的称为"砧青瓷""天龙寺青瓷""七官手青瓷"的一类青瓷。其名称之由来是：宋、元时，日本有很多僧人往来中国，也带回了宋龙泉的高级青瓷，日本将它称为"砧青瓷"（唐代诗人李白《闻夜砧诗文》借引器形如砧），元朝时日本的梦窗国师所留给天龙寺的一个龙泉青瓷香炉，这个香炉是日本派遣到中国的"天龙寺船"贸易船所带回来的，因此这一类元朝高级的青瓷叫做"天龙寺青瓷"。日本直到现在花道、茶道仍然很喜欢用龙泉青瓷。另外关于"七官手青瓷"的由来：

"……官自具船、给本、选人、入番贸易诸货，其所获之息，以十分为率，官取其七，所易人得其三……"[27]

这里由官出资所行之贸易，所得利益官七分，牙人三分，由这种方式所交易的青

瓷货品，这应是"七官手青瓷"之代称的由来。[28]有官家资本参与的情形来看带动龙泉青瓷商品买卖，应有相当大的影响。事实上关于官方出资的贸易形态，在宋朝时已实行，熙宁三年（1070）时王诏提议设立市易务，隶属于都提举司，这时候是以西蕃诸国入中土的货为主。[29]

这是对与西北近连诸番国之地，货物往来有利可图而做的建议，由官出资买入，再由牙人去销售，也就是像现在的国营贸易、总代理之类的商业行为，如此可获相当多的利益。因此，到熙宁五年就有更具体的出资、收益分摊的方式出现，在京城也要设了置市易务。[30]

这种交易方式卖方可以收官钱，也可以换官物。则半年一次或一年一次向官借资金，要付二分利。这种商业行为给官方带来了利益，不只是蕃物买卖，在京城人口众多，形成一种官营事业，于是范围越扩越大，不止边境，京城、海港、连内地比较大的商业地及产地都置了市易司，都来与官方做生意，其中也包括越州、定州等产瓷之地。[31]当然，由于文中没有记明买卖何种货物，推测应是以有利可图之货为对象，特别是瓷器，日用品、高级品都是当时最好的买卖货物。这种方式延伸到元朝则处州龙泉的青瓷亦成为官营事业的对象货物之一，"以十分为率，官取其七，所易人得其三"衍生出一套商业形式，出资本的官抽利七分。市易司便是一个增加皇室、官方财源的一个机构。这种商业形式，也将龙泉青瓷商品推销到广大的国内外各地。所以在"官取其七，所易人得其三"的这种情形之下，属于这个时期、龙泉所生产的这类商品，飘洋过海卖到日本，自然而然便以"七官手"来称之，这是这个时期特定种类的商品。

明朝陆容对龙泉窑的记实

对于龙泉青瓷而言在文献上最重要的，是明成化二年进士陆容所著的《菽园杂记》，他是昆山人，由于他任浙江参政，尤有政绩，但后来"以考察去位，闻者大骇"[32]，在《菽园杂记》里记载了很多明朝开国以来至弘治初的事，与《实录》有可对照的纪实。在此书中有一段记述与龙泉青瓷相关的资料。这段文虽不长，把龙泉刘田及周围窑的情形、每个制作及成品情况、销售等整个过程，简洁正确地记述下来。以绿莒色与生菜色来形容当时青瓷烧成时的色泽，令人见其文如见其色。并且说"然上等价高，皆转货他处，县官未尝见也"[33]。

自宋以来，宦居于浙江之文人或官员，也唯陆容一人能到窑产地实地勘察。他对处州、龙泉之地应做了相当的考察。一般文人、官员对烧窑之事不是很清楚，最主要

的原因是只对贡瓷、名窑感兴趣，对于工匠制造问题不关心而已。而陆蓉能将龙泉窑产地历史及范围的记述，及对于泥质釉料等烧造程序叙述简要明确，成品后之集散流程皆一一述及。上等品也如陆容所说的"然上等价高，皆转货他处，县官未尝见也"。这些述及龙泉窑盛产繁忙期时，精美产品出窑后，经由"检税亭"课税后，便转货他处，连县官也未尝见。在其后万历时代的高濂，其所著的《燕闲清赏笺》内《论诸品窑器》之项中，提及宋龙泉可与官窑争艳，"……今则上品仅有葱色，余尽油青色矣，制亦愈下……，龙泉制觉细精致谓之章窑……"[34]

元中期至明中期龙泉窑与宫中的关系

元末朱元璋的势力在江南逐渐扩张，在至正十九年（1359）攻打金华时，有一则与青瓷相关的记事。当地有位名叫任维平的饱读经书文士，在朱元璋率三军下金华时，与其弟维信去求见，当时朱元璋正在御食，于是命以"青瓷"为题赋诗来测试这位求见者的才华，任维平即作了一首诗：

"贮酒盛浆小类瓶，曾近扬武求民兵。若教假入神仙手，捧出中天日月明。"[35]

这首七言律诗正道出朱元璋当时的心志，使他大为高兴，这一年攻下金华的朱元璋，得到刘基这位良辅。虽然在此时尚未称王，但亦据一方之势，在此用膳时之"青瓷"瓶应是龙泉青瓷，亦应非粗器才是。

朱元璋后来称帝，建立明朝，洪武帝对于祭祀特别重视，举凡大祀、中祀、小祀在制度上都有详细的规定，对于祭器也做了很大的改革："今拟凡祭器皆用磁。"[36]在洪武二年（1369）时便规定祭器以瓷来代替。平常提及明朝的瓷器与宫中有关的大凡都以景德镇为代表，事实不然，龙泉窑到元朝已有部分圈足满釉垫圈烧的青瓷器，在明朝属于高级品，亦是足满釉的垫圈烧，以供宫中用器。由一则资料可知龙泉窑由官员来督运的史实：

"韩时中，洪武末同知，廉洁公平，督运海舟、青器，措置得宜，民心悦服。"[37]

由元中期至明中期的龙泉青瓷高级品，其烧造可以发现有相当数量是圈足满釉垫圈烧的产品，在造型与纹饰上都是与景德镇的青花瓷同步。这类的产品，应是成为皇室用器或赏赐、贸易品。[38]元中期、明中期时，龙泉窑特别烧出了垫圈足包釉的宫廷式的用瓷，不但供宫廷用，也为土耳其王室伊斯坦坦布尔的托普卡帕皇宫，及德黑兰的阿鲁德比回教寺院里所用。

据考古发掘，大窑枫洞岩窑址出土洪武(1368—1398)及永乐(1403—1424)年间的官窑器。在永乐官窑器的堆积层中有"永乐九年(1411)十一月廿九日立毛自记号""永乐秋

辛卯(1411年)太岁吉日置号"及印模"永乐……年置"等纪年铭的重要数据瓷片出土。在景德镇也出土了永乐四年(1406)、永乐九年纪年的瓷片。[39]这也说明处州与饶州以同步调处理书写年款的方式。在大窑枫洞岩窑的明代官窑中，碗、盘等经常移动使用的器皿，都是圈足上满釉，在圈足内底用垫圈支撑烧成的，这种"圈足底面满釉"也就是明朝洪武、永乐的官窑品。

龙泉窑的大作坊坊主——顾仕成

在天顺改元为成化时，龙泉县制瓷业有位顾仕成，在地方志里留有他的记载："顾仕成，父没，事继母李氏孝谨，凡母嗜好，率如所欲，疾供侍汤药，衣不解带，及没哀毁既葬，卢墓三年，……景泰壬申（1452）立孝子坊以旌之。"[40]

由此可知顾仕成应活跃于15世纪中叶，在实物上可以看到有碗内底印有顾仕成制的青瓷碗产品，此时期的龙泉青瓷都是胎厚釉厚。除了有文字印款之外，亦有孝子、忠义等故事图文作装饰。顾仕成应该是当时龙泉制瓷业的大作坊的老板，在方志上会有记其事，除了是"孝子"旌名外，应也是一个瓷器大作坊产业家。[41]他的亲家李善(少子衡赘顾仕成女)也因而在退官之后居龙之水南。在此文内有李善捐俸缗，将原本石凳的道路易为砖凳通往县邑道路，在地方上属公德之举，而现在龙泉大窑窑址的地方，仍留有一小段砖凳的路，虽然只剩下一小段，但铺垫得很平稳。在1992年参访时，当地人都称此地区为"官场"，言是因龙泉县有女选入宫中为妃，而特别铺砖凳之路。但《龙泉县志》中并没出现"有女选入宫中为妃"的记载。或许此段砖凳之道，是李、顾二家政商结合的一段姻缘路吧，而李善在正统间为县丞，以捕盗功升知县，是官员，因而被当地人称为"官场"吧。

在考古方面，对于龙泉大窑枫洞岩窑，由明朝早期到中期的堆积层分期编年做得相当详细，在明中期的积层中，3号居住址层出土了"顾川祠堂"铭文的青瓷片。这也佐证了"顾氏制瓷"的规模。在清朝的《龙泉县志》中，有一则值得注意的资料，即："青瓷器：一都琉田。瓷窑昔属剑川，自析御立庆元县，窑地遂属庆元，去龙邑几二百里。明正统时，顾仕成所制者，已不及生二章远甚，仕成以后质粗色恶，难充雅玩矣。"[42]

这则清朝的方志记载着青瓷的烧造已转由庆元来烧造，可能是竹口一带。而此文中又提及另一个讯息，即是顾仕成所制的已不及生二章，因此，这句话引出一个设想，即是在明朝正统时，龙泉地区亦有章生一的哥窑的烧造。当然，也可以解释为《龙泉县志》所指的"已不及生二章远甚"，可能只以物品相比，没把物品出产时间

的先后问题考虑在内。事实上，《格古要论》一书内所提及的官、哥等名窑，一直以来，是文人雅士所求之物，也是仿品不绝的。关于哥窑做为他日课题，在此不论及。此文中亦提及自顾仕成之后，"龙泉青瓷即质粗色恶，难充雅玩"，这是从古玩的角度而发的。在《格古要论》中有古龙泉窑之条旧称："古青器，土脉细且薄，翠青色者贵，粉青者佳，……有一等盆底双鱼盆口有缀环，体厚者不甚佳。"[43]这时的龙泉窑应传承元后期制作，胎都偏向厚，为一般商品制作。

对于龙泉窑仍以薄胎为贵，文中很明显地指着南宋的龙泉窑。到了嘉、万年间，明朝立国已历近二百多年，社会太平日久，国势日渐趋弱，人们沉溺于安逸的生活，对于古书画、珍玩，日盛一日，这方面的著述记载也跟着多起来，这时除了固有的宋五大名窑之外，对宋龙泉青的评价愈来愈高。

结语

以上所述的是文献中所能找到的周边资料，以及对龙泉青瓷生产情况的了解。虽然龙泉青瓷产量大，流通面广，但由于没正式入贡，只扮演着在北宋五大名窑之下辅助的角色。在实际生活使用上，却是应用非常普及的，在中、上层社会担任了生活上重要的器皿角色。元中期与明早期至成化年间，与景德镇同步，亦接受宫中指定样式、纹饰，这一类高级圈足满釉垫圈烧的产品，也供官民同用。在陶瓷史中，一个地区能以单一色系产品，繁荣这么长久，生产如此大量供应海内外，除了龙泉之外，似乎找不到第二个窑系。

蔡和璧
2017年8月8日于锄烟舍

注释

1. 《处州府志》卷第四,十七页,(明成化)刘宣撰,成化间刊本,中央图书馆善本藏书。

2. 《酉阳杂俎》前言:"卒于懿宗咸通四年（863）。少年苦学精研,尤深佛理,曾任秘书省校书郎等,出为卢陵、缙云、江州刺史,终太常少卿。"（P_{2-3}）南方生点校,中华书局,1981年版。

3. 《处州府志》卷八"官秩":"……处州府,知府大中段成式。"雍正十一年,曹抡彬修。

4. 《笔记小说大观》第二十二编三册（P_{1520}）。此书成于南宋开禧二年（1206）,在绍兴年间（1131-1162年）,宋朝的宗室子弟颇多好学者。在政治面,宋朝对于宗室及皇亲采取的政策是:"国朝之制,不属宗室以吏事,悉留京都,以奉朝请。"换而言之,宗室弟子不予高职重任,以防据群结党,对执政的皇帝造成不利。因此一般好学子弟如能入试取进士者,大都指任地方判官获知府之类的官职而已。赵彦卫亦属此类官职的宗室弟子,当了个远离中央政权的地方官。

5. 《笔记小说大观》第二十二编第三册,P_{1572}。

6. 年永抗所著的《龙泉窑调查发掘的若干往事》（《东方博物》第三辑P_{84}）述及"……先后在大窑乙区和金村分别发掘到相同的三迭层。乙区的堆积以y2为代表的上层最精美,在金村却以中层的产品最丰富……"

7. 《处州府志》卷一,雍正十一年版,曹抡彬重修,沿革疆域,四页下。

8. 朱伯谦著《龙泉青瓷简史》,《龙泉青瓷研究》,P_4,文物出版社,1989年版。

9/10. 关景晖《通济堰詹南二司马庙记》,载《处州府志》,成化年间刊本,刘宣撰,卷四,十七页;龚原《治滩记》,载《处州府志》,成化年间刊本,刘宣撰,卷二,十六页。《浙江通志》,明嘉靖四十年刊本,薛应旗撰。各方志此篇文稍有差异,但文题一样。

11. 《处州府志》卷十三,六页上,曹抡彬修。

12. 《浙江通志》卷八,二十一、二十二页。

13. 《龙泉县志》卷之一,舆地、山水,十九、二十页。

14. 朱伯谦《龙泉窑研究的回顾和展望——代序》,《东方博物》第三辑,杭州大学出版社,P_4。

15. 《龙泉青瓷简史》,朱伯谦著,《龙泉青瓷研究》,文物出版社,1989年版,P_8。

16. "治内山多田少,昔民力耕种尚俭啬,商旅惮于远出,贸迁不越邻封,积书教子宜

业，相望可为十邑首称，惜乎今不古若仰教之未淳，抑亦山川气运否塞也。"《处州府志》，明成化年间刊本，刘宣撰，卷十三，二页，龙泉县，风俗之项。

17.《处州府志》卷十三，山川之条，三页，明成化刘宣撰。

18.《处州府志》卷十三，古迹，廿七页，明成化刘宣撰。

19.《浙江通志》，例义，一页下。

20.朱伯谦《龙泉窑研究的回顾和展望—代序》，《东方博物》，第三辑，杭州大学出版社，P$_4$。

21.《明太祖实录》，卷一四六，壬子之条及一四五，丁丑之条。

22.见《宋代草市镇研究》第五章，P$_{308}$，秀州商税额表。《宋会要辑编》，仓货之二之十一，"大观库"。

23.《处州府志》，成化，刘宣撰，卷十三，廿五页，古迹。

24.《考古》，1981年6期，科学出版社，P$_{505-510}$。

25.《大明会典》，卷一百九十四，陶器条述："洪武二十六年定:凡烧造共享器皿等物，需要定夺制样，计算人工物料。如果数多，起取人匠赴京，制窑兴工，或数少，形移饶、处等府烧造……"

26.参考《新安海底引扬げ文物报告书》1983年中日新闻社。《新安海底引扬文物》，东京国立博物馆编集，1983年，中日新闻社出版。

27.《元史》，卷九十四，食货二。

28.长谷部乐尔《新安海底引扬げ文物报告书》，国际"新安出土青磁"，P$_{105}$。

29."市易务……照宁三年……惟秦凤一路与西蕃诸国连接，蕃中物货四流。……欲于本路置市易司，借官钱为本，稍笼商贾之刹，即一岁之入亦不下一、二千万贯……"，《宋会安辑稿》，卷一万四千九百八十九，十页，食货，五百之三十一。

30."熙宁五年（1073）……宜令，在京置市易务……，召诸邑牙人投状充本务行人。……非时勾集内行人，供人供自己或借他人产业，金银充抵，当五人以上为一保，遇客人贩到货物。出卖不行，愿卖入官者，官为勾行牙人与客人两平商量其价，据行人所要物后，先支官钱收买，愿折博官物者亦听随抵当物力多少，令均分余，请立一限或二限送纳价钱。半年出息一分，一年即出息二分……其余条约委三司、本司官申中书详定施行。"，《宋会要辑编》，卷一万四千九百八十九，十一页。

31.在北宋熙宁八年时，"熙宁八年二月诏泰州、永兴县、凤翔府、润州、越州、真

州、大明府、安肃县、瀛州、沧州、定州、真定府，并置市易司……"《宋会要辑编》，卷一万四千九百八十八，十七页。

32.陆容《浙江通志》，卷三十五，十八页。

33."青瓷初出于刘田，去县六十里，次则有金村窑，与刘田相去五里余，外则白鹰、梧桐、安仁、安福、绿遶等处皆有之，然泥油精细，模范端巧俱不若刘田，泥则取于窑之近地，其他处皆不及。油则取山中蓄木叶烧炼成灰，并白石末澄取细者合而为油，大率取泥贵细合，油贵精。匠作先以钧运成器，或模范成形，候泥干则蘸油涂饰，用泥筒盛之，寘诸窑内端，正排定以柴筱日夜烧，变候火色红焰无烟即以泥封闭火门，火气绝而后启，凡绿莹色莹净无瑕者为上，生菜生者为次之，然上等价高，皆转货他处，县官未尝见也。"《菽园杂记》，卷十四，十页，嘉庆十五年，张海鹏校梓，民国五十九年版，台北广文书局。

34.杨家骆编《美术丛书》，"观赏汇录"上，P$_{352-353}$。

35.《处州府志》，卷三，五十五页，仕宦国朝。

36."礼部奏按礼记郊时牲日：郊之祭也，器用陶匏，瓦器尚质故也。周礼笾人凡祭祀供簠、簋之实，疏曰：外祀用瓦簋。……今拟凡祭器皆用磁，……惟笾以竹。诏从之。"《明太祖实录》，卷四四，洪武二年八月，丁亥之条。

37.《处州府志》，卷九，二页，官绩、文治。

38.参考王建华《故宫博物院藏明代龙泉青瓷掇英》，《故宫博物院院刊》，1994年，第1期，P$_{36}$。

39.《皇帝の磁器-新発見の景徳鎮官窑》图198，出光美术馆，1995年出版。

40.苏遇龙撰修《龙泉县志》，卷十，人物孝友，二十六页上，乾隆二十七年版。

41."李善，字志中，浦城人，正统间，县丞，以捕盗功升知县，待人以实，处事以公，捐俸缗易砖甃通邑路，旧皆石甃，士民怀惠，少子衡赘孝子顾仕成女，遂家于龙之水南。"〔明〕苏遇龙编修《龙泉县志》，卷三，赋役、物产，十八页及卷八，五页，政绩。

42.苏遇龙撰修《龙泉县志》，卷三，赋役、物产十八页，乾隆二十七年。

43.曹昭著《格古要论》，卷下，六卷，四十九页。

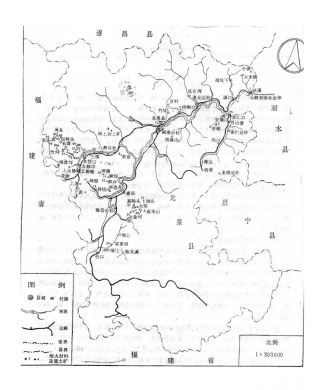

附图1
龙泉县水路分布图

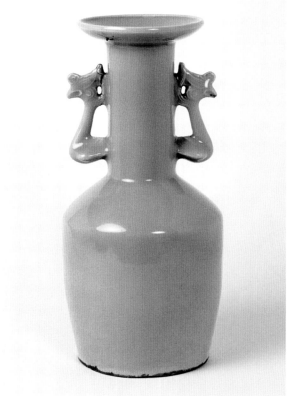

附图2
龙泉凤耳盘口瓶（大阪久保惣
纪念美术馆）

18. ◉青磁鳳凰耳瓶　銘萬聲　龍泉窯　13世紀　1口　高30.8cm　和泉市久保惣記念美術館
Mallet shaped vase with phoenix-shaped handles, known as *Bansei*

Preface 1
Zhejiang Celadon - Longquan Kiln

At the Zhejiang Celadon and Shanghai Painting and Calligraphy Exhibition, a large amount of Shanghai paintings and calligraphy works as well as Zhejiang celadon are exhibited. Porcelain exhibitions include nearly 90 representative works of celadon of each era which were produced in Zhejiang, covering a time period from the Jin Dynasty to the Qing Dynasty. All are works of Longquan celadon except a plump and elegant sheep-shape celadon of Yue Kiln which was made in the Jin Dynasty. Exhibits of stationery and incense wares are all exquisite and rare. About 7 or 8 pieces of incense wares are from the dynasties of Song, Yuan, Ming, and Qing, all with shiny glaze and features of the times. Four five-tubed vases are distinct in their shape and charm, with the lotus-petal five-tubed vase topping them in terms of dignity and beauty. Three dragon-tiger vases have a walking dragon stuck along the neck with a vivid look. While the vases of the Northern Song feature a sharp shape, those of the Southern Song look much tender, but all have their cover knobs ornamented with different animals. The original dragon-tiger vases are a pair of a dragon vase and a tiger vase meaning the fighting between them is so fierce that their souls even rise to the heaven. The 10-arris ewer with very elegant engraved designs suggests a sense of tension by its shape. Three-plate box and cover with clearly engraved patterns can fasten tightly due to the well-cut body and cover. The vase with elephant-ear shaped rings of the Yuan Dynasty is humble in size, but it has an evenly-distributed and shiny glaze on the neck, shoulder and body, and the powerful ear ring also looks grand. The goblet with engraved patterns is a masterpiece covered with floral patterns. The pink polish against the transparent green glaze adds to its value and charm. The exhibits, though not many in number, offers a peer into the landscapes of Longquan kilns at different times.

Yue kilns in Zhejiang had adopted the burning process for nearly 1,000 years, which was then inherited by Longquan kilns, so the celadon in this region had a nearly 2,000 years of history of being produced by this craft. Also, it was unique and peerless in the world. After inheriting the process from the Yue kilns, Longquan kilns became world known with its well-made products in large quantity. Speaking of Longquan kilns, people understood that they were talking about the celadon, which had left them with a very deep impression. So a long history is indeed the carrier of a valuable legacy. It is hoped that the exhibition can spark greater interest of the participants in the exhibits by giving them a brief introduction about the background and history of Longquan kilns.

In the tang dynasty, Chuzhou was surrounded with high mountains and fast-flowing rivers.

Since the Shang and Zhou Dynasties, the production of celadon by burning was on a decline due to the exhaustion of resources by the consumption of raw materials and fuel over a long period of time. But the decline of the industry in Shanglinhu of Yuyao, the celadon production center was shifted to Longquan rich in clay. Located in the south of Zhejiang, Longquan is a mountainous area. Before the Middle of the Song Dynasty, Longquan had not a convenient road transportation, and though there were rivers flowing through it, many parts were rapids, as was described in the Regulation of Rapids by Gong Yuan of the Song Dynasty.

"According to old record, Jinyun and Lishui were notorious for the monsters in the river, after being controlled by Duan Chengshi, prefecture chief of the Tang Dynasty, those places turned beneficial…" (Note 1). The river is the Ou River today, when Duan Chengshi served as the prefecture chief, he put the monsters under control. Duan Chengshi (?-?), was born in 803 (the 19th year of the regime of Emperor Dezong of Tang) or later. (Note 2). He served as prefecture chief in Chuzhou in Dazhong Reign, Tang Dynasty (about the 850s), and it made a big difference in the area by regulating rivers and shoals of Jinyun. (Note 3), as for Longquan, also belonging to Chuzhou, there is no records of Duan Chengshi regulating rivers despite the fact that it faced the same problems as Jinyun. At that time, Longquan was an undeveloped area with its local industries still in their infancy.

Longquan celadon mentioned by the people of Song Dynasty

Entering the Northern Song when the whole society enjoyed prosperity, porcelain became popular among the upper class people. In the Records upon Resting after Plowing by a writer of the Yuan Dynasty there was a line quoted from Yi Zhi that said, "…Longquan County of Chuzhou is famous for its kiln quality." (similar to the contents of Xuanza Lu by Gu Wenjian). Judging from the context, they must be talking about the Longquan kilns of the Northern Song, for they praised it as quite "excellent". In literary sketches such as the Dongjing Meng Hua Lu by Meng Yuanlao, there were records of the Northern Song, but there was no mentioning of Longquan kilns. Similarly, in literary sketches such as Tales of the Old Capital by Zhou Mi of the Southern Song there was no description of the celadon of Longquan kilns. As late as Southern Song, Zhao Yanwei, a member of imperial clan finally had records in his Yunlu Manchao that "Wares of celadon are all from King Li, alternative name Mi'se. But some people argue they are from King Qian. The products made in Longxi kilns are light green, and the color of moxa from Yue kilns. Lu Guimeng of the Tang Dynasty has such lines as read: in autumn the Yue Kilns come to operation, and their products are as green as the

mountains; the wares are great for holding good wine at night, which will offer us so much fun. From this we know that they are not from King Li nor King Qian. Somewhere near Lin' an there are also porcelains made of a better quality than those made in the above places." (Note 5)

In the Yunlu Manchao written in the Southern Dynasty, we finally see records that described the porcelain of Longxi as light green. That article mentioned both Yue kilns, Longquan kilns, and Royal kilns, all three famous kilns in Zhejiang, and further described the celadon colors as the color of moxa and light green respectively, which were burned by different flames. Because he was a member of the imperial clan, he knew quite well about the royal kilns, as recorded in his article that the royal kilns in Lin'an also produced celadon by burning process (as mentioned as Yunlu Manchao). Based on this it is safe to conclude that in the early 13th century, Longquan celadon glaze (light green) had reached its mature stage, and was the quality goods of Longquan kilns. Yunlu Manchao was published ten years later than the Qing Bo Za Zhi by Zhou Hui, but the latter never mentioned Longquan kilns though it gave description of other kiln wares. Zhao Yanwei alone gave a special note about celadon, which is quite valuable for Longquan kilns which had failed to be included in the suppliers of tributary porcelains. In terms of products, Longquan kilns had reached its prime in Southern Dynasty, but no goods with ring foot covered by glaze was found among the quality products of Longquan celadon.

Archaeological excavation shows that sites where exquisite products were proved existing in Jin Village and Dayao Site. Archeologists have found the same three layers in Section B of Dayao and Jin Village. In Section B, the most exquisite products are excavated in the upper layer as represented by y2, while in Jin Village the middle layer has the most products. (Note 6)

Porcelain production in the outskirts of Longquan County in Tang Dynasty

Prior to 758 (the second year of Qianyuan of Tang Dynasty), Longquan was a town. And thanks to an occasion it was promoted to a county. According to local chronicles, "At the foot of Kuocang Mountain there is Jianchi Lake of Huanghe Town, also referred to as Longyuan. Then Tang rulers changed it into Longquan for the sake of Gaozu. In 758 (the second year of Qianyuan of Tang Dynasty), DuguYu, the then governor of Yue Zhou, submitted a request that the Longquan Town be promoted into a county. In 1122 (the fourth year of Xuanhe of the Song Dynasty, the Chinese character for dragon was forbidden to use as the name of any county or town, so it was renamed Jianchuan. In 1131 (the first year of Shaoxing of the Song Dynasty, it was again renamed Longquan until the Ming Dynasty." (Note 7)

In Tang Dynasty, surrounding the Yue Kiln were the Lvbukeng Kiln in Lishui County and

the Huangtan Kiln in Qingyuan County. For administrative areas, they were promoted from towns to counties as their population grew, at a time in the ancient China when The Book of Tea was published, and a time when Gu Kuang (in about 757), Meng Jiao (in about 785) and other men of letters began to admire the wares for tea. As tea gained grown popularity in Jiangnan, quality celadon made by the Yue Kiln attracted more attention, which also provided momentum for neighboring areas in celadon making by burning. And the situations in the two places were described as follows.

"Lvbukeng of Lishui County, a site of celadon kiln existed from late Southern Dynasties to Tang Dynasty, and those of Tang Kilns found in Huangtan of Qingyuan County…In 1959, local excavation resulted in some unearthed products, of which most were bowls with thick walls and blue yellow glaze, but of ordinary quality. In the northeast of Huangtan and the south of Long-Qing Highway, the kilns were seriously damaged, and the original mounts were reduced to small ones, with kiln furniture and bricks scattered in a large area, along with pieces of bowls and other wares. The quality of the celadon wares produced by both kilns were low, far less than their contemporary counterparts from the Yue kilns, Wuzhou kiln and Ou kiln. And the situation remained largely the same until late Five Dynasties and early Song Dynasty. (Note 8)

In the second year of Qianyuan, Longquan had a growing population after becoming a county. But due to its poor road conditions and poor water transportation, its industries were not well developed. And the rich resources of quality china clay were yet to be tapped. However, turning into a county from a town sent a signal that the boom of its porcelain industry was coming.

Longquan County after its waterway coming into service in the seventh year of Yuanyou of Song Dynasty

Longquan was an area surrounded by mountains with poor transportation. Though Duan Chengshi oversaw the regulation of the rivers of Jinyun in Tang Dynasty, a convenient waterway was not in place until 1092 (the seventh year of Yuanyou of Northern Song). The coming to service of the waterway marked a new chapter in its history of industrial growth. Several local chronicles such as Zhejiang Annals, Chuzhou Annals, and Longquan Annals, included the Regulation of Rapids by Gong Yuan of the Song Dynasty. The article offered important information about the time when Longquan started to enjoy a convenient access to the outside world.

"Three big rivers of Kuoshu County saw confluence in Lishui into one big river which flows into the sea via Zhi and Ou. Hidden shoals and dangerous reefs pose a great danger to the

boats and crew, who, after suffering great losses in terms of property and life, pleaded to the government that something be done about the rapids. But the officials always blamed the wreck on the dangerous waterway, refusing to do anything. In the winter of the sixth year of Yuanyou, Duke Guan of Kuaiji was appointed as the governor of the area. In his spare time he would read the maps of the town and sighed: what a treacherous waterway it is! Top priority must be given to the regulation of the water. I hope only that a good waterway will make the local people lead a safe life, and I desire nothing more. When the locals heard this, they were happy and said: Alas, we finally get the chance to have the rapids controlled. The following year, namely the seventh year of Yuanyou (1092), the locals donated money for the project, and neighboring towns and counties also pleaded for the Duke to oversee the engineering covering their waterways. They all agreed to participate in the project whenever their farming is done. So, from July until December, a total of 65 dangerous reefs were removed, of which half were located in Longquan, 20% in Jinyun. With that done, the river became safe and beneficial to the boats, and there was no more wreck happening. The locals said: how long the river had posed a danger to us and how many deaths it had caused…Now due to the efforts of our lord we finally enjoyed a safe journey by water. So let us sing praises to him our lord." (Note 9)

The above mentioned Duke Guan was Guan Jinghui, a Kuaiji local. In the middle of Yuanyou he was appointed governor of Gua County where the waterway was quite dangerous, so he launched a project to regulate the water. (Note 10)

It recorded clearly that it was by the end of the seventh year of Yuanyou that the rivers were put under control, with 165 reefs removed, of which half were in Longquan. After that, great improvements had been made on the transportation linking Longquan to the outside. Since locals could only join the project when farming was done, it showed that farming was the main industry at that time. We can presume that it was after the completion of the engineering that Longquan was driven by porcelain instead of agriculture in its economic development. So the seventh year of Yuanyou marked a turning point for the industry.

In Southern Song Longquan reached its prime in porcelain production

In 1092 (the seventh year of Yuanyou) the reefs were removed. Then, during the 35 years from then on until 1127 when the Southern Song moved to the south, the porcelain industry gradually gained momentum. But during that time the Northern Song was suffering defeats in war and had to retreat to the south, until Gaozong settled in Hangzhou as the capital. By that time the Yue kilns in Zhejiang had no more prosperity to enjoy, and the Ding kilns and Ru kilns were all in the possession of the Jin regime. After the Southern Song finally settled down in the south, kilns were built in rural places 2 km in the southwest of Lin'an, the then

capital, to meet the demands of royal household for their daily use and sacrifice ceremony. As the population of the capital grew, and people started to enjoy a luxurious life, the capital gradually became a consumer center, which in turn increased the demand for the products of Longquan kilns.

Since late Northern Song after the waterways were improved, there were lots of business carried out between Longquan and the outside world, offering greater momentum for the porcelain industry of Longquan. Jin Village and Dayao were the main producing areas of celadon in the west of Longquan. The two places were separated by a steep ridge, and both enjoyed the same vein of china clay in rich amount. Also, they both produced fine celadon with the same quality, making themselves the porcelain making areas with the highest quality in Southern Song. In addition, Longquan kilns products were in high demand from other regions as trading goods, which in turn increased the output. The three driving forces, namely its location as the capital, the boom of economy and the strong demand, greatly promoted the massive production of porcelain wares with good quality in Longquan.

These porcelain wares, due to their fragile nature, were not for bumpy roads. Since the waterways were improved in the seventh year of Yuanyou, the porcelain wares were easily transported by water to all places of the country. According to the chronicles of prefecture, "Qin river is 5 miles to the south of the county, Jiang river 6 miles to the west, Da river one mile to the south, and the Qin and Jiang rivers saw confluence and flow to the east of the prefecture." (Note 11) In Longquan County, the two waterways were used as the main courses, then "The products from Longquan in the west, Jinyun in the north, Suichang and Songyang in the northwest all come to Lishui, from which they then take the waterway via Qingtian to Yongjia in the east and then to the sea." That is, all porcelain wares were carried along the Ou River to Wenzhou, where they were shipped overseas.

Zhejiang Annals had the detailed description as follows:"Ling river, also known as Zha river or Da river, flows before the government period of the county. Its upper stream is the Qin river and Jiang river converging into one. It comes to Chazhou and expands to as wide as two miles, where a bridge called Jichuan crosses over it. It then divides in two where the Liucha Pavilion stands. After that the two branches see confluence into one and flow into the sea." (Note 12)

And the porcelain wares shipped by this waterway were all from Dayao and Jin Village and the surrounding areas. In the Longquan County Annals of Qianlong a more detailed was offered. According to that record, apart from the three rivers in the south, there were also Fei river, Yu river, and in the east there were Tieshao river, Daotai river, Anren river (which leaves the 22th city Anren in its east and converge with another river into the Wu river),

Anfu river, Dashi river, Wu river, and Dujiao river. Also, there were Dian river, Wutong river, Yuzhang river, Xiaomei river and Jin river (leaves the 11th city Jindan via Niutou Hill where it flows into the Jiang river and Shi river). (Note 13) Compared with the rivers in the east and south, and based on the distribution of sites of ancient kilns in Longquan and Qingyuan (see figure quoted from Research on Longquan Celadon, Figure 1 on page 2), the areas on their sides were covered with kilns. As the waterway improved, the roads were in less use. And recently road conditions have improved. It was due to these main waterway and its branches that the Longquan kilns porcelain industry thrived and became best-sellers everywhere. About the situation of production, "In the excavation of dozens of dragon kilns, we found that the Longquan kilns were making porcelain using dragon kilns. The longest ones were of the Southern Song, most of which were more than 60 meters in length, and up to over 80 meters. In the late Southern Song, in order to produce high-quality porcelain wares with thick glaze, the dragon kilns were shortened, ranging between 30 meters to 50 meters. In the Ming Dynasty, compartment dragon kiln appeared. Comprehensive analysis shows that generations of artisans knew the structure and burning methods of the dragon kiln very well. From the deserted heaps we can also gain a glimpse into their process, which also provide a basis for determining the age of the porcelain wares. And the length and size of the dragon kilns, plus the size of the workshop can offer clue as for whether the industry was the main one or subsidiary business. Provided are also the information about the kiln owners such as Gu Shicheng of Ming Dynasty, as well as the means of production used by the staff." (Note 14) In Memory of Excavation of Longquan Kilns by Mou Yongkang, a description of the stack layers of the site was given. And the Related Issues of Longquan Kilns in Anfu Area also gave a description of the porcelain producing areas in the east and its boom.

"In Southern Song, the sites for producing celadon by burning in Longquan are…Of which most are porcelain kilns, and Dayao and Jin village have the most concentrated kilns with the highest output. In Dayao and its surrounding areas, we found 24 sites of kilns at that time. The next area is Jin Village, where we found 16 sites of porcelain kilns, of which most were the stacked relics of those in the early Southern Song. Also, the kilns covered a wide area, and the stacking layer of pieces of porcelain and kiln furniture were quite thick." (Note 15)

Long-term archaeological efforts had unearthed many quality goods of Longquan Dayao and Jin Village produced in Southern Song. We observe that none of them have ring foot covered by glaze all over.

A look at the production of Longquan celadon from the perspective of tax on kilns in Chuzhou

Though in Southern Song Longquan had reached its prime, delivering countless works of celadon to everywhere across the country, including the quality goods, legend has it that the locals of Longquan had a disliking for traveling a long distance. (Note 16)Longquan has lots of mountains, so the locals had a fear of long trip away from home to do business. But mountains are perfect for Taoist priests, and the famous ones include Jiugu Mountain, Phoenix Mountain, Liuhua Mountain, and Chessboard Hill. In Tang Dynasty or earlier it was great to become an immortal. (Note 17)In addition, Longquan was a destination for producing famous swords. There is a site called "Jianchi Lake" where Ou Yezi was said to have casted swords, "The sword, after being casted, is quenched in the lake named Longyuan, and it looks black. Ou Yezi was the senior official of King He Lu of Wu, and was worshipped at temples after death." (Note 18)Since the Spring and Autumn Period, it had been famous for quality swords, and until now the Longquan swords are still famous at home and abroad. The practice of Taoism and swordsmanship requires a quiet environment. The craftsmen in Longquan had a good mastery of the art of sword casting, especially of the timing. This bore a relationship with the fact that the earliest celadon products were made in Zhejiang. And from this it can also be concluded that the Yue kilns in Tang Dynasty produced secret-color glaze porcelain by sealing the bowls with glaze. Longquan kilns in Southern Song also produced shiny celadon with light green color by using reduction flame. So it was by no accident that sword casting and porcelain making by burning occurred at the same place. It was probable that they two related closely to the mastery of furnace fire. And both sword casting and porcelain making were profitable business, and no wonder taxed by the local government.

The kiln industry of Longquan was one of the main tax sources. Though the exact tax was unavailable of the Song and Yuan Dynasties, according to the Chuzhou Chronicles of the Chenghua version, the tax on kilns for the five counties of Chuzhou are as follows.

Lishui County: 28 kilns for bowl and plate, 4 kilns for jar, and 11 kilns for tile and brick.A total of 1390 ingots for tax on the kilns (Chuzhou Chronicles of the Chenghua version, V.3, Local Product PP. 19).

Songyang County: 30 kilns for jar, vase, brick and tile.A total of 381 ingots for tax on the kilns (V. 9, Local Product Exploitation and Smelting PP. 17).

Longquan County: 8 kilns for plate and bowl, 4 kilns for jar and vase, and 9 kilns for brick and tile.A total of 13,777 ingots for tax on the kilns (V. 13, Local Product PP. 16). (Note: in Ming Dynasty, Chao represents the bank note, and one ingot equals 5 Guan of Chao.)

Qingyuan County: 12 kilns for bowl, and 2 kilns for brick and tile.A total of 71 ingots for tax

on the kilns (V. 15, Local Product PP. 12).

Yunhe County: 21 kilns for bowl and 4 kilns for brick and tile.A total of 1,290 ingots for tax on the kilns (V. 16, Local Product PP. 6).

The number of kilns and the amount of taxes recorded should be earlier than the time when the local chronicles (published in Chenghua period) were made, for it was a rule for local chronicles to quote data from previous chronicles. Comparison of the counties shows that Longquan contributed greatest to the tax revenue. Further, the amount of the tax was also a consideration when recording the tax. For example, the future tax was based on the tax recorded that year, so if the figure recorded was big, the future tax would become a heavy burden when the harvest was poor though when business was enjoying its boom that would not be a problem. So the local chronicles stressed, "Tax revenues recorded here are the average. The especially high one was omitted for fear that it will be used as a basis." (Note 19). Apart from Longquan, the total taxes paid by the other four counties were only one fourth that of Longquan. Longquan contributed tenfold taxes despite a smaller number of kilns could be attributed to the fact that Longquan had large-scale kilns where high-quality products were made. A professional workplace usually adopted the division of labor and products in production, so that each workplace was specialized in one product, be they bowl, plate, jar or vase. By doing so, a smooth production line was achieved. In addition to this, Longquan also had kilns specialized in high-quality wares sold at higher prices. That was why with a lesser number of kilns in Longquan could contribute tenfold tax over other counties. The taxpaying situations recorded in the local chronicles might use data from the Southern Song or prior to Chenghua, which does not matter. But, given the Southern Song layers appearing in the archaeological accumulation layer, it means that it was an ear with rich taxes. As Zhu Boqian put it in the Review and Prospect of the Research on Longquan Kilns as Preface, "… Their good knowledge about the structure of the dragon kilns of all ages and the burning method adopting sagger placing, the universal traces of burning adopting sagger placing, offer partially a basis for determining the ages of porcelain wares after we have an understanding of the burning method adopting sagger placing. Meanwhile, the length, size of dragon kilns and the size of workplaces also provide an insight into whether they were subsidiary business co-conducted by several farmers, or whether they were such porcelain kilns as owned by kiln owners like Gu Shicheng who hired workers for the production." (Note 20). Some scholars argue that only when kiln industry became a professional business could such a large-scale production become possible. Judging from the depth of the accumulation layer of Longquan sites, it could not be a subsidiary business co-conducted by several farmers. In fact, it must be a combination of petty farmers and influential merchants in response to the changes of the

times. At first, there might be an even distribution of farming and handicraft industry, due to the supply and demand relations. Then the ratio of farming to handicraft industry would automatically change according to the needs of the times.

The above tax data are from the Chuzhou Chronicles published in Chenghua period, and what were recorded must be the situations in the Chenghua period of Ming or prior to that, because the unit it used was ingot. In the period of Hongwu there was such literature as, "1900 ingots of silver are paid to workers working at Raozhou and other prefectures" and "4970 ingots of silver are paid to workers working at Suzhou Prefecture". (Note 21). But in Song Dynasty the unit was Guan, or string of money. (Note 22)

The tax amount proved that it was about the production of the Longquan kilns in Chenghua or earlier, a period when the business was thriving. Based on this, it can be presumed that Longquan kilns in Southern Song or Yuan must enjoy a greater boom, even better than Ming Dynasty. And the tax on kilns belonged to the tribute, which, along with estate, tea, liquor and vinegar, was a regular and official taxation. There is no tax amount corresponding to porcelain, nor tax data about the porcelain in Song or Yuan. However, the local chronicles of Longquan offers a special term related to taxation, namely "tax checking booth".

"tax checking booth" was peculiar to Longquan County.

Only the chronicles of Longquan had such term as "tax checking booth", which was included in the list of antiquity of the Chuzhou chronicles, "The tax checking booth is several steps west of the Commandant Department." (Note 23). While next to it was the "Shouzhao booth—located in the Painting Workplace of the county". Since both were listed as the antiquity, they must be deeds of the past. In the section of antiquity, notes with reign titles were largely the products of Song Dynasty. Though this one bore no reign title, it might be the site of Song or Yuan, or continue to be used until the Yong and Xuan of Ming Dynasty. And the tax checking booth must be a site which was built when the Longquan porcelain wares were exported in great amount.

In Chuzhou Chronicles published in the 11th year of Emperor Yongzheng (V. 1, PP. 37, Antiquity Section) it was recorded as tax simplifying booth. In the 27th year of Qianlong, the Longquan Chronicles (V. 2, PP. 12, section of construction and bridge), it was also called tax simplifying booth, but added with a line which read, "All are destroyed now." It was quite an interesting institution, because the Chinese characters for checking and simplifying are pronounced in the same way, but with different usage and meaning. In order of time, the earliest Chenghua version recorded it as tax checking booth, which should be a special taxation institution. But it was named as a booth, which meant a post station in the past, so a

tax checking booth could be understood as a tax station, through which goods were taxed and let pass. If so, such booths were established because of the large freight volume. Therefore the tax checking booth might be a goods tax threshold in the Southern Song Dynasty when large amount of celadon goods were delivered. After passing the booth and taxed, they became the daily use goods or exports, but there is no way to determined when it was established and when terminated.

Among the trading goods in Song Dynasty, porcelain wares played an important role. In sites in Japan, Egypt, Southeast Asia and other regions, lots of celadon pieces have been unearthed. Salvage of shipwrecks also found large amount of celadon wares of Longquan kilns, as was the case of shipwreck in Xin'an Mokpo of South Korea, which was found to contain lots of Longquan celadon wares. The Longquan celadon wares and porcelain pieces were also found from the sites of Southern Song and Yuan across China. All these show the goods were in great demand at that time, which in turn led to large output and high tax contribution. Because the Longquan kilns of Chuzhou paid a higher rate of tax, it was reasonable for there being tax checking booth. And that was why tax checking booth was listed in the section of antiquity in the Chenghua version of the Chuzhou Chronicles. The antiquity might be a necessary institution when the Longquan kilns enjoyed a boom, and might be set up in Southern Song, Yuan, or early Ming.

To sum up, tax checking booth, tax on porcelain trading, and kiln collections all showed that the celadon wares of Longquan in Southern Song must be very high in output, and attracted much attention. In Southern Song and Yuan, the celadon was a luxury goods produced in great amount, but it failed to be listed among the top kilns for tributary porcelain. While the ruins of Longquan kiln wares unearthed from the sites of the capital of Southern Song showed that the Longquan kiln wares were not covered with glaze, which was the main reason it failed to be a kind of tributary porcelain, but they must be used in quite a large number in the capital.

Green and shiny glazing color blending with ornament of utensils

Fashion is something common to the times. As for Lishui, Qingyuan, and Longquan, their celadon wares made in Tang Dynasty and Five Dynasties were similar to those made in Yuezhou, both representing the features of their times. In early and middle of Northern Song, the products of the three places were quite the same as those made in Jingdezhen in shape, with many floral patterns on the body. In Southern Song, Longquan kilns took the lead in the production of quality celadon, with less ornament on the utensils but rather highlighting a feeling of simpleness and elegance. This might be related to the thick-glaze products of Longquan kilns, because thick glaze made it hard for floral patterns to stand out. Also, thick

glaze required a shorter time of burning. As mentioned before, "In Northern Song, most of the dragon kiln could be up to 60 meters in length, and the longest one over 80 meters. In late Southern Song, in order to produce thick-glaze luxury porcelain, which was susceptible to peeling of glaze if burned for too long, dragon kilns were built shorter ranging from 30 meters to 50 meters." Such an improvement was the product of the craftsmanship. This shows that the forming of the light green of the celadon of Longquan kilns bore a close relation with the length of the dragon kilns, which were capable of producing celadon of shiny light green color in large quantity at each time.

Such luxury celadon was mainly produced in the Dayao and Jin Village in the west of Longquan, where thick-glaze and quality celadon was made. In Southern Song, in order to highlight the light green of the celadon, Longquan kilns must give top priority to the thickness of the glaze. For example, the Longquan celadon ware, double handles vase (see figure for reference) collected in Kuboso Memorial Museum of Arts, Osaka, Japan, is designated as national treasure by the Japanese government. Another one collected in Japanese Yangming Library is designated as important cultural property. The ware is characterized by a plain surface without any patterns, and its shoulder and belly are composed of several small parts, thus preventing too large an area of thick glaze from peeling during burning process. The beauty of a thick glaze can be seen from the surface of the vase mouth. That is, during the fettling of the mouth, its inner edge was dug deeper, where the glaze was applied thicker, thus a green shiny glazing color was formed there, the highlight of its beauty. Furthermore, fine processing was applied in many places of the ware of Longquan with a plain surface without any design.

And there was also long neck vase with bow string pattern. While fettling, convex bowstring patterns were made with the same distance apart from each other around the long neck and shoulder. The patterns were used for ornamental sake, and also prevented the glaze to flow. Such patterns were common in the hard clay pots and cans with natural finish made in Zhejiang in the Han Dynasty. The production began with several convex bowstring patterns being made on the shoulder, in order that after the kiln stopped burning, the ash fell on the surface of utensils, and the ash would gather there on the surface to form a kind of glaze. When gathering thick, the glaze would trickle down, and on this occasion the convex bowstring patterns would stop it from flowing down. Apart from this function, it also acted as an ornament. Such pattern-like ornaments were common to found in Han and Tang for the celadon using feldspar glaze, which was easy to flow.

This kind of ornament was also applied to royal kilns and the thick-glaze celadon of Longquan in Southern Song. It enabled the surface to be divided into several small parts, and also served

as a key decoration that was simple but elegant. The thick-glaze wares produced by the royal kilns and Longquan kilns were not necessarily put on a thick layer of glaze both inside and outside. As we often see, when a utensil is put there, the glaze on the exterior surface is rather thick, even and quite pretty, while the parts to which we seldom pay our attention to, or the inner surface of small-mouth vase and jar, or the inside of the ring foot are applied with glaze only once, or in a little amount. In some cases, only the upper inner walls of the utensil is glazed. By doing so, not only is labor saving achieved, but also the failure of products can be avoided which is caused by too much glaze applied. But it could also be because that the small mouth made the glaze applying difficult. For pot and jar with a bigger mouth, the interiors must be dealt with more details when applying glaze, for the inside is exposed to our sight. That is why the inside is applied with glaze as thick as the outside, so as to achieve an overall perfection.

Compared with Northern Song, Longquan kilns of Southern Song highlighted more the attractiveness of the thick glaze. As a result, the decorative technique of fine line pattern was seldom used, because a thick layer of glaze would obscure the fine lines. In some cases, some simple floral patterns made by a special technique would be used to cover the outer wall of a bowl, plate, writing brush washing plate throughout. As for wares like vase, stereoscopic double ears were used as decoration. Also, half-module could be printed as applique pieces as ornament, a method used more often than other kilns. All these were applied out of the consideration that no negative impact was exerted on the attractiveness of thick glaze. Therefore, in Southern Song, the top priority in making the quality celadon wares of Longquan kilns was given to producing the expected effects by matching the glaze with the shape. During that period, both the body and glaze were even and well proportioned (they gradually grew thicker in the middle of Yuan). Such quality products sold at higher prices must be levied at a high tax.

"In early Yuan Dynasty, the shape of utensils and the process were basically the same as the late Southern Song. But the middle and late Yuan saw a quite different technique than that of Southern Song. That is, the technology was less sophisticated, the wall of utensils became thicker, the body was grey, and the glaze looked yellow or grey against a green impression. Also, the glaze was applied thinner, but carving patterns were used more." (Note 24). In the middle of Yuan, the body and glaze of the wares of Longquan kiln became thicker, making the glazing color turn bright green. As for the features of the products of Longquan kilns in Yuan and Ming Dynasties, there were more porcelain varieties in Yuan, but the bowl and plate were the major products. Unlike the Song, at this time the utensils were of bigger size, and accordingly the wall turned thicker because a big ware with a thick body was easy to burst

when burning. Big utensils like Haihui teapot and big vase in the Yuan and Ming Dynasties required a special treatment. That is, the lower part of the utensil was formed with the bottom left undone, which was added with a plate-like pad as the base. And by treating the body and the bottom independently then joining them together, the bottom would not burst while burning. This technique represented a highlight in the middle Yuan until the middle Ming.

It was not until late Yuan Dynasty and Hongwu of Ming Dynasty that the wares of Longquan kilns had their bottom covered fully with glaze. Excavation in 2006-2007 proved that the Fengdongyan Kiln of Dayao was the royal kiln in the Yuan and Ming Dynasties. Some unearthed utensils were of the same shapes and patterns as those produced by the royal kilns of Jingdezhen in Hongwu and Yongle of Ming Dynasty, as well as those produced by royal kilns of early Ming, which were unearthed in Zhushan of Jingdezhen (Note 25). All these showed that both Longquan kilns and those of Jingdezhen were royal kilns designated by the court.

Origin of the name of the "Qiguanshou" celadon of Japan

In terms of trading porcelain, the wreck founded in Xin'an Mokpo, South Korea, was the most shocking discovery so far, with quality porcelain founded in large quantity. For the 1976 wreck salvage, nearly 20,000 porcelain wares were found, of which the celadon wares were most made by Longquan kilns, which served as the best reference data for the kiln products made in the 13th and 14 centuries (Note 26). Of the more than 10,000 Chinese porcelain wares found in the wreck salvage, one was a big celadon plate of Longquan, whose ring foot was engraved a line "for the public use in the Commander Department". The work had its ring foot covered with glaze, with the interior bottom left bare for the burning. This kind of celadon wares with their ring foot covered with glaze should be tributary porcelain, just the same as those in Tang and Song Dynasties.

Since Song Dynasty Japan had imported Longquan celadon from China, and the exports included Zhen celadon, Tianlong Temple celadon, and Qiguanshou celadon. About the origin of the name, we must take a look back on the Song and Yuan Dynasties. At that time, many Japanese monks came to China, and they would take some quality celadon wares of Longquan back home, which the Japanese called Zhen celadon (Tang poet Li Bai had poems and essays about "zhen", a kind of stone used for washing clothes, which was then used to describe the shape of utensils). In Yuan, Japan's state preceptor Meng Chuang left in Tianlong Temple a thurible, a work of Longquan celadon, which was carried back by the Tianlong Temple Boat, a merchant ship the Japanese government sent to China. Since then such quality celadon works of the Yuan Dynasty was named Tianlong Temple celadon. Today the Japanese still love to

use Longquan celadon utensils for ikebana and tea ceremony, especially those of certain social status.Other explanations of the origin of Qiguanshou

"The official departments offer the ships, capital, crew, and conduct trading overseas. The profits gained are divided into ten parts, seven of which for the official department, and the three parts for the dealers…" (Note 27). The way the profits were divided must be the origin of the name of Qiguanshou because Qi in Chinese means seven while guan means the official: seven parts for the official and the rest for the dealers.

(Note 28) The official capital should have a big impact on promoting the trading of Longquan celadon goods. In fact, Song Dynasty already saw governmental capital join the trading. In the third year of Xining (1071), Wang Zhao proposed to set up a trade institution under relevant administrative department in charge of the imported goods from the countries in its west (Note 29). Such a proposal was made in an attempt to make profits from trading with countries in its west. The official department imported goods, which were sold in the market by the dealers, a practice quite like the commercial activities such as state-run trading with general agents today. By doing so, a fat profit could be earned. Therefore in the fifth year of Xining specifications about how to contribute capital and how to share the returns were made, along with the establishment of a trade institution in the capital (Note 30).

This kind of trading enabled the seller to obtain money or objects from the government. And 20% interest rate was set for the funds borrowed from the government. This commercial practice was profitable for the government. And the initial trading with the nations in the west gradually expanded, driven by the large population of the capital, into a state-owned business, whose continuing expansion (Note 31) resulted in the establishment of trade institutions in the commercial areas of the capital, borders, ports, and inland cities. And the business with the government also included that of Yuezhou and Dingzhou. Though no detailed description of the trading goods was found in record, we can make a presumption that what was traded then must be profitable goods, especially porcelain, daily necessities and prime goods. In Yuan Dynasty, under the influence of this practice, Longquan celadon also became one of the trading goods of the government. "Of the ten parts of profits, seven to the government and three to the dealer." Based on this, a new business format formed, and the trade institution became another revenue source for the royal household and the government. Driven by this business model, the goods of Longquan celadon were promoted and sold across the country and overseas. Due to that profit sharing mechanism, the goods produced by Longquan were shipped across the sea to Japan, hence the name of Qiguanshou occurred.

Record of Longquan kilns by Lu Rong of Ming Dynasty

The most important literature about Longquan celadon was the Shu Yuan Notes by Lu Rong, a Jinshi of the second year of Chenghua period. (Jinshi refers to a successful candidate in the highest imperial examinations) He was a local in Kunshan, and performed his duty quite well when governing Zhejiang. But later on "he was relieved of his office after an investigation, much a shock to the public" (Note 32). In his book he recorded many deeds from the founding of Ming Dynasty until early Hongzhi period, and many of his writing could be proved true by checking against the True Records of Ming. A paragraph of the book was about Longquan celadon, which, though very short, offered a concise description of Longquan Liutian Kiln, surrounding kilns, process, products, and sales. He compared the color of the celadon to those of green beans and green vegetables, creating a vivid impression. And he said, "But quality goods are traded elsewhere at a higher price, which even the local governors fail to see." (Note 33)

Since Song Dynasty, of those who had served as officials in Zhejiang, only Lu Rong made field investigation of the kilns, including those in Chuzhou and Longquan. Normally, it was not for scholars or official to understand the kilns, and at the best they were expected to feel interested in the tributary porcelain and famous kilns, but not in the process or technologies involved in the production. By contrast, Lu Rong gave a clear and concise description of the history of Longquan kilns, the clay quality, glaze used, and the process, as well as the sales of the finished products. According to him, the quality goods "are sold elsewhere at a higher price and even the local governors fail to see". It must be common for such quality wares to be sold elsewhere after passing the tax checking booth, and even the local governors fail to have a look at them. In the Leisure Pastime by Tu Long of the Wanli, there was a section On the Kiln Wares, in which a line was given to the Longquan wares in the Song Dynasty, "… Now the prime goods are available only with green color, and the other are all oily blue with worsening quality…And only those from Longquan are well made with good quality, and people said they were produced in Zhang kiln…" (Note 34).

Relation between Longquan kilns and the court in middle Yuan until middle Ming

In late Yuan, Zhu Yuanzhang had his influence in Jiangnan expanded. In 1359 (the 19th year of Zhizheng) he led his army to attack Jinhua, and there we have an episode about celadon. It is said that a local named Ren Weiping was well learned, and as Zhu Yuanzhang took Jinhua with his troops, his younger brother Weixin was asked to plead for an interview with Zhu Yuanzhan, who was at the moment having his meal, so he asked Weixin to make a poem about celadon. At that, he made for lines, reading: "Capable of daily use like a pretty bottle, it also

showed its power in the battlefield; if it is possessed by a worthy man, it will help him achieve great things." (Note 35)

The four lines were just what Zhu Yuanzhang was aspiring for, so he was quite delighted in it. And in the same year he got Liu Ji as his counselor and advisor. Though he did not claim throne, judging from his power and influence, the celadon he was using must be from Longquan instead of a vulgar product.

Zhu yuanzhang later became an emperor and established Ming Dynasty, and he took worship ceremony very seriously. There were specified instructions and rules about great sacrifices, superior sacrifices and inferior sacrifices, along with significant changes to sacrificial utensils under his order "From now on all sacrificial utensils must be porcelain wares" (Note 36). In the 2nd year of Hongwu period, it became a rule to use porcelain as sacrificial utensils. Though much literature suggests that the royal usage of porcelain in Ming Dynasty were mostly from Jingdezhen, it was not the fact. In Yuan Dynasty some of the goods of Longquan had the ring foot covered with glaze, and in Ming the prime wares were also of the same kind. A record offers a peer into the fact that wares of Longquan were overseen by officials during transportation.

"Han Shizhong, a sub prefect of late Hongwu period, clean and honest, delivered a god job in overseeing the shipping of celadon wares, and won the respect from the locals" (Note 37). Many of the prime goods of Longquan celadon produced in middle Yuan until the middle Ming were products with the ring foot covered with glaze, and of the same shapes and patterns as those blue and white porcelain from Jingdezhen. Such goods should be the trading goods or utensils used by the royal household in their daily life or as a reward for the officials (Note 38). Also, during the same period of time, palace-type porcelain was especially made by Longquan kilns with the glaze-covered foot and the inner edge supported by padding when burning, which was not only for the court, but also shipped overseas to royal TopkapSaray Museum in Istanbul, and one Islam temple in Teheran. Also, luxury trading porcelain was produced.

The porcelain made in Hongwu (1368-1398) and Yongle (1403-1424) by royal kilns were unearthed from the excavation of Fengdongyan Kiln of Dayao. In the stacking layers of royal kilns of Yongle, such recording porcelain pieces were which said "Recorded on 29 November of the ninth year of Yongle, or 1411", as well as "Recorded on a traditional auspicious day in the autumn of Yongle, or 1411", and printed "Made in XX year of Yongle". Porcelain pieces bearing the year title of "fourth year of Yongle (1406)", or "Ninth year of Yongle" (Note 39). All these show that Chuzhou and Ranzhou used the same way to mark the reign title. Of the Ming royal kilns found in the Fengdongyan of Dayao, the bowls and plates were all daily

necessities, and all covered with glaze in the ring foot and with the inner edge supported by padding when burning. This so called "ring foot covered with glaze" is generally used to describe the product of the royal kilns of Hongwu and Yongle.

Gu Shicheng, owner of the big workshop of a Longquan kiln

During the time when Tianshun was renamed Chenghua, there was a man named Gu Shicheng who was also a business man in the porcelain industry in Longquan County. According to the local chronicles, "Gu, treated his mother very well after his father passed away. Whatever his mother liked he would managed to get it for her. When she fell ill, he attended her bedside day and night until she passed away. Exhausted and wore, he lived beside her tomb for three years…In the 1452 of Jingtai, the county established a Filial Monument in honor of him (Note 40). Hence we know that he must live in the mid-fifteenth century, and celadon bowls bearing his name in the inner bottom were also found. And at that time Longquan celadon wares were all thick body and thick glaze. Apart from the bearing of his name, pictures of filial and loyal stories were also used as ornament. Mr. Gu must be a big boss owning a big workshop in the porcelain industry of Longquan. Because we know that the youngest son of Li Shan, who was later promoted to the chief from a former assistant of the county magistrate of Longquan, became the son-in-law of Gu, an event recorded also in the local chronicles. So he was not only famous for being a filial son, but also a very wealthy person (Note 41). And Li Shan (his youngest son Heng married into Gu's home and live with him) later on also moved to the south of Longquan after retirement. Recorded was also a story about Li who contributed his salary to the construction on a stone road into a brick-paved one which led to the county government. Such a deed was indeed for the public interests. And where the site of Dayao remained there is still a length of brick-paved road that was done quietly well. In the 1992 visit, the locals called the place "officialdom", because some beautiful girls were chosen by the court as imperial concubine, which required the road to be paved with bricks. However, such an episode was not recorded in the local chronicles. So it was more probable that the road was paved with bricks because Li and Gu cooperated by marriage. In a year of the Zhengtong, Li was promoted to the head of the county for his merit in maintaining public order, then he contributed his salary to the construction on a stone road into a brick-paved one. Since it was a deed worth of public praise, the road paved with bricks with his donations was called "officialdom".

The chronological order have been well done for the stacking layers of the Fengdongyan Kiln of Longquan Dayao from early Ming to its middle by archeologists. For the stacking layers of middle Ming, celadon pieces bearing the "Guchuan Ancestral Temple" were unearthed from

the No. 3 layer, which reflected the scale of the porcelain making by Gu Family. A noteworthy notice in the Longquan Chronicles of Qing Dynasty recorded: "All celadon wares are from Liutian. In the past porcelain kilns belonged to Jianchuan, then belonged to Qingyuan after the establishment of the county, some 200 miles away from Longyi. During the Zhengtong period of Ming Dynasty, the wares made by Gu Shicheng were not as good as two brothers of Zhang. And after Gu, the products were worse in quality, and could not be used for elegant pastime." (Note 42).

According to the chronicles, the production base of celadon was shifted to Qingyuan, somewhere in Zhukou. And it also mentioned that wares made by Gu Shicheng were not as good as those of two brothers of Zhang, which offered a clue that in the Zhengtong of Ming, Longquan had already Ge kilns of Zhang Shengyi. Of course, it might be only about the comparison of wares without considering the different times of delivery of wares. In fact, according to Essential Criteria of Antiquities, the products of royal kiln or Ge kilns were hotly pursued by refined scholars and were always mixed with fakes. I am not going to speak more about Ge kilns here. According to the article, after Gu the products were worse in quality, and could not be used for elegant pastime. Obviously it was said from the viewpoint of an antique admirer. In the Essential Criteria of Antiquities, a line about the ancient Longquan kilns went like this: "Ancient celadon wares, with a thin body, and the most valuable are of a bright green color, to be followed by light blue…The top basins are with patterns of two fish on the bottom plus a decorated ring, but those with a thick body come inferior in quality." (Note 43)

During that period, the products of Longquan kilns were similar to those of the late Yuan, with a thick body and produced for commercial purpose.

As for the preference for thin body, it was clearly the style of Longquan kilns of the Southern Song. By Jiaqing and Wanli, it was nearly 200 years since the establishment of Ming. People became used to the peace of time despite declining national strength. As people became increasingly interested in antiquities, including paintings, calligraphy and rare curios, writings about these also increased, so did people's praise of Longquan celadon of Song Dynasty.

Conclusion

Based on the literature about Longquan celadon available, we acquire an understanding of the production of Longquan celadon wares. Despite the large output and wide circulation of Longquan celadon wares, they were not included in the list of tributary porcelain, but shadowed by the five famous kilns of Northern Song. It was widely used in daily life, however. In the households of middle and upper classes, its presence was widely witnessed. In middle Yuan and early Ming until Chenghua, the kilns also produced goods with the shapes

and patterns designated by the court, just the same as Jingdezhen. Also, the prime goods with their ring foot covered with glaze were also used by the officials and the common people. In the history of porcelain, there seems to be no other place like Longquan where a single industry could thrive for so long with its products sold both at home and abroad in so great a quantity.

Ts'ai Ho-Pi
On 8 August 2017 in his Chuyan Hut

Note 1: Chuzhou Chronicles, V. 4, PP. 17, by Liu Xuan, published in Chenghua, rare book collected in National Central Library.

Note 2: Preface of YawYang Essays, by Yaw Yang who "Died in 863 (the fourth year of Xiantong). A hard-working student when young, well learned in Buddhism, served as a reviser and other posts, prefectural governor of Luling, Jinyun, Jiangzhou, and ended up as the deputy director of Taichang Temple." PP. 2-3, punctuation and collation by Nan Fangsheng, Zhonghua Book Company: 1981.

Note 3: Chuzhou Chronicles, V. 8, pp. 1 of officer ranks, "…Chuzhou, Duan Chengshi as the head". Published in the 11th year of Yongzheng, edited by Cao Lunbin.

Note 4: Literary Sketches, C. 22, V. 3, PP. 1520. Published in 1206, the second year of Kaixi, the author served as the chief of Wu Cheng in 1131-1162, later on head of Xin'an (also Xizhou). Lots of members of the imperial clan were hard-working students. In politics, the court expected its members to act according to the rules: "The laws of our country rule that no members of the imperial clan should take senior posts, but they should stay in the capital and appear in the court when requested." In other words, they should take no senior posts in order to prevent them from forming cliques, which would pose a danger to the emperor. So the hard-working members who passed the imperial exam would be appointed as a chief local official. Zhao Yanwei was no exception, so he served as a local official.

Note 5: Literary Sketches, C. 22, V. 3, PP. 1572.

Note 6: In Memory of Excavation of Longquan Kilns by Mou Yongkang, Cultural Relics of the East V. 3, PP. 84, "Archeologists have found the same three layers in Section B of Dayao and Jin Village. In Section B, the most exquisite products are excavated in the upper layer as represented by y2, while in Jin Village the middle layer has the most products."

Note 7: Chuzhou Chronicles, published in the 11th year of Yongzheng, re-edited by Cao Lunbin, V. 1, PP. 4, Territory History.

Note 8: Brief History of Longquan Celadon by Zhu Boqian, Research on Longquan Celadon, PP.4, Cultural Relics Press: 1989.

Note 9: Temple of Tongji Weir Zhan Sima and Nan Sima by Guan Jinghui, Chuzhou Chronicles by Liu Xuan in Chenghua, PP. 47; Regulation of Rapids by Gong Yuan, Chuzhou Chronicles by Liu Xuan in Chenghua, PP. 26; Zhejiang Annals by Xue Yingqi in 40th year of Jia Jing. There are little differences in the articles published in local chronicles, but all under the same title. Edited by Cao Lunbin.

Note 11: Chuzhou Chronicles by Cao Lunbin, V. 13, PP. 6. Edited by Cao Lunbin.

Note 12: Zhejiang Annals, V. 8, PP. 21-22.

Note 13: Longquan Chronicles, V. 1, PP. 19-20, Territory and Landscapes.

Note 14: Review and Prospect of the Research on Longquan Kilns as Preface by Zhu Boqian, Cultural Relics of the East, V. 3, PP.4, Hangzhou University Press.

Note 15: Brief History of Longquan Celadon by Zhu Boqian, Research on Longquan Celadon, PP.8, Cultural Relics Press: 1989.

Note 16: "In the prefecture mountains are many while fields are few, and in the past farmers were industrious and frugal, while the merchants showed unwillingness to travel afar. So trading was conducted within the prefecture, and the money they earned were used to collect books to teach their children in hope of passing the imperial exam. What a pity that education is not taken as seriously as before, which might also be due to the poor transportation." Chuzhou Chronicles by Liu Xuan in Chenghua, V. 13, PP. 2, Customs of Longquan County.

Note 17: Chuzhou Chronicles by Liu Xuan in Chenghua, V. 13, PP. 2, Mountains and rivers.

Note 18: Chuzhou Chronicles by Liu Xuan in Chenghua, V. 13, PP. 27, Historical Site.

Note 19: Zhejiang Annals, PP. 1, Explanatory notes.

Note 20: Review and Prospect of the Research on Longquan Kilns as Preface by Zhu Boqian, Cultural Relics of the East, V. 3, PP.4, Hangzhou University Press.

Note 21: Ming Taizu Records, V. 146, RenZi and V. 145, Dingchou.

Note 22: see Study on Marketplace of Song Dynasty, Chapter 5, PP. 308, Tax Bill of Xiuzhou. Song Huiyao Jigao, section 11 of chapter 2 of Warehouse Goods. Grand View Library.

Note 23: Chuzhou Chronicles by Liu Xuan in Chenghua, V. 13, PP. 25, Historical Site.

Note 24: Archaeology, No. 6, PP. 505-510, Science Press: 1981. Zhejiang task force of Archaeological Research Institute, Chinese Academy of Social Sciences.

Note 25: Statutes of the Ming Dynasty, V. 194, Porcelain, "In the 26th year of Hongwu, a law was adopted that shapes and patterns should be pre-determined when any shared utensils are to be produced, along with the calculation of costs of labor and materials. If the amount is large, labor force should be enlisted to the capital with kilns built and construction started; if the amount is little, the task should be assigned to Chuzhou or Raozhou…".

Note 26: see Report on Xin'an Cultural Relics Salvaged from the Sea, China and Japan News Service 1983. Xin'an Cultural Relics Salvaged from the Sea, by Tokyo National Museum, China and Japan News Service 1983.

Note 27: History of Yuan, V. 94, Section 2 of Consumer Goods.

Note 28: Report on Xin'an Cultural Relics Salvaged from the Sea, Unearthed Celadon from Xin'an, by Hasaibaibuguji, PP. 105.

Note 29: "Trade institution…in the third year of Xining…the only route linking to the countries in the west is Qinfeng Road along which lots of goods were traded…we suggest

that a trade institution be set up there funded by the government and operated by recruiting the dealers, and the revenue is expected to be more than millions of Guan each year…"Song Huiyao Jigao, V. 14989, PP. 10, Section 531 of Consumer Goods.

Note 30: "In the fifth year of Xining (1073). A proposal was made for a trade institution to be established in the capital…dealers were recruited…so that employment has a regular basis. By offering labor, or mortgaging something for funds, at least five people are needed to act as guarantee, after that trading could be conducted. If goods cannot be sold, the official government can buy them after the dealer negotiates with the merchants about the prices. After the deal is made, payment should be made with the official funds. If some merchants prefer barter trade, suitable prices should be calculated. As for the interest, it must be 1 percent for half a year, and two percent for one year…as for other provisions, please refer to the regulations." Song Huiyao Jigao, V. 14989, PP. 11.

Note 31: In the eighth year of Xining:

"In the eighth year of Xining, the order was issued for there to be set up trade institutions in such prefectures as Taizhou, Yongxing County, Fengxiang, Runzhou, Yuezhou, Zhenzhou, Damingzhou, Ansu County, Yingzhou, Cangzhou, Dingzhou, and Zhending…"Song Huiyao Jigao, V. 14988, PP. 17.

Note 32: Zhejiang Annals by Lu Rong, V. 35, PP. 18.

Note 33: According to Shu Yuan Notes, "At first celadon was mainly made in Liutian, some 60 miles away from the downtown county, to be followed by the kilns in Jin Village, more than 5 miles from Liutian, which is again followed by Baiyan, Wutong, Anren, Anfu, Lvrao, and other places. But Liutian takes the lead in the quality of clay and shapes, for the clay is located near its kilns, an advantage over the other places. While the oil is made from the ash by burning the fallen leaves, which is blended with the powder of white stones. It is a rule that good clay must be sticky, while oil well refined. The workers first make it into shapes by a wheel or model, then after the clay dries they will apply some oil and put it in the mud barrel. After that done, they then put the products in the kilns under which woods are burning day and night. After the fire produce only flame without any smoke, the kilns are closed with clay, and to be removed when there is no more fire. As for the finished products, the top one is of pure green without any faults, followed by those of vegetable colors. But the better the goods, the higher their prices, and they are sold elsewhere, so even the local officials have no change to see them." V. 10, PP. 40, 15th year of Jiaqing, proof reading by Zhang Haipeng, Guangwen Press of Taibei, the 59th year of the republic of China.

Note 34: Series of Fine Arts, Section of Compiling of Appreciation, by Yang Jialuo PP. 352-353.

Note 35: Chuzhou Chronicles, V. 3, PP. 55, Officer and Dynasty.

Note 36: "Ministry of Rites in its proposal for the sacrifice ceremony to be based on The Book of Rites said: in rural sacrifice ceremony, the utensils should be pottery for it highlights simplicity and pureness. The Rites of Zhou ruled that in such ceremony only square grain receptacle and a round-mouthed food vessel with two or four loop handles are proper. So we propose that such vessel should be used for rural sacrifice…while other ceremonies only porcelain is used except that split-bamboo food basket continues to be used. And the proposal is approved." Ming Taizu Records, V. 44 Dinghai, August of 2nd year of Hongwu.

Note 37: Chuzhou Chronicles, V. 9, PP. 2, Achievements of Officials, Civil Administration.

Note 38: Refer to Masterpieces of Longquan Celadon of Ming in Palace Museum by Wang Jianghua, Palace Museum Journal, No. 1, PP. 36, 1994.

Note 39: Emperor's Porcelain – New Discovered Jingdezhen Royal Kilns, Figure: 198, Idemitsu Museum of Arts 1995.

Note 40: Longquan Chronicles by Su Yulong, V. 10, PP. 26, Figures of Filial Piety and Fraternity, published in 27th year of Qianlong.

Note 41: "Li Shan, courtesy name Zhi Zhong, a Pucheng local, in the middle of Zhengtong he was promoted to the post of head of the county from an assistant of county magistrate due to his merit in maintaining public order. Honest and clean, he also donated his salary to pave the road leading to the downtown with bricks which was formally a stone road, which was a deed winning the respect and acclaim from the local people. His youngest son Heng became the son-in-law of Gu Shicheng, and after retirement he settled down in the south of the county." Longquan Chronicles by Su Yulong in Ming, V. 3, PP. 18, Tax and Products, V. 8, PP. 5, Achievements of Officials, published in the 27th year of Qianlong.

Note 42: Longquan Chronicles by Su Yulong in Ming, V. 3, PP. 18, Tax and Products, published in the 27th year of Qianlong.

Note 43: Essential Criteria of Antiquities by Cao Zhao, V. 3, Part 6, PP. 49.

Figure: 1
Map of Waterways of
Longquan County

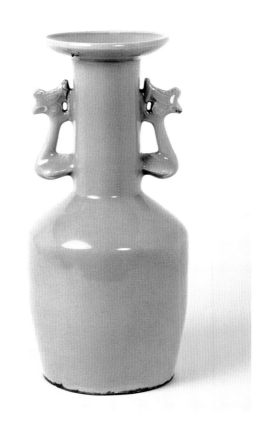

Figure 2:
Phoenix Ear Plate Mouth Vase
Kuboso Memorial Museum of
Arts, Osaka

18. ●青磁鳳凰耳瓶　銘萬聲　龍泉窯　13世紀　1口　高30.8cm　和泉市久保惣記念美術館
Mallet shaped vase with phoenix-shaped handles, known as *Bansei*

序二

海派书画

　　本次展览可以说是艺术的盛会，它由中国陶瓷和中国绘画组成。确切地说，是中国陶瓷的一个大宗——青瓷的历代精品，从魏晋到明清的至精至美的青瓷作品，不啻一部看得见摸得着的中国青瓷史。与之相配的则是中国海上画派也称作海派的优秀作品。青瓷已由权威学者阐述，这里仅为展览中的海派绘画作简要的介绍。

　　海派绘画滥觞于清代晚期，成熟于民国，中华人民共和国成立以后，更是一派崭新景象。从中国绘画史的角度讲，海派绘画是传统中国绘画的终结点，同时又是现代中国绘画的开始阶段，它几乎包罗了所有中国近、现代绘画的名家大师。创新迭出，风貌鲜明，生机勃勃，将中国绘画推向新生。

　　晚清画家张熊，是最早的海派画家，他原籍浙江嘉兴，大部分时间在上海生活、创作，他的画风，为早期的海派画坛树立了一个标杆。在此之前从各地到上海来讨生活的画家，画风良莠不一。张熊稍稍降了些格调，用较为通俗的绘画语，满足了上海工商阶层的需求，从而开拓了上海的新审美，齐整了先前良莠不一的画风，这是海派绘画最早的亮点。

　　此展中张熊的《墨梅图八屏》，枝干舒展有致，挺拔劲道，花朵圈点合度，笔法温醇敦厚，一改扬州八怪的张狂恣肆之态。这是昭示海派画家，以买方的需求来创作，在抑制自己中展示自己，在看人眼色里摆出自己的眼色，从而出现画家的独特性，又从而改变买方的审美。这就是海派画家在求生存中求发展的生存促进发展，发展改变生存的生存发展之道。

　　任伯年及其任氏亲属，为海派绘画注入了巨大的能量，他们个个善画，题材广泛，人物、花鸟、走兽、虫草甚至山水都有不凡的佳作。其中，任伯年更是傲立在这些佼佼者中的承上启下的大画家。展览中钱镜塘旧藏的任伯年《富贵大吉图》主角神态洒脱，寥寥数笔，淋漓尽致地表现出所思所想，这是画最讲究的传神。任伯年深谙此道，在花鸟画之外，他的肖象画也莫不合真，莫不在真的上面传达出对象的精神状态。因此，这幅《富贵大吉图》，信手拈来皆现华彩。从这幅画里，我们一睹任伯年写意花鸟画的绝技。

　　据说吴昌硕是受到任伯年的启迪，才进入丹青领域的。不过吴昌硕开始作画的时候，已经具备了十分了得的书法和诗文造诣，他的石鼓文书法，在有清一代可作一、二数，吟诗颂文也是张口即来；如此他甫入画坛，便一鸣惊人，凭借石鼓文遒劲苍然

的线条，他的大写意花卉的笔法骨架，当时无人能望其项背。

这次展出他的《桃实图》，画的是粗干壮枝上的累累桃实，书法入画的走向以及绘画形象上的书法趣味，悉数呈现。海派绘画因为有了吴昌硕，才羽翼丰满。他和任伯年一样，征服了上海的观众，改变了上海观众的审美，使海派画家在上海这个讲究艺术商品化的大都市，获得了创作的自由。

黄宾虹是徽州籍，生于金华，早年在徽州学习，之后便足迹天下，四方奔波，为生活也为钟爱的山水画。他和上海的渊源很深。他的作品在当时可能被视作另类，既无法靠到新安画派，又与黄山画派攀不上亲；自由吞吐，特立独行的奇肆风格，极合海派绘画的特征。其实，黄宾虹的创作主张受到海派绘画的影响，从他与傅雷的书信往来便可知一斑。这次亮相的《山水图》，是他不多见的大幅作品之一，大面积的皴法，一般很难排解线条重复往返的单调弊端，而这《山水图》，巨大的图面，几乎是以皴法为主，皴法的密实，密实中的变化，变化主导着笔法的走向，看似团团乱麻，然而秩序井然，这是黄宾虹金文书法根底的行书、草书化。他的经心之作，有着刻意中的随意，点点随意构成的刻意，才见阔大气象。

另外黄宾虹的山水四屏条，充满着疏朗自如，悠哉游哉的轻松性质，也是绘画中的上乘之作。

前述任伯年将写意画从那种样板式的画法外另辟蹊径，将传统中蕴藏的丰厚力量作创新的动力。张大千的《凤凰女图》，线条又回到了十八描的传统老路，张大千有过传统人物画的基础，又在敦煌作过研究，临摹了大量壁画，再加自己的融会贯通，所以，他可以游刃有余地使用传统，同样游刃有余地将传统不露痕迹地纳入他的创新之中，新瓶里装着陈酿，从里到外都是新的景象。

徐悲鸿的马，依然是他的经典，这可能是经典样式中的上乘之作，墨色沉着，笔法厚实，内在的精微，墨的气息附着在马的形象上，我们从马的身上，闻到了阵阵墨香。

《峡江帆影图》是陆俨少的代表作之一，陆俨少画浙山、皖山、川西诸山，都留下了可圈可点的佳作，但他画的三峡山水，无疑有独特的体会和感受，抗战胜利后，他结筏沿长江而下，过峡出江，历经艰险，同时也对峡江的山水有了深刻的观察，这是他晚年画风变格的一大基础。而他至精至佳的作品，十有八九是描写三峡的。这幅《峡江帆影图》一依他画三峡的格式，其严谨处在江水的笔法，这也是他的创格，那种曲线的美，那样曲线下水波、水浪、旋涡，所体现的水的姿态是前无古人的。

花鸟画一直是海派绘画的骄傲，不仅名家辈出，而且，创新的力度也是空前的。谢稚柳以山水画闻名，可他的花鸟画在众多极为优秀画花鸟画中，竟一枝独秀，技压

群芳，他的《芙蓉青竹图》，显示出宋画的风范，谢稚柳对宋代花鸟的传统，了然于心，不仅是鉴定家的眼力，更是鉴赏家的眼光，他纳鉴于赏中，宋人的好处及缺点，他都有辨识，所以他吸取的是宋画的精华，他知道这种精华的来龙，也知道这种精华的去脉，便可轻车熟路般地运用发展之道。这画就可以把宋人一丝不苟的写实放在自己疏放悠闲的心情上。谢稚柳的花鸟大气谦和，于所谓"四花旦"外别树一帜。

这次展出的海派绘画，品质极高。除上述介绍的以外，还有贺天健、王个簃、程十发等名震上海乃至全国画坛的大师。因而，这次展览或也可以说是海派绘画一个高端脉络的展览。

江宏

二○一七年九月五日于尚尚书屋

Preface 2
Shanghai Painting and Calligraphy

The exhibition is indeed a grand event, consisting of Chinese porcelain and Chinese paintings. To be exactly, the exhibits definitely include a big category of Chinese porcelain: quality goods of all generations of celadon. In other words, the works of celadon covering a time period ranging from Wei and Jin until Ming and Qing unfold vividly the history of Chinese celadon. Also, the exhibits include Shanghai paintings and calligraphy. Here only a brief introduction is to give to the latter since the former has been illustrated as above by the authoritative scholar.

Shanghai painting started from the late Qing and reached a stage of maturity in the Republic of China. Since the founding of New China, it has taken on a new look. From the perspective of Chinese painting history, Shanghai painting represents the end of traditional Chinese paintings, and also the starting of modern Chinese paintings. Under this category we can see a long list of almost all the famous masters of paintings in modern China. They brought the art to a new height with their creative practice and fabulous works.

Zhang Xiong, a painter of the late Qing, was the earliest Shanghai painter. A local of Jiaxing, Zhejiang, he spent most of his time in Shanghai. His painting style set a benchmark for Shanghai painting in its early stage. Prior to that, painters coming to Shanghai to try their fortune varied in style and quality. Mr. Zhang slightly lowered the standard, using a common painting language to cater to the needs of the commercial communities in Shanghai, thus opening up a new era of aesthetic practice, and giving a uniform look to the painting style. This represented the earliest highlight of Shanghai painting.

In the exhibition, Mr. Zhang's ink painting of plum blossom was quite impressive, with well-designed branches and evenly distributed flowers, quite different from the wild style of Eight Eccentrics of Yangzhou. His paintings show that the Shanghai painters based their creation on the needs of the buyers, pursuing self-development with self-constraint, insisting while catering to the market needs, so as to highlight their features while changing the buyers' tastes. Such is the way Shanghai painters achieved survival through seeking development.

Ren Bonian and his relatives under the same surname contributed greatly to Shanghai painting. They were all good at painting, and their works covered a wide range of subjects, including figures, flowers and birds, animals, pets and plants, and landscapes. Among them Ren Bonian was the outstanding one. In the exhibition his Prosperity and Auspiciousness once collected by Qian Jingtang was a masterpiece, in which the characters were free of any

worry, and whose thoughts were vividly expressed by a few strokes, embodying the highest technique of his paintings. Mr. Ren is a master of this technique, so his works, both bird-and-flower paintings and portrait paintings were reflective of the reality and the connotation, as is the case of Prosperity and Auspiciousness, from which we can admire his unique skills of enjoyable bird and flower paintings.

It is said that Wu Changshuo was enlightened by Ren Bonian so that he joined the ranks of painters. But before he started to draw, he had already a good mastery of calligraphy and letters. For example, his Shiguwen calligraphy ranked first or second among his peers, and he could remember lots of poems. So he made a great coup the moment he picked up a brush to draw a painting. And, by using the lines unique to Shiguwen, his paintings of freehand flowers had their distinct style and architecture, making him peerless at his time.

In this exhibition, his Peach Fruit was about a tree of fruits, in which the trends of integrating calligraphy into painting, as well as the calligraphy taste reflected in the images of painting were clearly illustrated. It was due to the creation of Wu Changshuo that Shanghai painting became refined. Same as Ren Bonian, he won the heart of audience of Shanghai, and changed their aesthetic taste. As a result, painters of his kind enjoyed more freedom in creation in Shanghai, a metropolis encouraging the commercialization of arts.

Huang Binhong, born in Jinhua, but his had his native place of Huizhou. He studied in Huizhou in his early years. After that, he traveled around the world for earning money and also for his beloved landscape painting. He had a deep connection with Shanghai. His works were regarded as alien at the time, which could not be viewed as the Xin'an Art School, nor the Huangshan School. Free and unusual style fitted quite well into the Shanghai School. In fact, Shanghai paining had a great impact on his creation philosophy, as witnessed by his correspondences to Fu Lei. The Landscape is among the few large works of his. When there are extensive brush strokes, it is not easy to avoid the monotony feeling caused by repeated lines, which, however, is not the case for the Landscape. Because the work, amidst the extensive brush strokes covering the huge drawing, the changes to the density and the directions of the lines work together to strike a balance, resulting in an orderly arrangement. This suggests that the drawer had a profound mastery of Jin calligraphy, for which he applied in his cursive handwriting and grass writing. His masterpieces are a mix of deliberate considerations and randomly arrangement, thus creating a feeling of grandeur.

In addition, his four-screen landscape paintings are highly suggestive of ease, comfort, and a carefree state of life, and such works constitutes his masterpieces.

As mentioned before, Ren Bonian based his freehand brush works on the breakthroughs he had made in reforming the stereotype brushwork, but traditional technique also has great

potential for new development. So Zhang Daqian in his Phoenix Girl, applied the traditional techniques. He had a good mastery of traditional figure painting, and he also performed studies in Dunhuang where he did a lots of copying of the wall paintings. Further, he knew how to draw in combination of the strengths of all these. So, he could make good use of the traditional techniques while integrating them into his innovative practice. By doing so, he created a new landscape.

Xu Beihong's horse-themed paintings are still his classic, and the Horse might represents his masterpiece, with ink color well penetrated and pure brushwork well applied. As a result, the fragrance of the ink seems to float around us.

Xiajiang Sails is one of the master works of Lu Yanshao, whose masterpieces include those about the mountains of Zhejiang, Anhui, and western Sichuan. And his paintings about the landscapes of the Yangtze Gorges are definitely remarkable. After the victory of the Anti-Japanese War, he travelled down the Yangtze River, which offered his an insight into the landscapes there and formed a basis for the transformation of his style at his old age. Nine out of ten of his master works are about the Yangtze Gorges. The Xiajiang Sails, a work in which he took his usual approach, features the treatment of the waves. That is the beauty of curves he revealed, including that of the waves and swirl, making his work a pioneering one.

The flower-and-bird painting has always been a pride of the Shanghai painting. Many painters were known for this painting, and the degree of innovation was unprecedented. Xie Zhiliu, a painter famous for landscape painting, outshone his peers in flower-and-bird painting. Lotus and Bamboo is his work which carried forward the style of Song painting. With a good mastery of flower-and-bird painting of Song, the insight of a connoisseur and the taste of an admirer, he knew clearly both the strengths and weakness of the Song technique. Based on this dialectical understanding of the traditional brushworks, he brought new momentum to the legacy. That is, he could express a carefree mood in the realistic style of Song painters. His works are both magnificent and gentle, distinguishing themselves from the "Four Huatan".

The paintings in this exhibition are of high quality. Apart from the above mentioned painters, there are also works by He Tianjian, Wang Geyi, Cheng Shifa and other famous painters. So the exhibition is the presentation of top works of Shanghai painting.

Jiang Hong

5 September 2017, Shangshang Book House

浙江青瓷 越窑

越窑展品图版
Exhibits of the Yue kiln

1. 晚唐 越窑八棱净瓶
 Eight-edge kalasa of the Yue kiln of Late Tang

2. 晚唐 越窑穿带壶
 Pot with handles for raising ropes of
 the Yue kiln of Late Tang

3. 晚唐 越窑葫芦瓶
 Gourd shaped vase of the Yue kiln of Late Tang

4. 晚唐 越窑花口盏
 Cup with floral-pattern mouth
 of the Yue kiln of Late Tang

5. 晚唐 越窑盖托
 Cup tray of the Yue kiln of Late Tang

1.

晚唐　越窑八棱净瓶

Eight-edge kalasa of the Yue kiln of Late Tang

足径8厘米　残高15.2厘米　H:15.2cm

　　溜肩，鼓腹，腹部呈八棱形，圈足稍外撇。颈肩交界处饰三周与肩腹相对应的凸棱纹，呈阶梯状。外底一侧刻一"公"字。浅灰白色胎，胎质细腻坚致。通体天青色釉，釉面莹润。足端刮釉并有多个泥点垫烧痕。

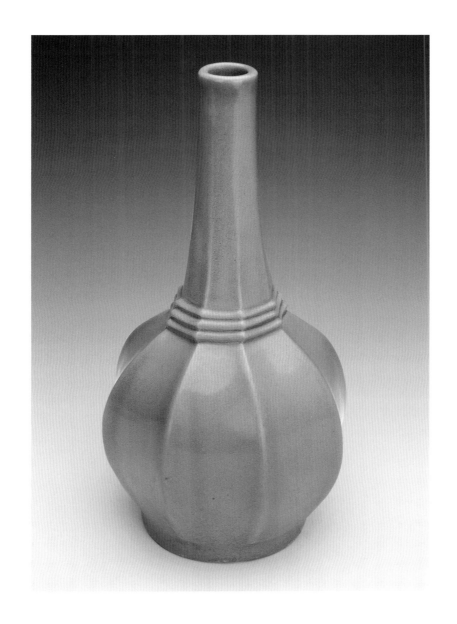

2.

晚唐　越窑穿带壶

Pot with handles for raising ropes of the Yue kiln of Late Tang

足径8.5厘米　残高21厘米　　H:21cm

　　束颈，溜肩，腹部扁圆，圈足外撇、变形。腹部两侧各有两个小横系，圈足两
侧与系相对的位置各有一个长方形穿孔。浅灰白色胎，胎质细腻坚致。通体天青色
釉，釉面莹润。足端有多个泥点垫烧痕。

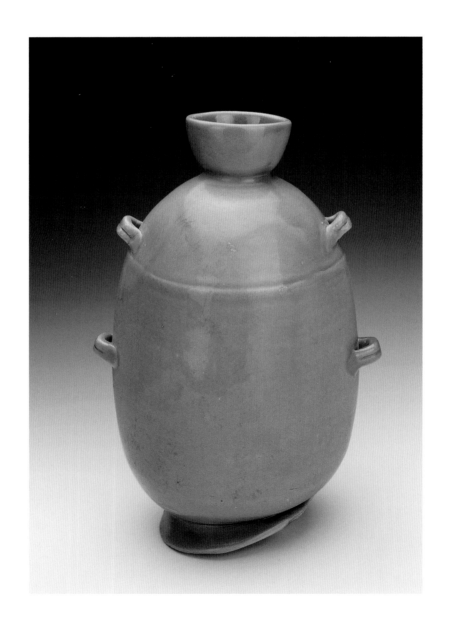

3.

晚唐　越窑葫芦瓶

Gourd shaped vase of the Yue kiln of Late Tang

底径7.2厘米　残高15.8厘米　　H:15.8cm

　　椭圆形下腹，平底内略凹。灰胎，胎质细腻坚致。通体青色釉略泛灰，釉面莹润。器底外缘刮釉并有多个泥点垫烧痕。

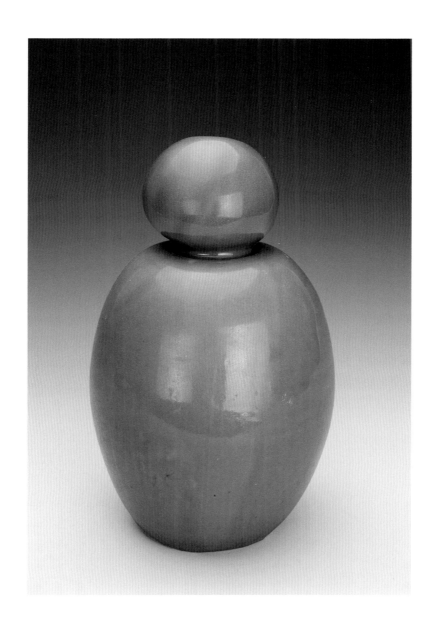

4.

晚唐　越窑花口盏

Cup with floral-pattern mouth of the Yue kiln of Late Tang

口径11.1厘米　足径7.2厘米　高6.3厘米　　H:6.3cm　D:11.1cm

敞口，圆唇，斜弧腹，下腹微折，喇叭形圈足外撇。五花口，与口沿凹缺相对应的腹部有短直凹弧一道。浅灰白色胎，胎质细腻坚致。通体天青色釉，釉面莹润。足端有多个泥点垫烧痕。

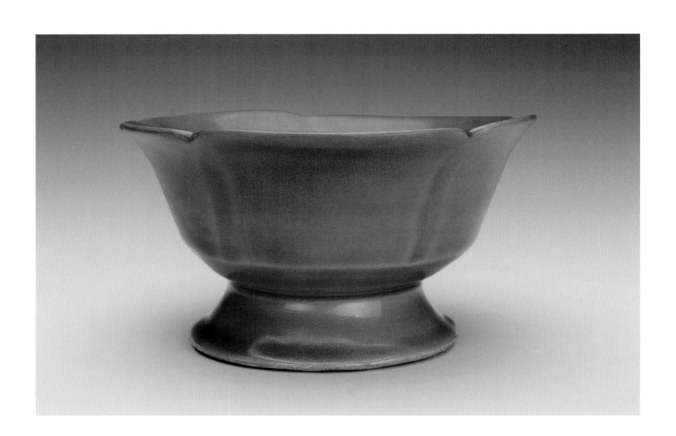

5.

晚唐　越窑盏托

Cup tray of the Yue kiln of Late Tang

直径16厘米　足径7.2厘米　高5.5厘米　　H:5.5cm　D:16cm

　　内底有托杯，托杯为敞口，圆唇，深弧腹；托盘为八瓣菱花口，圆唇，浅弧腹，平底，喇叭形矮圈足。托盘外壁与花口凹缺相对应的腹部有短直凹弧一道。浅灰白色胎，胎质细腻坚致。通体天青色釉，釉面莹润。足端有多个泥点垫烧痕。

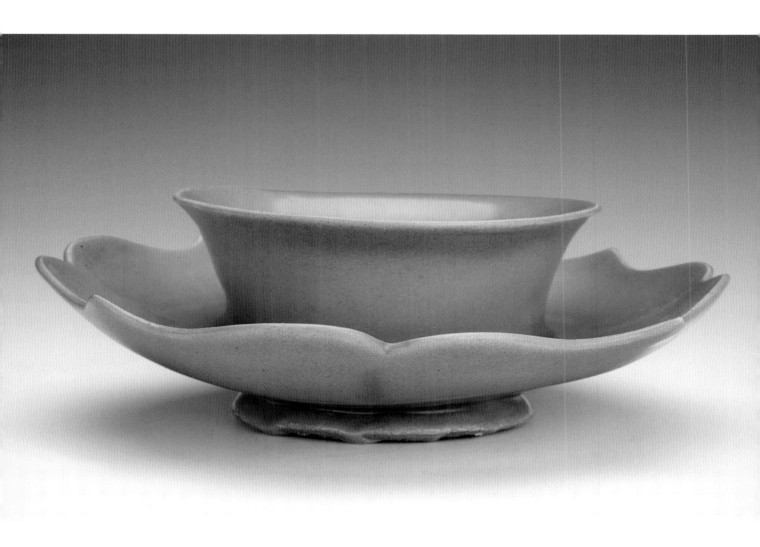

南宋龙泉窑珍品　朱伯谦

龙泉窑展品图版目录
Exhibits of Longquan kilns

23.元 龙泉窑折沿盘
Plate with folded edge of the Longquan kiln of Yuan

24.元 龙泉窑兽蹄三足炉
Thurible supported by three hooves like feet
of the Longquan kiln of Yuan

25.元 龙泉窑葵口花卉纹扳沿大盘
Bit plate with folded edge and featured
by sunflower shape of the Longquan kiln of Yuan

26.明 龙泉窑刻花鼓凳
Drum stool with engraved floral patterns
of the Longquan kiln of Ming

27.明 龙泉窑刻花缠枝莲纹盖罐
Pot & cover with engraved lotus patterns
of the Longquan kiln of Ming

28.明 龙泉窑笔架山龙首砚滴
Water dropper with dragon head
of the Longquan kiln of Ming

29.明 龙泉窑带盖鼎式三足香炉
Ding shaped thurible with cover
of the Longquan kiln of Ming

30.明 龙泉窑大盘
Big plate of the Longquan kiln of Ming

31.明 龙泉窑菊瓣纹小盘
Small plate with chrysanthemum patterns
of the Longquan kiln of Ming

32.明 龙泉窑刻花缠枝牡丹纹胆瓶
Vase with engraved peony patterns
of the Longquan kiln of Ming

33.明 龙泉窑刻花爵杯
Goblet with engraved floral patterns
of the Longquan kiln of Ming

34.明 龙泉窑刻花双耳鼎式炉
Ding shaped thurible with two standing handles
and engraved floral patterns
of the Longquan kiln of Ming

35.明 龙泉窑骨盆
Basin of the Longquan kiln of Ming

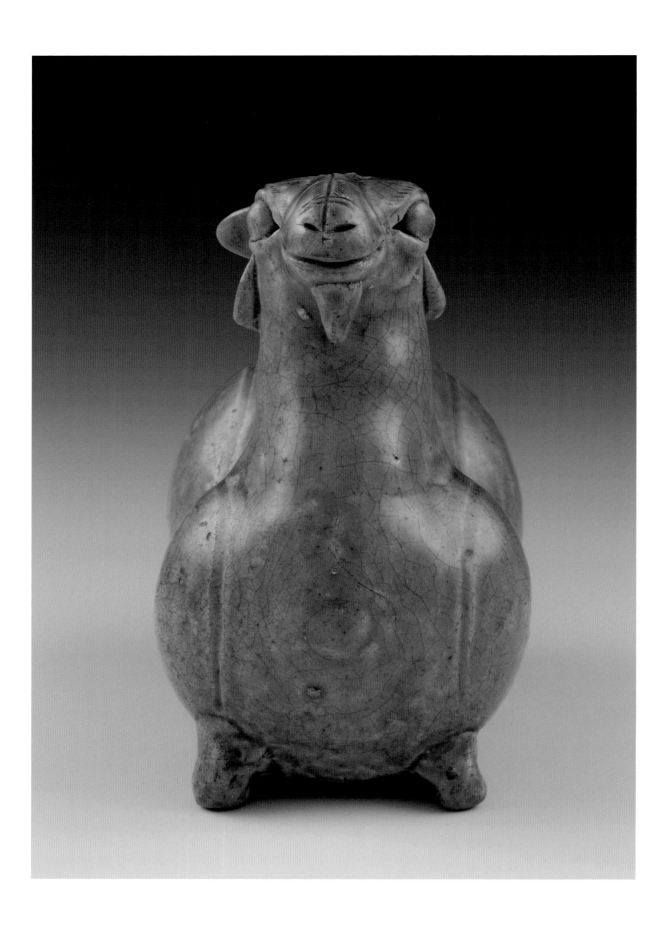

1.

西晋　越窑羊尊
Sheep Statue of the Yue kiln of Western Jin Dynasty

高13.5厘米　长14.5厘米　　H:13.5cm　L:14.5cm

　　呈卧伏状的羊姿，首顶开一圆孔，刻画耳朵一对、眼睛一双，昂首张口，留一缕胡须。体态肥壮，两肋刻羽翼，尾部塑短尾。两侧胸部、臀部画圆圈凸显四肢肌肉，底部塑四只羊脚。全身施青黄釉。

　　羊在中国古代被视为祥瑞动物，羊形青瓷成为一时风尚，自三国至东晋均有烧造。

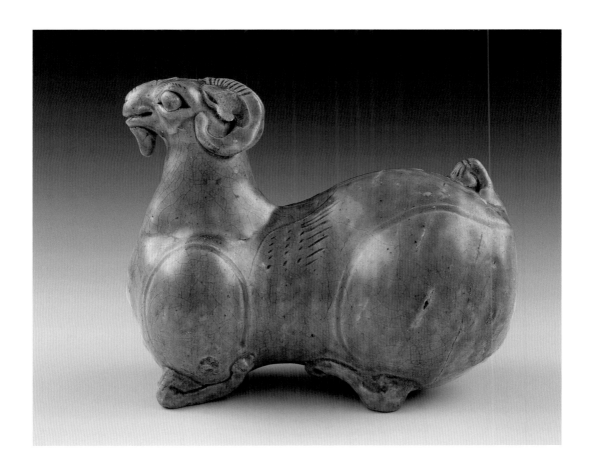

2.

北宋早期　龙泉窑刻划花十棱执壶

Ten separating edges handled ewer with floral patterns of the Longquan kiln of Five Dynasties

通高25厘米　腹径15厘米　底径8厘米　　H:25cm　D:15cm

　　八圆棱形盖，宝珠钮，盖下层镂九孔，盖为母口。壶平口，细长颈，丰肩，鼓腹。颈腹间装对称管状细长流及扁把，腹壁用凸棱线分成十棱，棱内刻花卉纹、如意祥云纹，内填篦纹，刻花繁缛，工艺精细。十棱圈足外撇，饰弦纹两圈，通体施淡青釉，外底满釉。

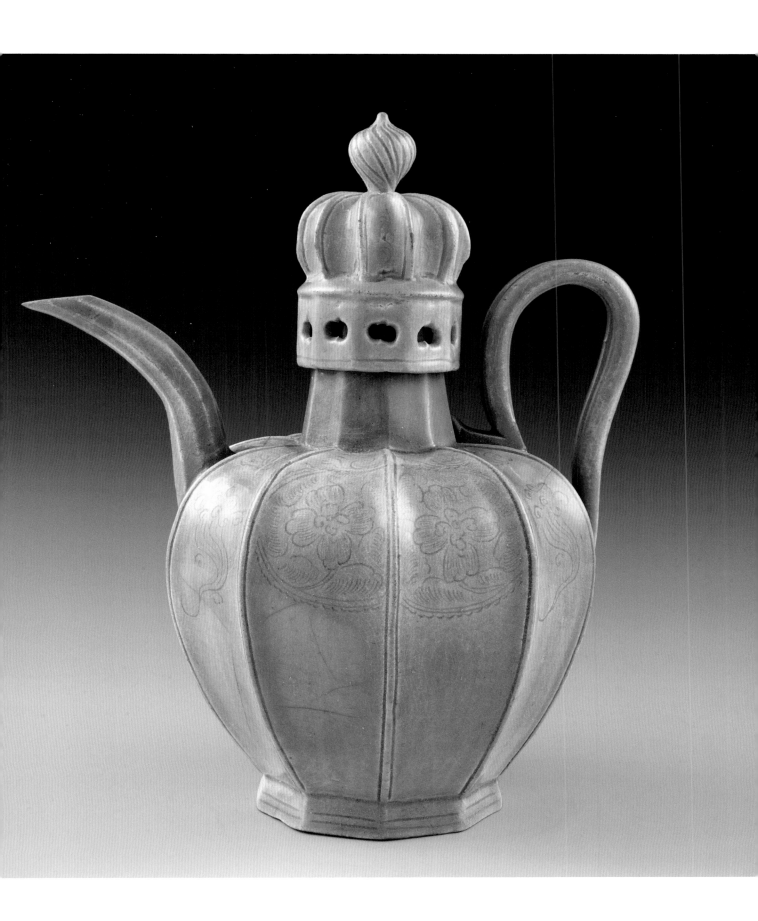

3.

北宋 龙泉窑刻花五管瓶

Five-tubed vase with engraved floral patterns of the Longquan kiln of Northern Song

通高30厘米 腹径13厘米 底径8厘米 H:30cm D:13cm

宝塔钮，盖面鼓起，盖沿平出，盖面刻折扇纹。瓶直口，肩部等距离塑贴五个喇叭形短管。腹呈六层堆叠而上装饰，第一、四、五层划卷草纹，第二、三层刻斜方格纹，第六层刻仰莲瓣，内填篦纹。胎灰白，通体施青釉，底露胎，呈火石红色。

（香港实业家翁周明先生旧藏）

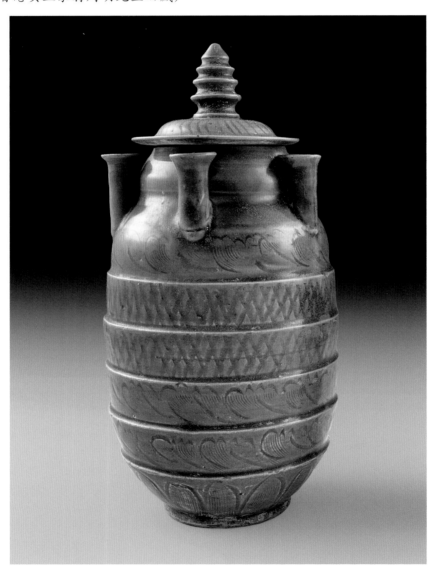

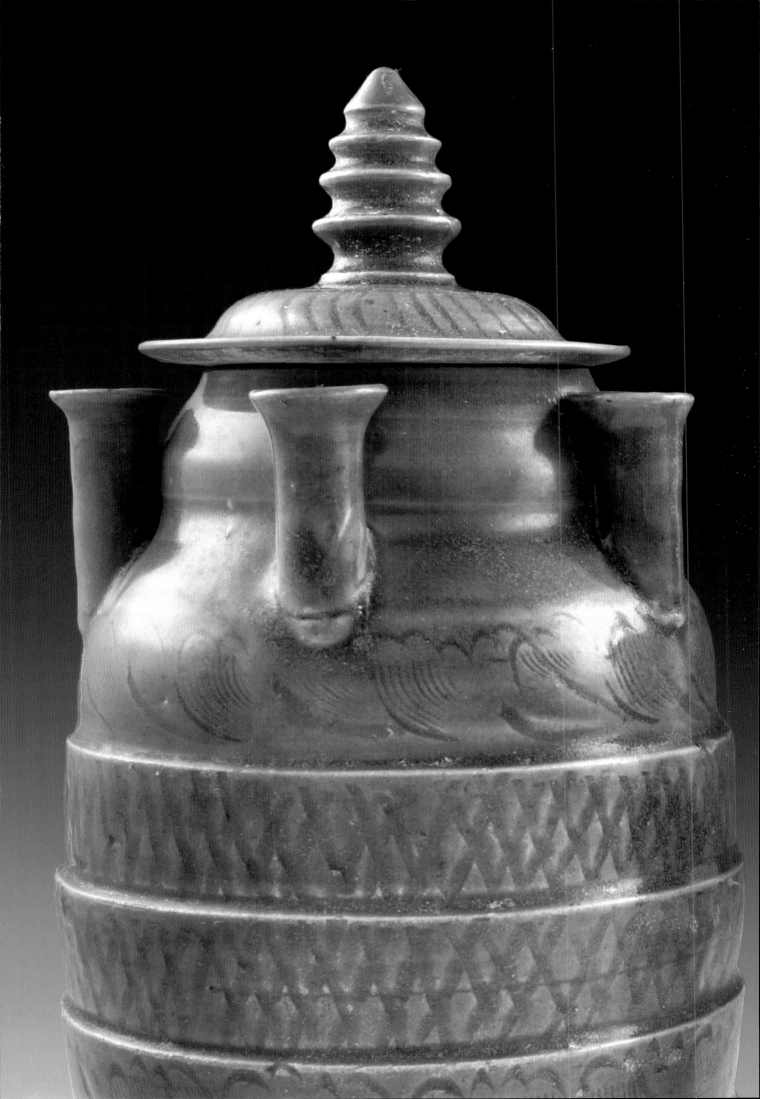

4.

北宋　龙泉窑刻花塔瓶

Tower shaped vase with engraved floral patterns of the Longquan kiln of
Northern Song

通高26.5厘米　腹径12厘米　底径7厘米　　H:26.5cm　D:12cm

　　宝塔钮，盖面鼓起，盖沿平出，盖面刻折扇纹。壶盂口，筒形颈，溜肩，鼓
腹，圈足。肩缘饰弦纹三条，腹上、下部各饰弦纹一圈，肩刻覆莲瓣、腹中部刻
卷草纹、下腹刻仰莲瓣一圈，均内填篦纹。胎灰白，通体施青釉，底无釉，呈火
石红色。

（香港实业家翁周明先生旧藏）

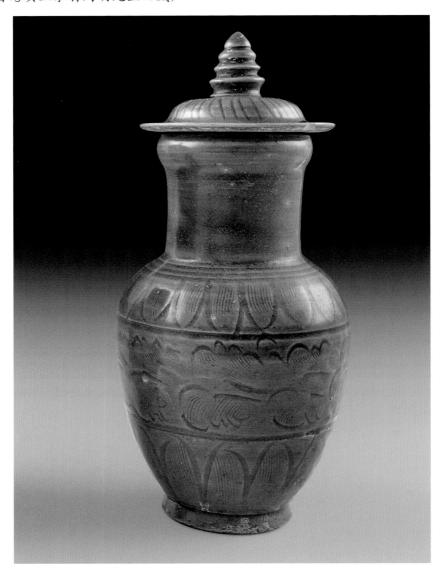

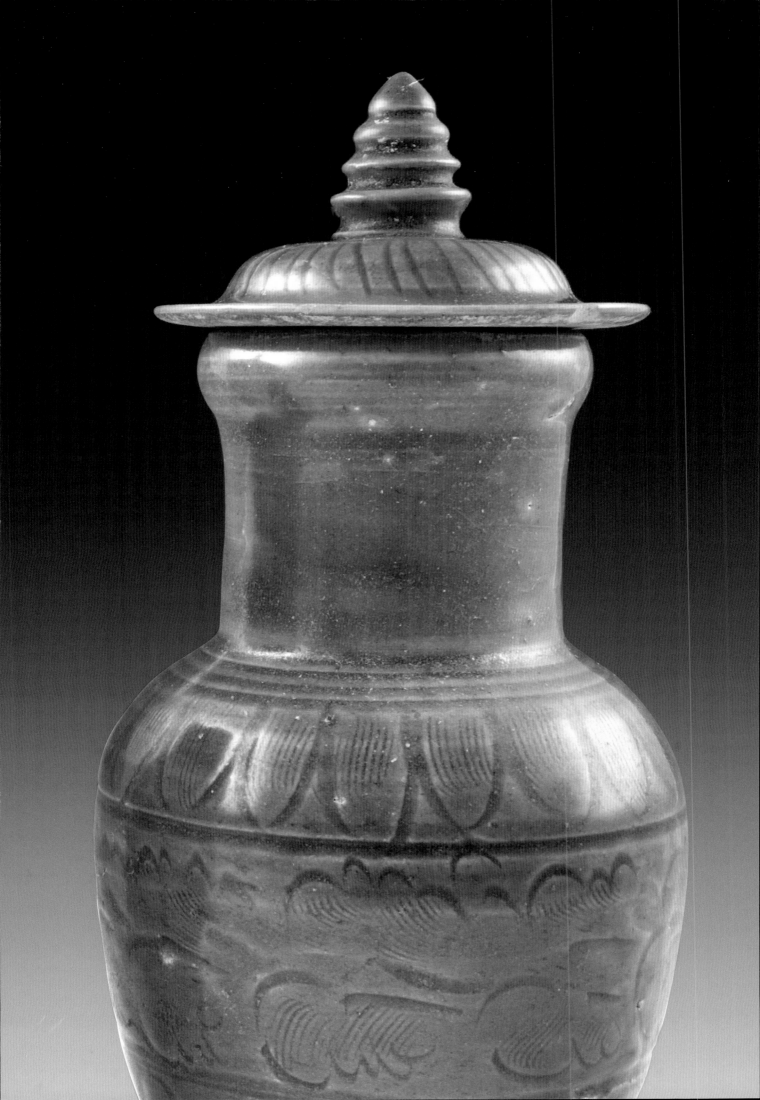

5.

北宋　龙泉窑刻花碗

Bowl with engraved floral patterns of the Longquan
kiln of Northern Song

高6.4厘米 口径11.6厘米 足径5厘米　H:6.4cm D:11.6cm

　　敞口，唇微外翻，斜直腹，小圈足。内壁上下各
刻弦纹一圈，中间刻团花三朵，内填篦纹，团花间以
水波纹相连，内底刻菊花一朵，外壁画折扇纹。灰
胎，施青黄釉，外底、圈足无釉，呈灰红色。

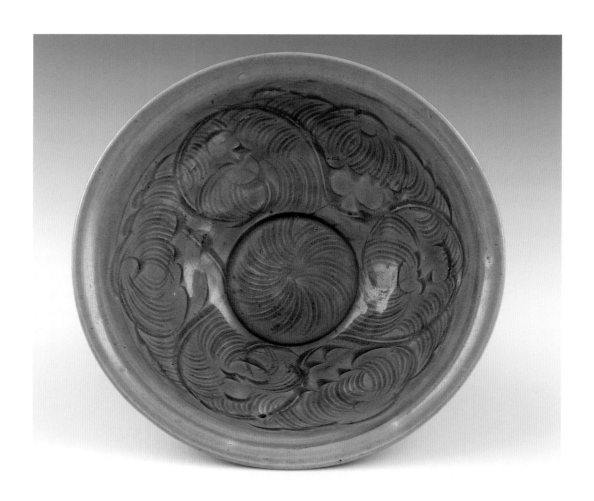

6.

北宋　龙泉窑刻花三连碟盖盒

Three-plate box and cover with engraved floral patterns of the Longquan kiln of Northern Song

高3.6厘米　口径13.2厘米　底径5.8厘米　　H:3.6cm D:13.2cm

　　盖面平，中间微鼓，内刻折枝莲花纹，篦点纹作地，盖缘下折成母口，盒为子口。矮直腹，小平底。盒内有三个小碟，可分置粉、黛、朱等化妆品。胎灰白，通体施青釉，子母口与外底无釉，呈朱红色。

　　瓷盒在唐代已出现，主要用途为盛装药品、香料和化妆用品，宋代各地瓷窑大都烧造。有莲瓣盒、菊瓣盒、八方盒、梅瓣盒、瓜式盒等样式。

　　（香港实业家翁周明先生旧藏）

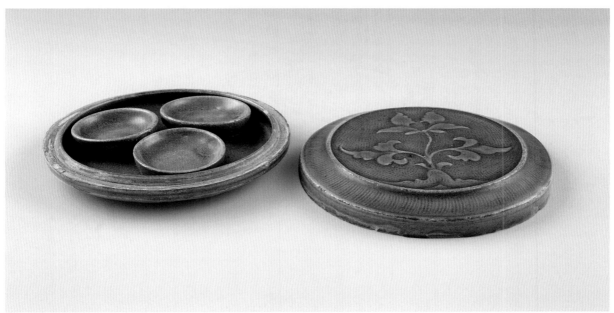

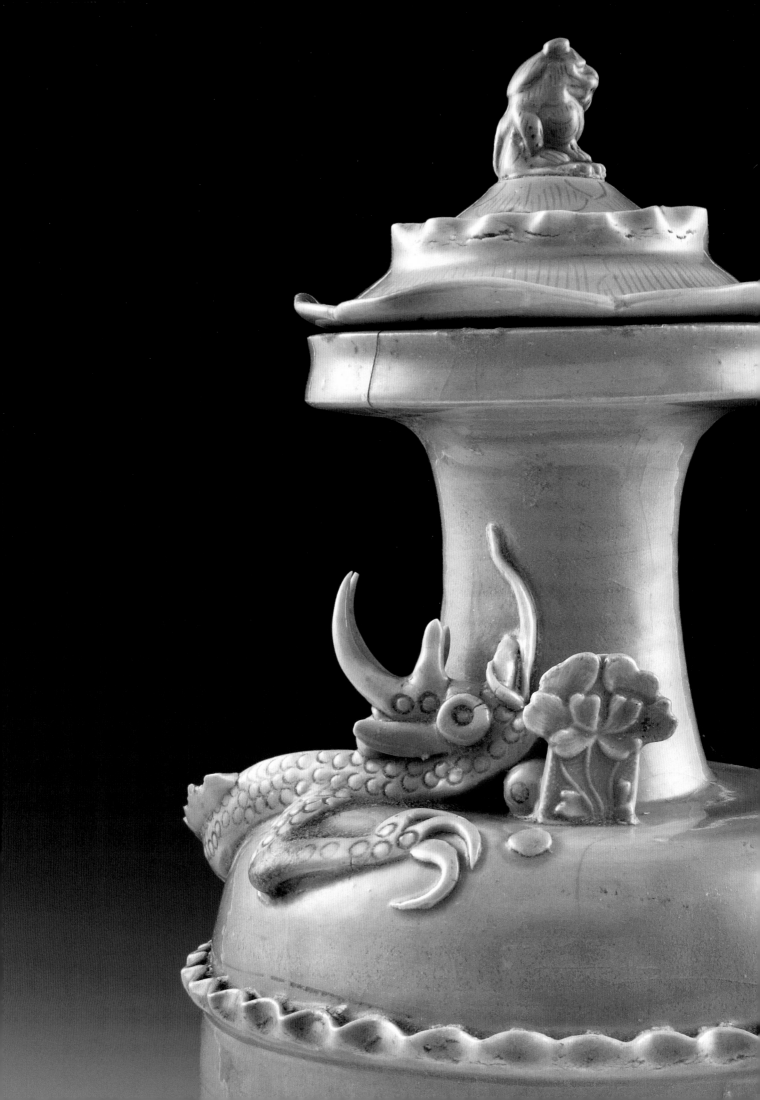

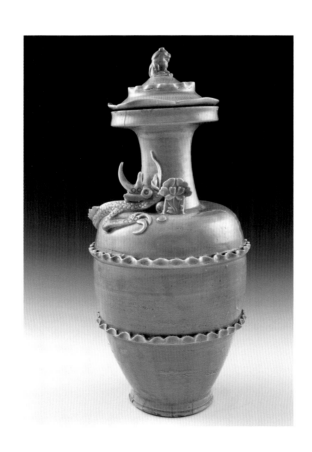

7.

北宋　龙泉窑塑龙双系盘口盖瓶

Paste-on-paste decoration dragon plate-mouth vase with two ties of the Longquan kiln of Northern Song

通高39厘米　腹径17厘米　底径10厘米　　H:39cm　D:17cm

　　瑞兽（狮形）钮，钮下饰波浪纹一圈，盖沿花口上卷，内缘有子口。盘口，长颈，腹上丰下腹弧收，圈足外撇。盖画篦纹。肩腹堆塑三爪龙一条，龙角、脊、鳞、爪清晰可见。龙形体矫健，回首，侧目而视，威武雄壮。颈肩装对称双耳，耳内浮雕牡丹花与枝叶。腹上、下堆贴波浪纹各一圈。胎白致密，通体施淡青釉，圈足露胎呈火石红色。

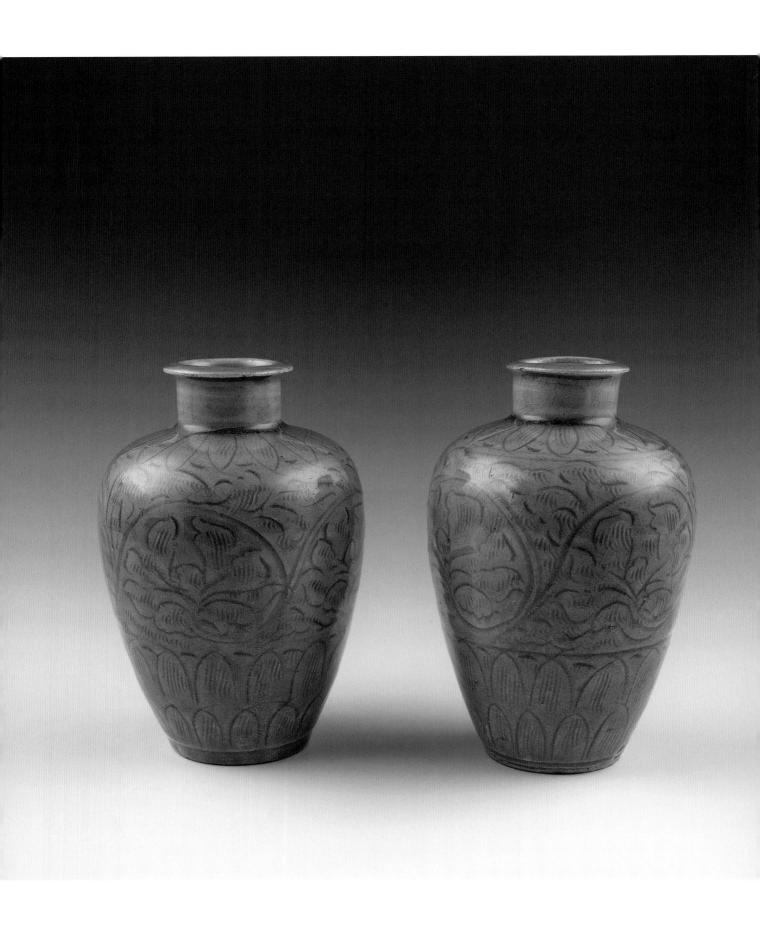

8.

北宋　龙泉窑刻花梅瓶（一对）

Plum vases with engraved floral patterns of the Longquan kiln of Northern Song
(a pair)

高15.6厘米　口径5.1厘米　底径5.7厘米　　H:15.6cm

　　直口平唇，颈较高，肩、腹较丰满，下腹内收成暗圈足。肩刻双重覆莲瓣，肩部外沿及腹部各饰弦纹一圈，腹刻缠枝牡丹纹、草叶纹，下腹刻三重仰莲瓣，纹饰繁密，内填篦纹。灰胎，施青釉，釉面透明，有开片。外底无釉，有垫饼痕。

9.

北宋　龙泉窑刻花梅瓶

Plum vase with engraved floral patterns of the Longquan
kiln of Northern Song

高35厘米　口径4.2厘米　底径9厘米　　H:35cm

　　直口平唇，颈较高，肩、上腹较丰满，下腹内收成暗圈足。肩部刻缠枝莲花五
朵，上腹刻缠枝牡丹纹，下腹刻三重仰莲瓣，内填篦纹，纹饰繁密。肩与上腹，上
腹与下腹各用双线弦纹分隔。灰胎，青釉，釉层开片，透明有浮光，外底边缘有积
釉现象，足底无釉，有垫饼痕。

　　梅瓶是宋代开始流行的一种贮酒器，北宋梅瓶肩、腹比较丰满，外壁刻缠枝莲
纹和莲瓣，器底较大，美观大方，摆放平稳，为龙泉窑高档器型。

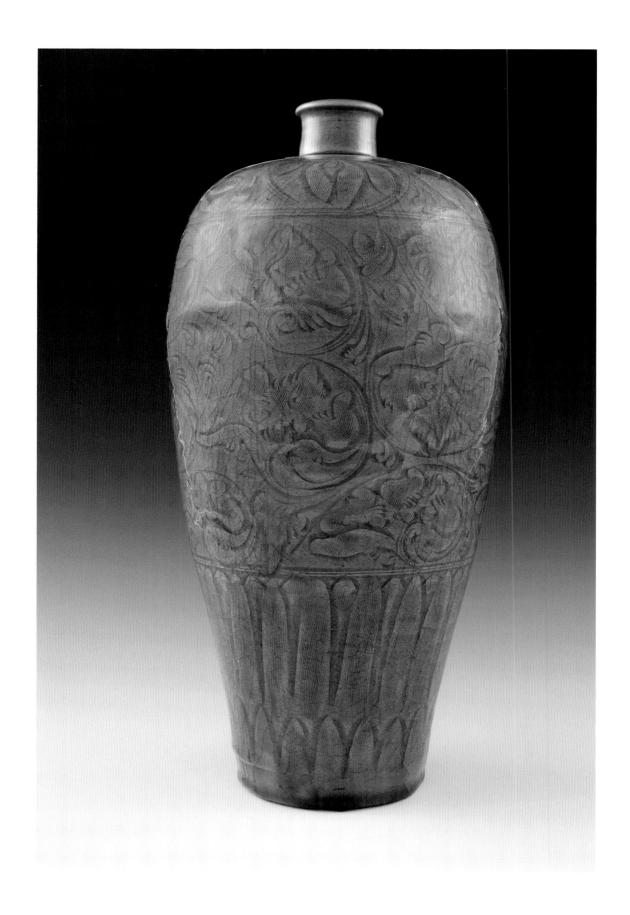

10.

北宋　龙泉窑刻花梅瓶

Plum vase with engraved floral patterns of the Longquan kiln of Northern Song

高33.2厘米　口径4.4厘米　腹径17厘米　底径9厘米　　H:33.2cm

直口平唇，颈较高，肩、上腹较丰满，下腹内收成暗圈足。肩刻缠枝花卉纹，
上腹刻缠枝牡丹纹，下腹刻三重仰莲瓣，内填篦纹，三组纹饰间饰二条双线弦纹。
胎灰白，通体施青釉，有开片。底无釉，呈砖红色。

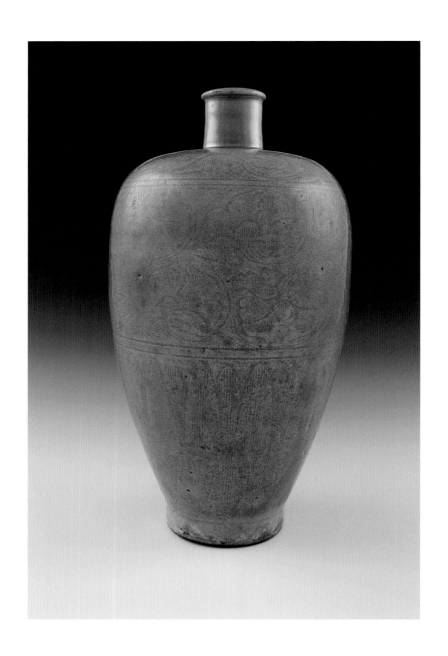

11.

南宋　龙泉窑莲瓣纹束口碗

Narrow-mouth bowl with lotus patterns of the
Longquan kiln of early Southern Song

高4.8厘米　直径11厘米　H:4.8cm D:11cm

　　束口，唇外卷，弧腹，小圈足。外壁刻仰莲瓣，内填篦纹。内外施粉青釉，釉层开"冰裂纹"。胎灰白，圈足无釉，呈土黄色。

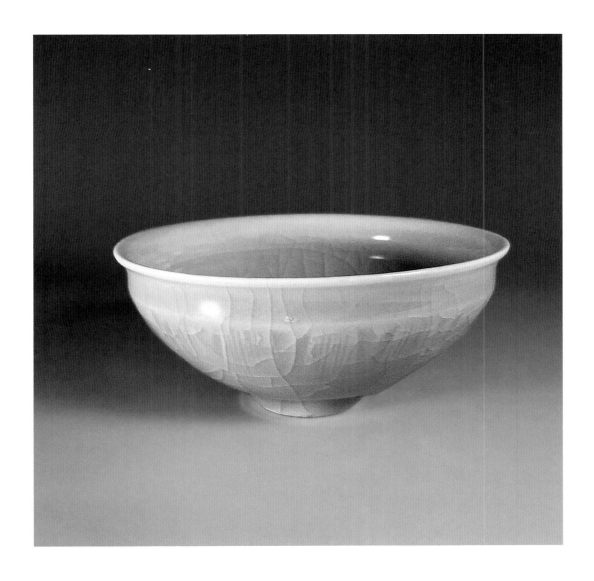

12.

南宋　龙泉窑圆口洗

Round-mouth writing brush washing plate of the
Longquan kiln of Southern Song

高5厘米　口径14厘米　足径7厘米　　H:5cm D:14cm

敞口圆唇，弧腹，下腹向内收，圈足。灰白胎，施粉青透明釉，圈足露胎处呈朱红色。

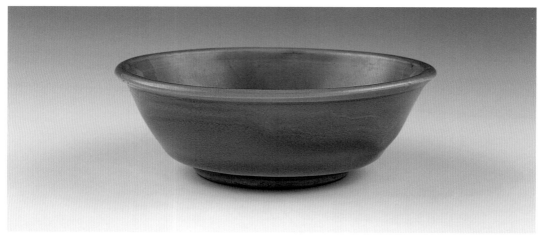

13.

南宋　龙泉窑莲瓣纹双鱼洗

Two-fish writing brush washing plate with lotus patterns of the Longquan kiln
of Southern Song

高4厘米　口径14厘米　足径6.3厘米　　H:4cm　D:14cm

　　敞口，折沿，浅弧腹，圈足。内底塑贴双鱼，鱼背相对，画弧纹两圈。腹外壁饰莲瓣，瓣脊凸起，瓣周用双线刻画出轮廓。施梅子青釉，圈足底部无釉，呈火石红色。

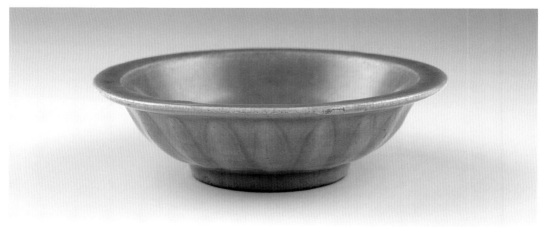

14.

南宋　龙泉窑小洗

Little writing brush washing plate of the Longquan
kiln of Southern Song

高3.4厘米　口径8.4厘米　底径4.4厘米　　H:3.4cm　L:8cm

敞口，斜折腹，圈足。釉面光素无纹，有开片。胎灰白，施青釉，釉色匀净。圈足无釉，呈土黄色。

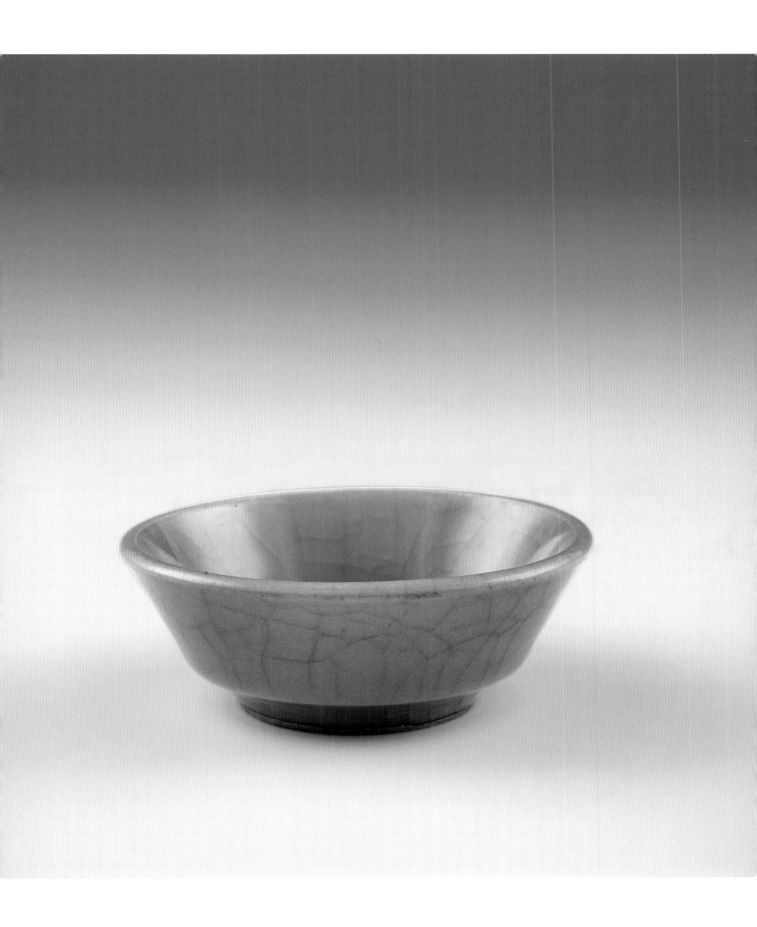

15.

南宋　龙泉窑堆塑龙瓶

Paste-on-paste decoration dragon vase of the
Longquan kiln of Late Song

通高26.5厘米　腹径12厘米　底径7厘米　　H:26.5cm　D:12cm

　　动物钮，盖微凸，盖缘平展，内有子口。瓶盘口，直颈，斜肩，腹渐收，圈足。颈肩部堆塑龙纹一条，火珠一颗，龙体盘曲，侧目而视，形象威武生动。通体施粉青厚釉，盖沿、口沿及圈足底无釉，呈朱红色。

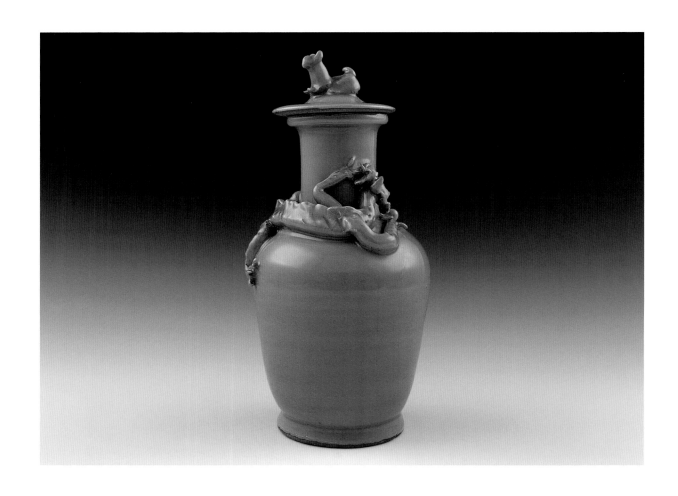

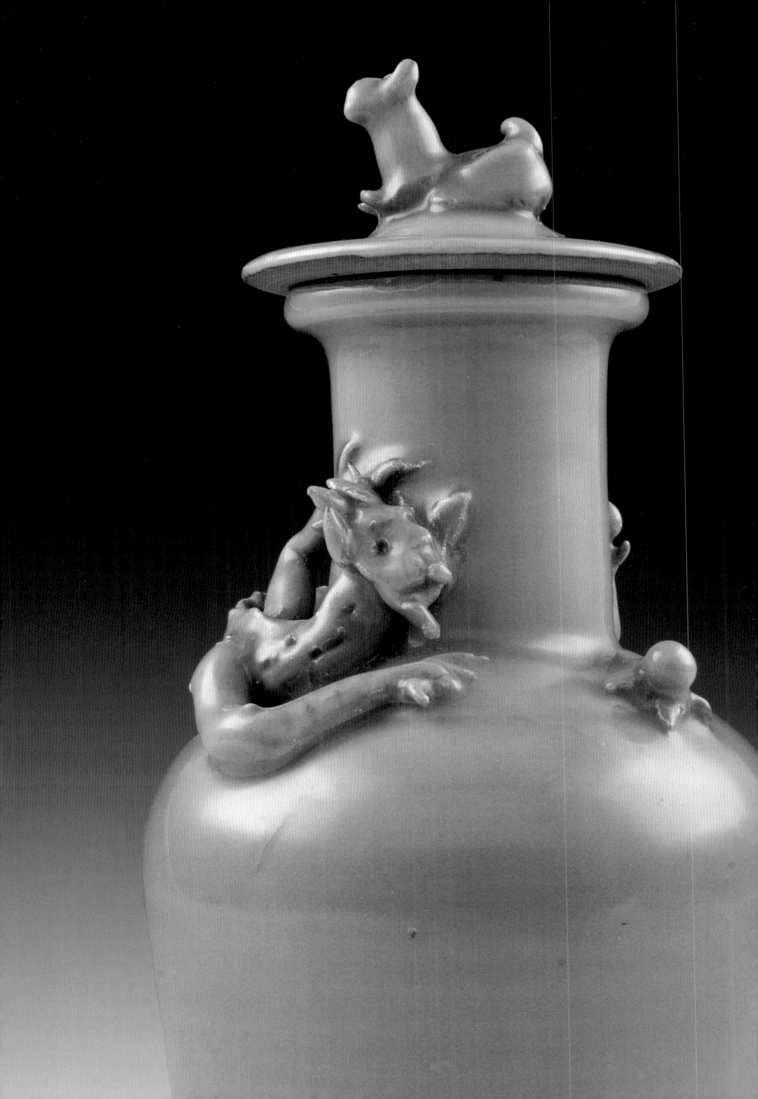

16.

南宋　龙泉窑堆塑龙瓶

Paste-on-paste decoration dragon vase of the
Longquan kiln of Late Song

通高22.5厘米　腹径13厘米　底径7.9厘米　　H:22.5cm　D:13cm

　　飞鸟钮，盖微凸，盖缘平展，内有子口，平口，直颈。肩与上腹分圆弧形三层，圈足。颈肩部堆塑龙纹一条，火珠一颗。盖面及瓶内外施粉青厚釉，釉层厚薄均匀，釉色极佳，盖沿、口沿及圈足无釉，呈朱红色。

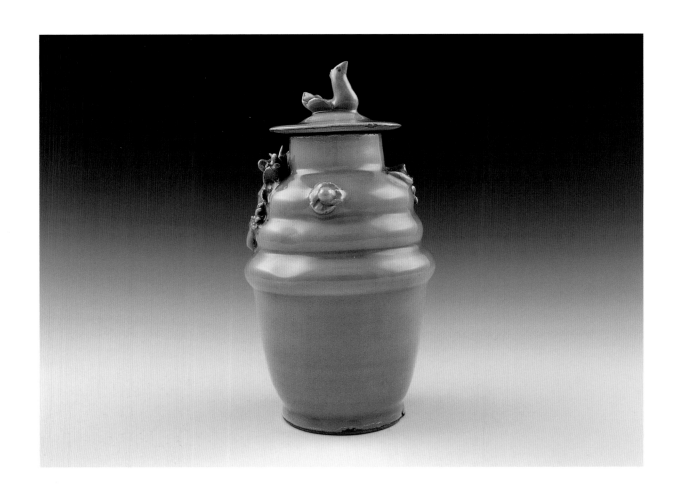

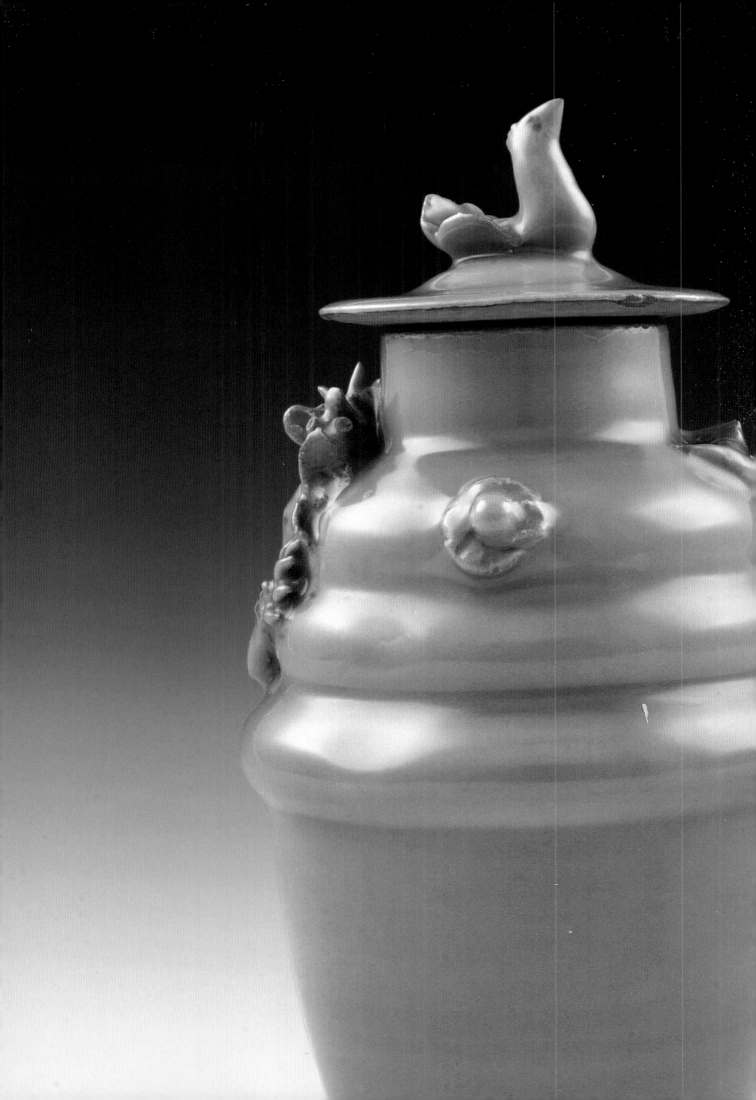

17.

南宋　龙泉窑鬲式炉

Ancient cooking tripod-like thurible of the Longquan kiln of Late Song

高9.8厘米　口径13厘米　　H:9.8cm　D:13cm

　　圆口，平唇微外斜，直颈，扁圆腹，乳形三足，各有一圆孔。肩部饰凸弦纹一圈，腹与足背饰三角形凸脊，俗称"出筋"。胎灰白，施粉青釉，釉色极佳，足底无釉，呈朱红色。

　　此鬲式炉仿商周铜鬲式样，龙泉窑鬲式炉始烧于宋代，系焚香用具。

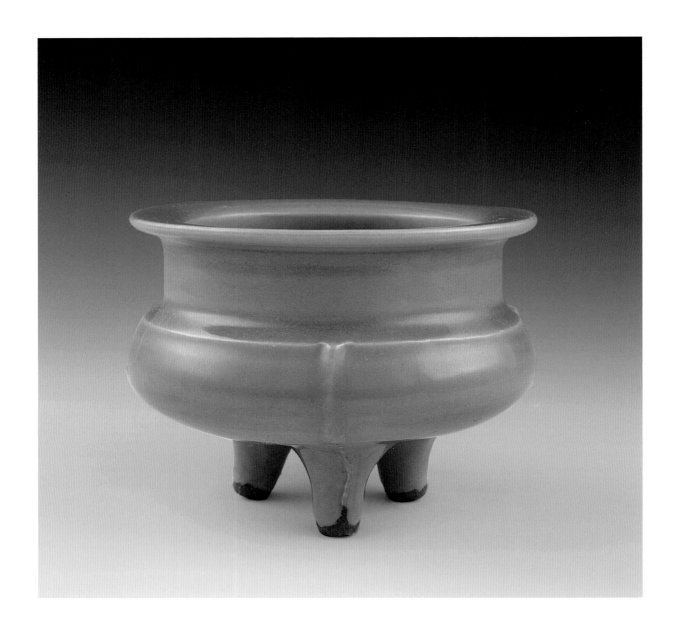

18.

南宋　龙泉窑五管瓶

Five-tubed vase of the Longquan kiln of Late Song

高24.5厘米 口径8.2厘米　H:24.5cm

　　飞鸟钮，盖微凸，盖缘下垂，内有子口。瓶盉口，直颈，肩与上腹饰三条弦纹分成三层，肩缘与一层间等距离塑贴五个圆型管。盖面、瓶内、瓶外施粉青釉，釉层厚薄均匀。盖沿、口沿、矮圈足无釉，呈土黄色。

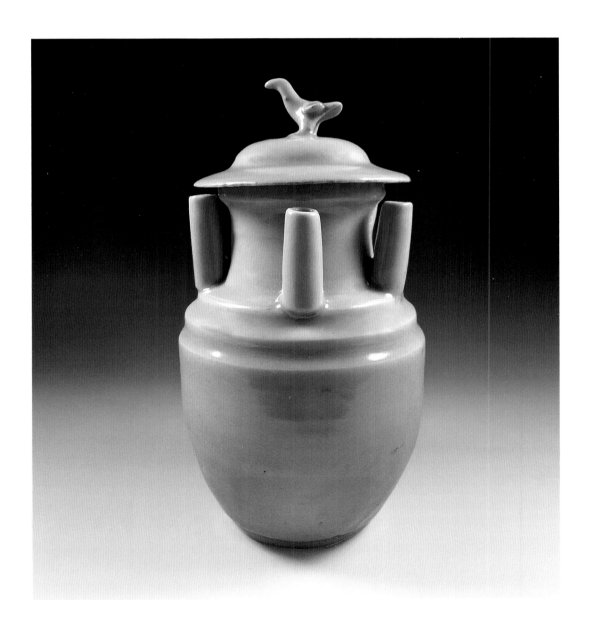

19.

南宋　龙泉窑莲瓣纹盘

Plate with lotus patterns of the Longquan kiln of Late Song

高4.2厘米　口径16.4厘米　足径5.8厘米　　H:4.2cm　D:16.4cm

　　敞口，弧腹，圈足。内壁近底处刻一圈凹弦纹，外壁刻莲瓣。莲瓣之间有积釉现象，口沿、莲瓣脊釉薄处隐现白色，形成自然美的装饰效果。胎白，施豆青釉，圈足露胎，呈淡朱红色。

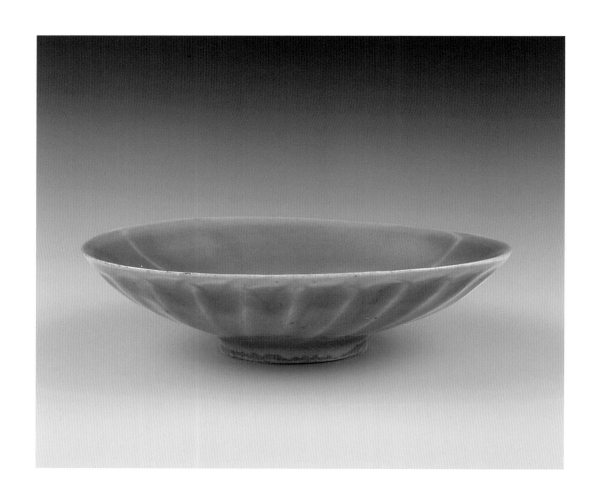

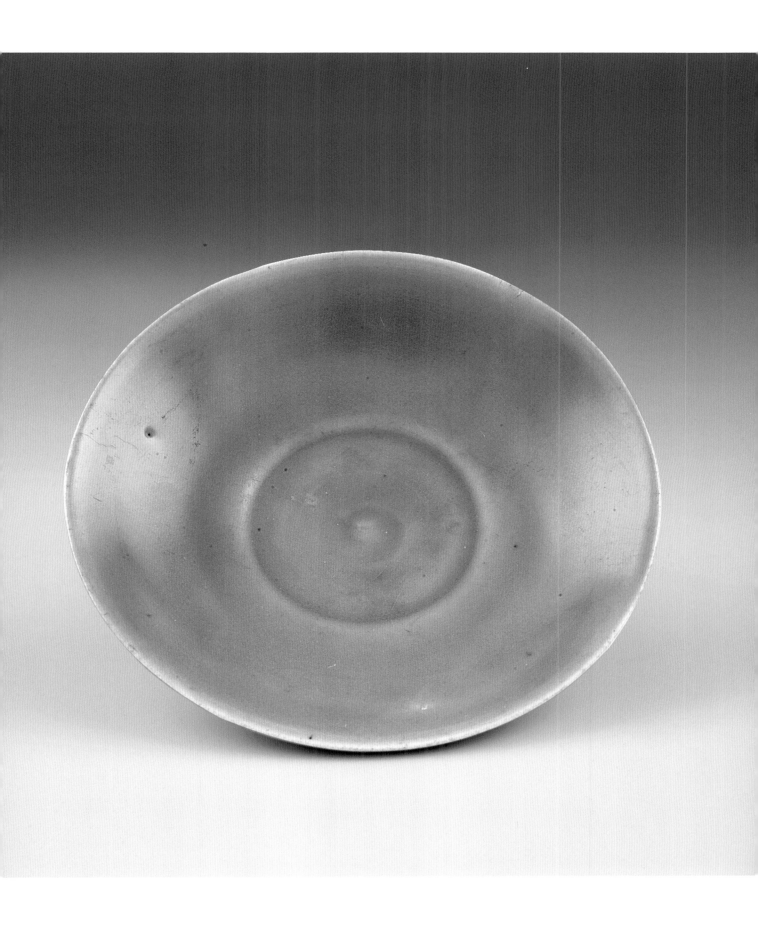

20.

南宋　龙泉窑莲瓣纹碗

Bowl with lotus patterns of the Longquan kiln of Late Song

高7厘米　口径12.6厘米　足径4.7厘米　　H:7cm　D:12.6cm

　　敞口，弧腹，小圈足。外腹壁刻宽仰莲瓣，口沿、莲瓣脊釉薄处隐现白色，莲瓣脊挺拔，刀法流畅，器型规整，制作精美。通体施粉青色厚釉，釉色绝佳。圈足底露胎，呈朱红色。

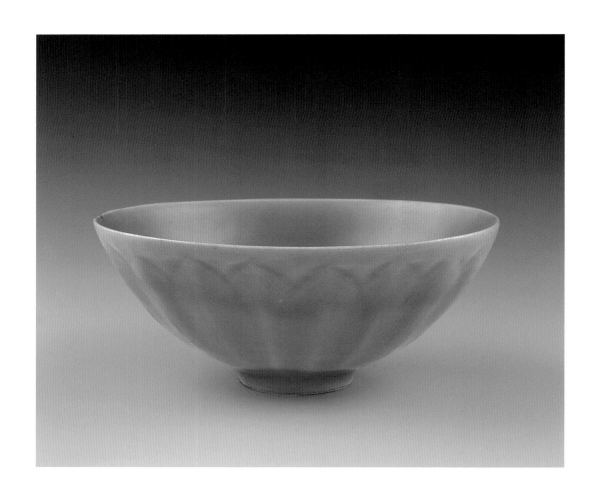

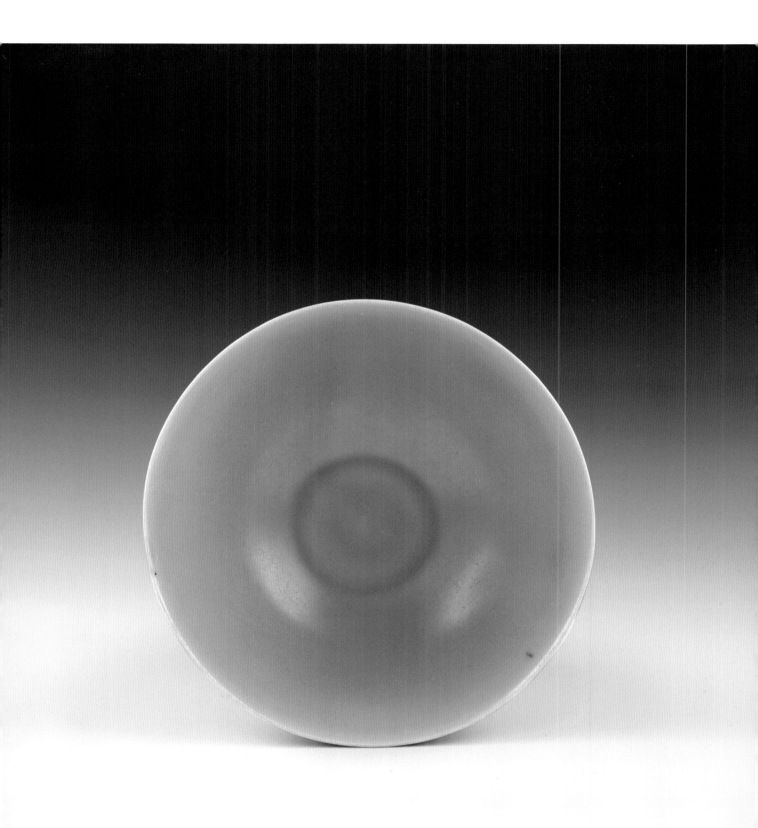

21.

元　龙泉窑八卦纹香炉

Thurible with trigram patterns of the Longquan kiln of Yuan

口径13.1厘米　足径4.1厘米　　H:6.7cm　D:13.1cm

　　直口，宽唇内折，筒腹，下腹内收。圈足着地，下承三蹄足悬空。外腹凸饰八卦纹、上下各饰弦纹一圈，通体施梅子青釉，胎体匀称，圈足、内底无釉，呈褐红色。

　　该器型造型优美，制作十分精致，为龙泉窑珍品。元代龙泉窑将一部分炉的外底作高，使他着地，炉足悬空，成为一种装饰，这种现象在南宋和明清是不存在的，时代特征很明显。

　　（台北著名收藏家张允中先生旧藏）

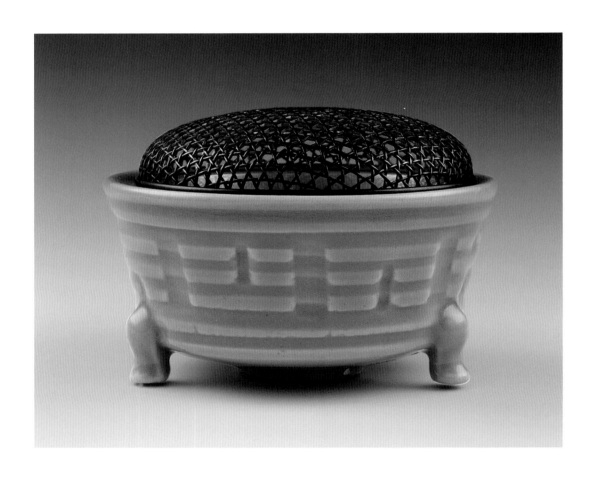

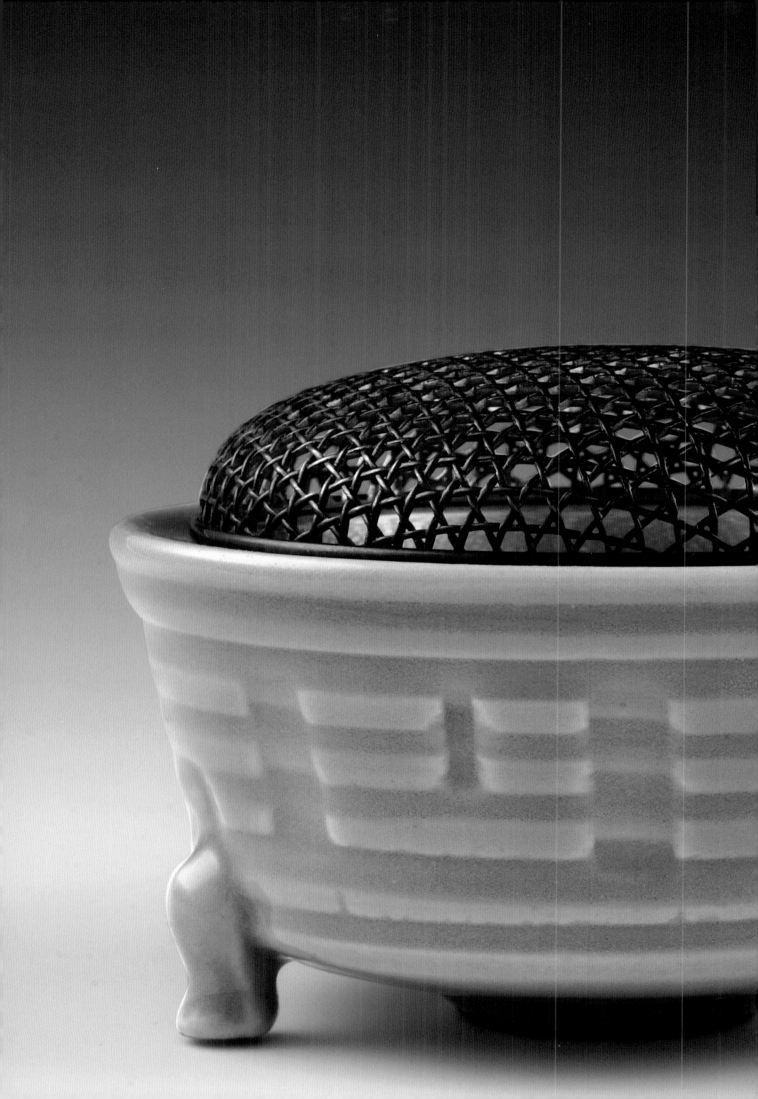

22.

元 龙泉窑塑贴双鱼洗

Paste-on-paste decoration double fish writing brush
washing plate of the Longquan kiln of Yuan

高5厘米 口径20.8厘米 足径8.9厘米 H:5cm D:20.8cm

　　敞口，折沿，浅弧腹，圈足。内底塑贴双鱼，鱼背相对，画弦纹两圈。腹外壁饰莲瓣，莲瓣较狭窄，瓣脊凸起，瓣周用双线刻画出轮廓。施梅子青釉，圈足底部无釉，呈深灰色。

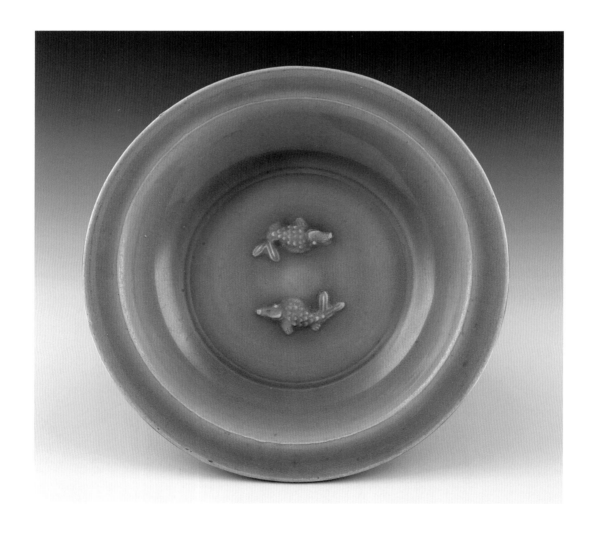

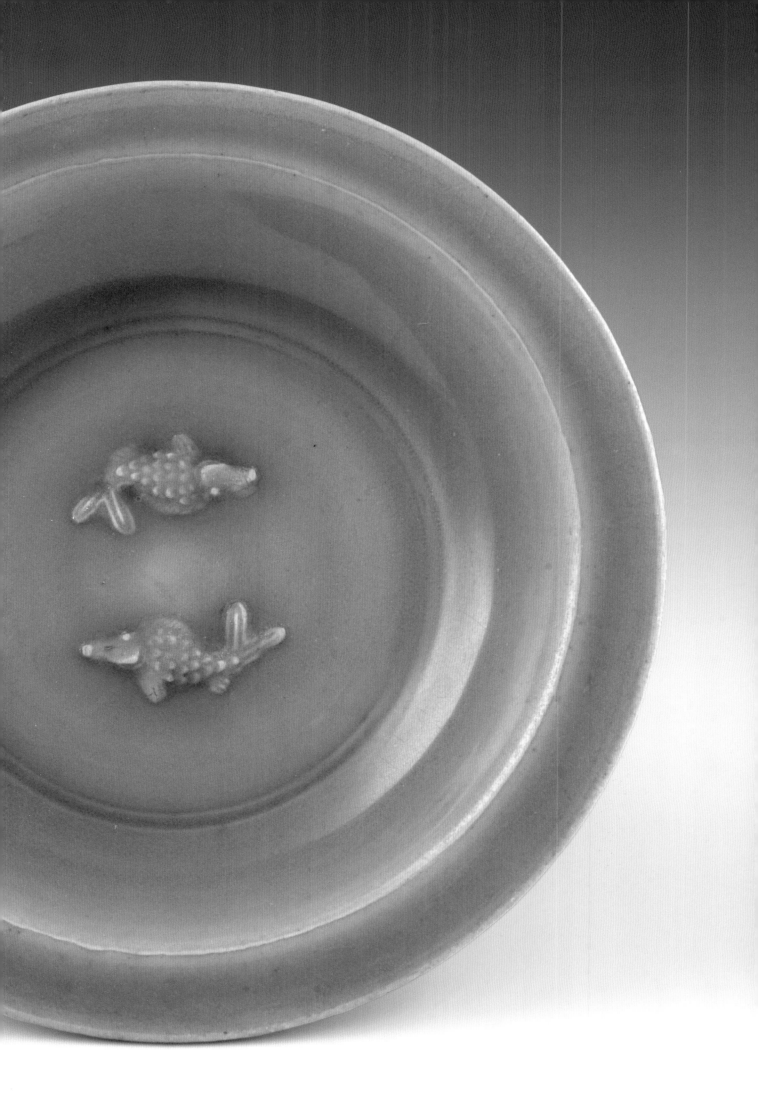

23.

元　龙泉窑折沿盘

Plate with folded edge of the Longquan kiln of Yuan

高3厘米　口径15.4厘米　足径4.3厘米　H:3cm　D:15.4cm

敞口，平沿，折腹，小圈足。胎灰白致密，施豆青色厚釉，口沿与折腹处釉薄透白，釉层均匀滋润，造型规整。圈足露胎，呈朱红色。

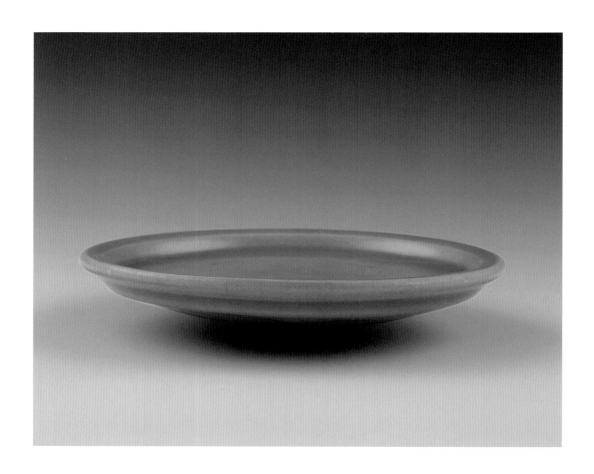

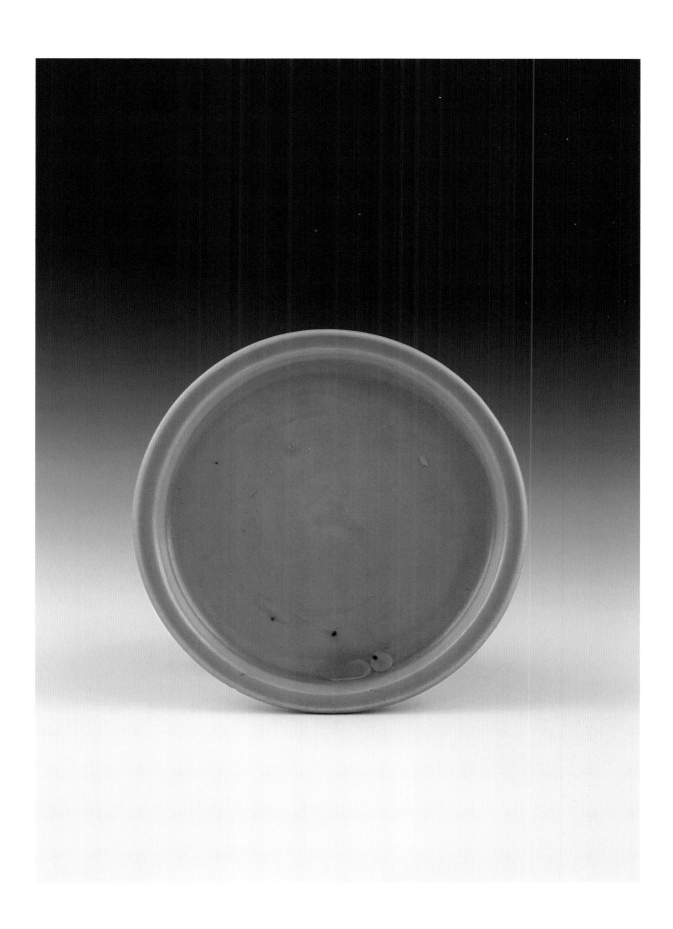

24.

元　龙泉窑兽蹄三足炉

Thurible supported by three hooves like feet of the
Longquan kiln of Yuan

高9厘米　口径27.3厘米　腹径30厘米　　H:9cm　D:27.3cm

　　束口平唇内卷，扁腹向内弧收，外腹壁与口部饰弦纹二条，中间有梅花鼓钉九个，腹壁凸饰八卦纹上部，后刻有"承志堂谢李芬公祠香炉"铭文，下腹壁饰弦纹二条，中间有梅花鼓钉七个，近底处装兽蹄足三个。内底印团花牡丹。胎灰白致密，施豆青釉，内、外底无釉处呈朱红色。造型规整，制作讲究。

　　承志堂：清末盐商汪定贵住宅，位于安徽省黄山市黟县（古徽州六县之一），建于咸丰五年（1855）。

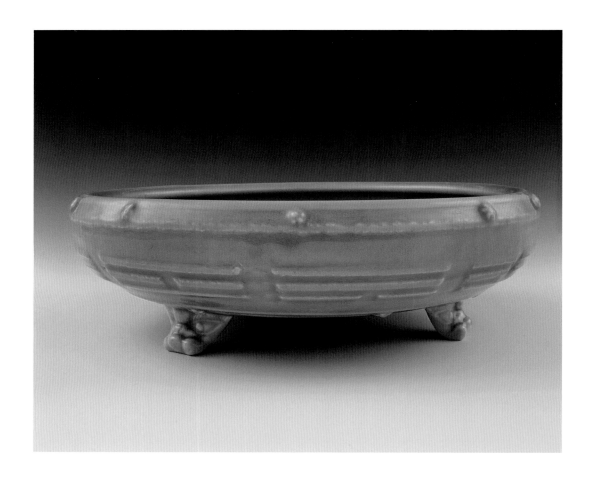

25

元末明初　龙泉窑葵口花卉纹扳沿大盘

Bit plate with folded edge and featured by sunflower shape of the Longquan kiln of Yuan

高9厘米　口径45厘米　足径23厘米　　H:9cm　D:45cm

　　葵口，扳沿，弧腹，圈足。盘口刻三十二个葵口，扳沿饰花卉纹一圈，内外壁分作十六莲瓣，刻缠枝牡丹纹十六组。内壁微凹，外壁、内底微凸，内底饰弦纹两圈、花树一棵。胎灰白坚致，施豆青釉，釉色浑厚温润。外底一圈露胎，呈朱红色。

　　（台北著名收藏家张允中先生旧藏）

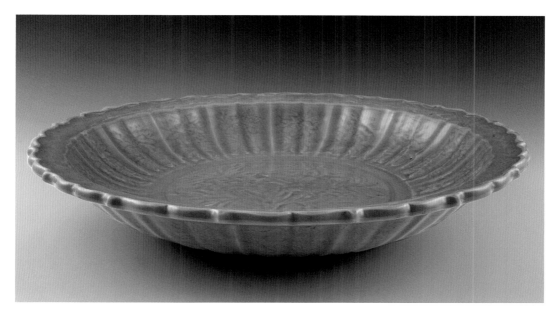

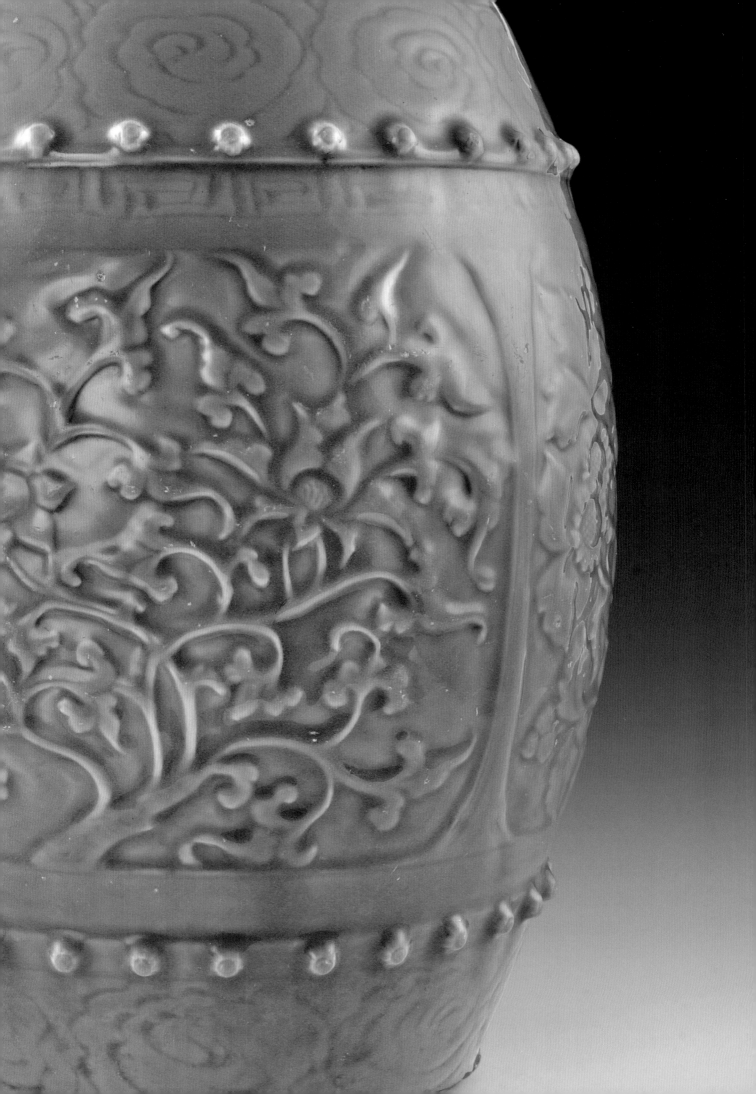

26.

明　龙泉窑刻花鼓凳

Drum stool with engraved floral patterns of the Longquan kiln of Ming

高46.5厘米　腹径33厘米　　H:46.5cm　D:33cm

　　鼓形，平面，腹部上下各有鼓钉纹一圈，凳面印古钱纹，腹部分三层，上、下层端印祥云纹、回纹，中部四面开光，分别刻折枝牡丹纹、菊花纹及枝叶各两对，形态各异，纹饰疏密有致。胎灰白厚重，施梅子青厚釉。

　　瓷座凳，宋时已烧制，据《陶说》载："宋学士王玮召对蕊珠殿，设紫花坐墩，命坐。"坐墩风行于明清两代，然而明清坐墩的显著不同之处在于：明代墩面普遍隆起，而清代均系平面。

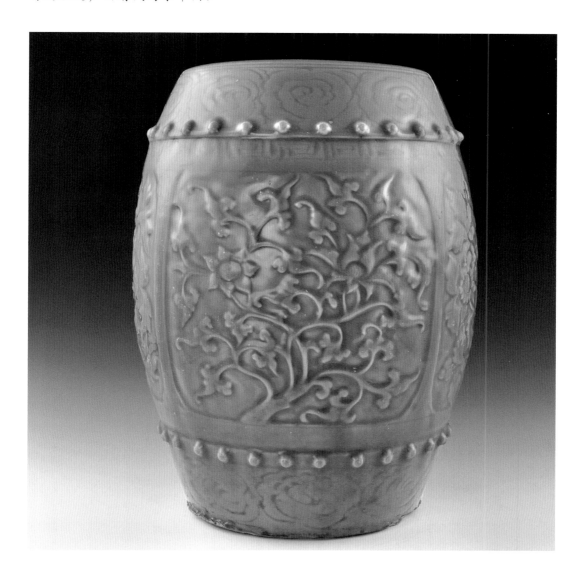

27.

明　龙泉窑刻花缠枝莲纹盖罐

Pot & cover with engraved lotus patterns of the Longquan kiln of Ming

通高10厘米　口径5.2厘米　足径5.1厘米　　H:10cm

　　宝珠形钮，圆盖，盖面微凸，盖内子口较高，斜肩，上腹鼓，下腹斜收，暗圈足。肩与腹刻缠枝莲花纹，莲花纹上、下刻两道弦纹，下腹刻菊瓣纹一圈。胎灰白致密，通体施青釉，釉面莹润不透明。盖内、罐口和圈足处无釉，呈红褐色。

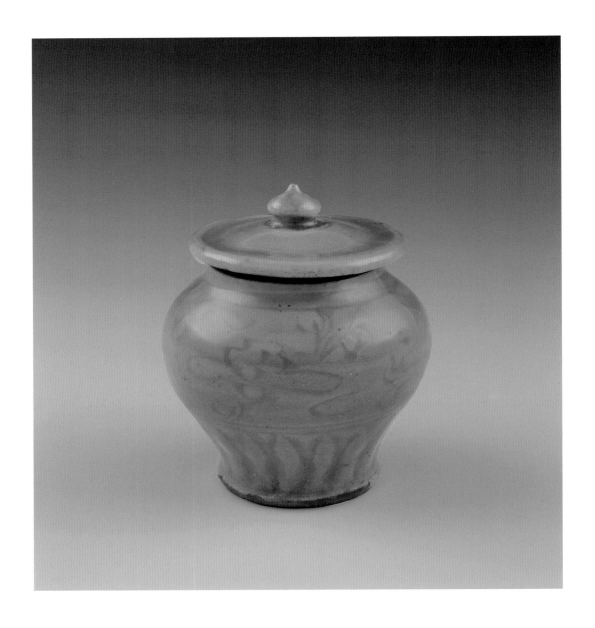

28.

明 龙泉窑笔架山龙首砚滴

Water dropper with dragon head of the Longquan
kiln of Ming

高13.5厘米 长15.6厘米 H:13.5cm L:15.6cm

　　该器以传说龙之九子中的"赑屃"（bìxì）为形而制。赑屃昂首张口，颈部饰有鳞片，中间三峰耸立，山峰内各饰两道人字形纹，形成"山"字形，尾部再饰山一座，构成三山五岳的宏伟造型。正面刻画高士、书童、树木、拱桥、水波纹，形态逼真，线条流畅，错落有致，勾勒出一幅高山流水觅知音的访友图。背面饰四道人字纹，山背镂一个圆形注水口，龙口为滴。整体器型较大，呈玄月状，造型稀有，刻画精细，胎质厚重，施豆青色厚釉，平底无釉，呈朱红色。

　　砚滴是古代文具，《饮流斋说瓷》有述"蟾滴、龟滴，由来已久。古者以铜，后世以瓷，明时有蹲龙、宝象诸状。凡作物形而贮水不多者则名曰'滴'"。龙泉窑砚滴为元代独有，有滴舟、鱼滴、童子牧牛等器型。

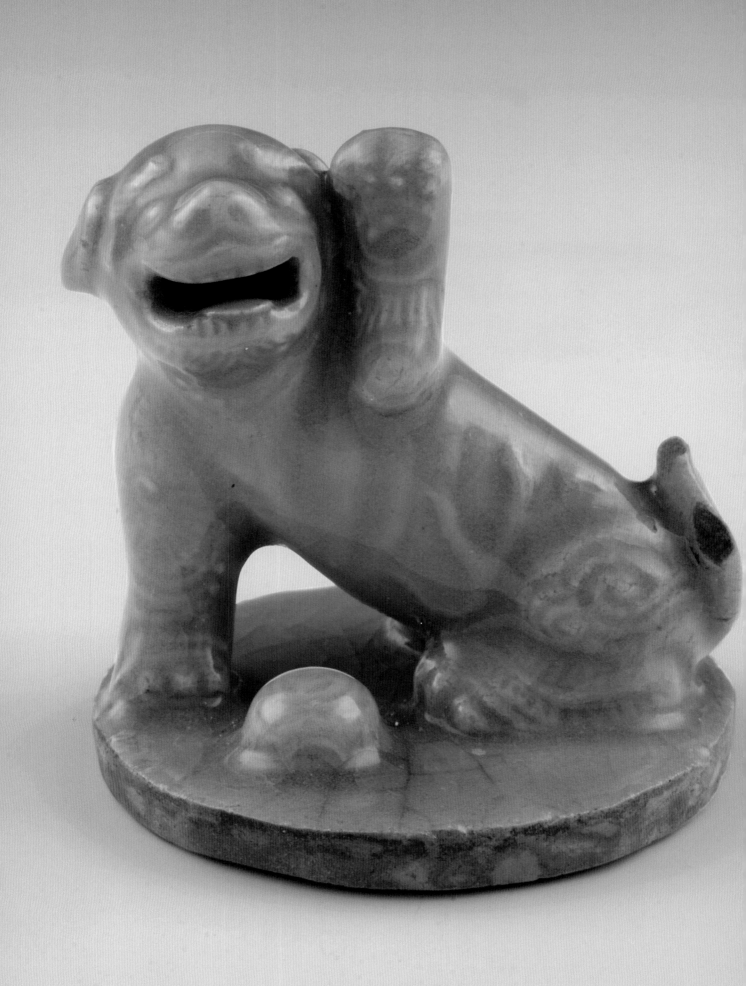

29.

明　龙泉窑带盖鼎式三足香炉

Ding shaped thurible with cover of the Longquan kiln of Ming

通高14厘米　口径9厘米　足径3.6厘米　　H:14cm

　　盖塑瑞兽狻猊（suān ní，龙之五子），张口大笑，前双足分别高举和伸直着地，足前塑方格纹钱球，后双足弯曲坐地，臀部短尾上翘，通体刻祥云等精美纹饰，造型生动活泼，栩栩如生。炉圆口，束颈，扁圆腹，下承兽蹄三足，颈肩附对称双耳外撇。胎灰白，施青釉，有开片，口沿与底部无釉，呈火石红色。

　　狻猊身有佛性，喜好香火，是文殊菩萨的坐骑，香炉盖上多见。五台山道场建有供奉狻猊的庙宇。

　　（台北著名收藏家张允中先生旧藏）

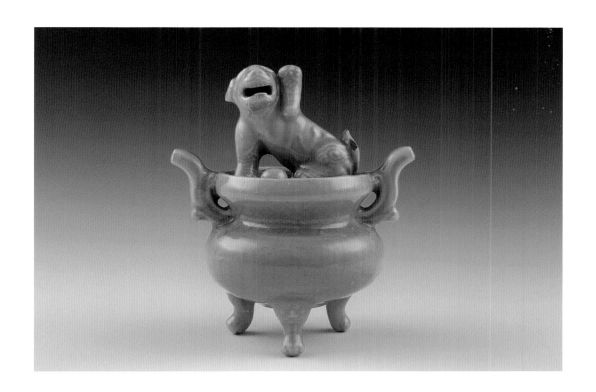

30.

明　龙泉窑大盘

Big plate of the Longquan kiln of Ming

直径52厘米　高10厘米　　H:10cm　D:52cm

　　敞口，圆唇，弧腹，平底，口腹分界分明，内底周一圈微凸。圈足较厚，胎白致密，施梅子青厚釉，釉色莹润，光素无纹，造型大气，外底一圈露胎，呈紫红色。

　　（台北著名收藏家张允中先生旧藏）

31.

明　龙泉窑菊瓣纹小盘

Small plate with chrysanthemum patterns of the
Longquan kiln of Ming

高3厘米 直径11.5厘米　H:3cm　D:11.5cm

　　十五个葵口，扳沿，浅腹，圈足。内、外壁分别用凹线或凸棱分成十五个菊瓣，内底印荷花二朵。胎体厚重，施青绿釉，外底、圈足无釉，呈火石红色。

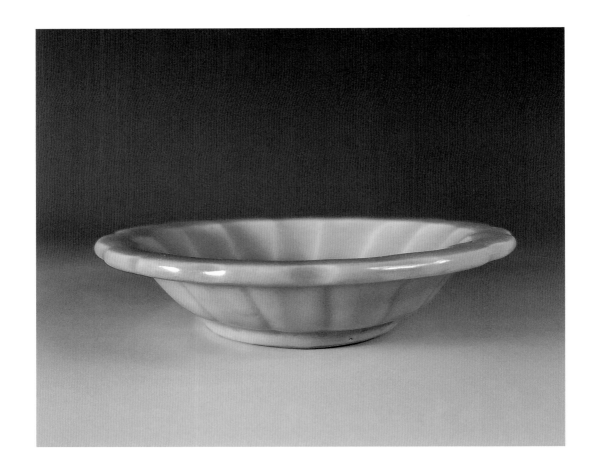

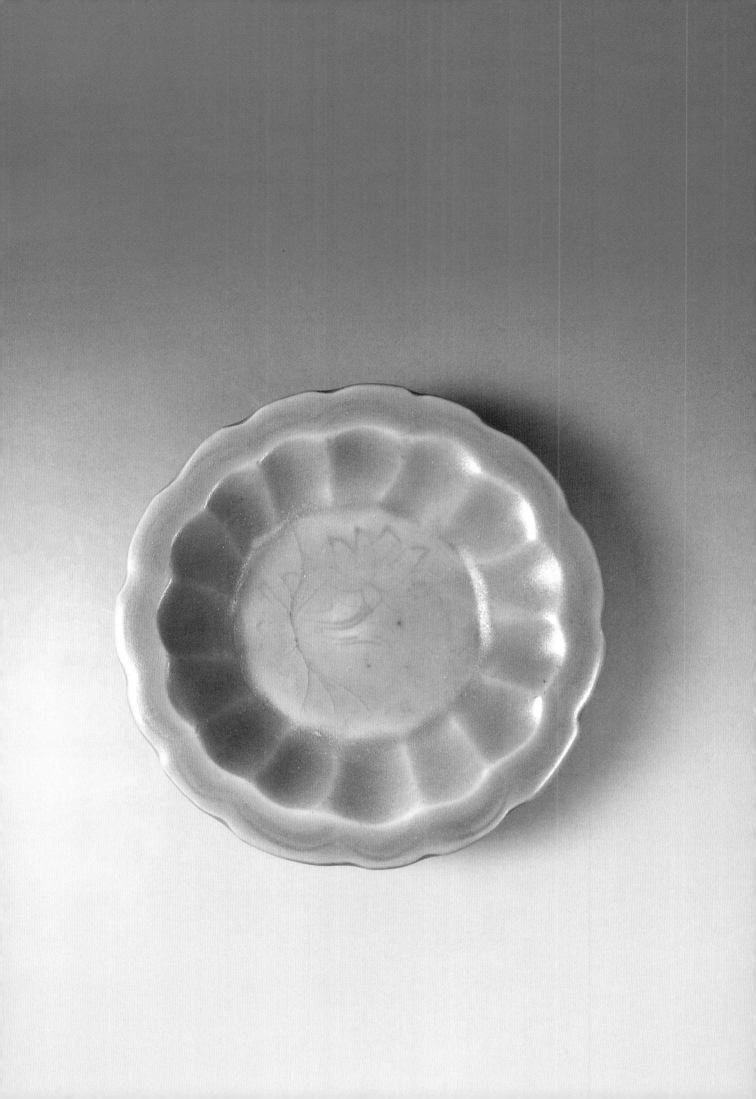

32.

明　龙泉窑刻花缠枝牡丹纹胆瓶

Vase with engraved peony patterns of the Longquan
kiln of Ming

高31.2厘米　口径6.8厘米　腹径13厘米　底径8厘米　　H:31.2cm

　　直口，圆唇外卷，长直颈，弧肩，圆鼓腹。颈、肩部饰两道弦纹，内填卷草纹，腹部刻牡丹纹和花叶各两朵。施青灰透明玻璃釉，釉层开片，呈"金丝铁线"。圈足无釉，呈红褐色。

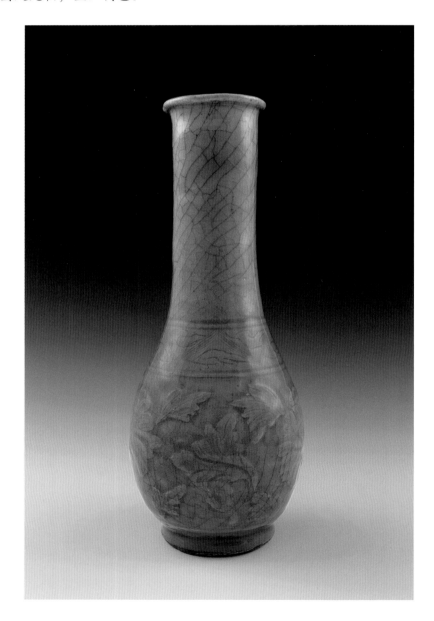

33.

明　龙泉窑刻花爵杯

Goblet with engraved floral patterns of the Longquan
kiln of Ming

高8.5厘米　口径4.5-5厘米　长11.8厘米　　H:8.5cm　L:11.8cm

　　敞口，口沿中间塑圆柱两颗，形似花生外壳，造型饱满。腹分成前、后、下三个部分，饰缠枝葵花纹，内填篦纹，刻画清晰，布局疏密有致，上腹近口沿饰弦纹一圈，下腹近足部饰鼓钉纹一圈，下承三柱足外撇。胎灰白，内外施青釉，足无釉，呈火石红色。

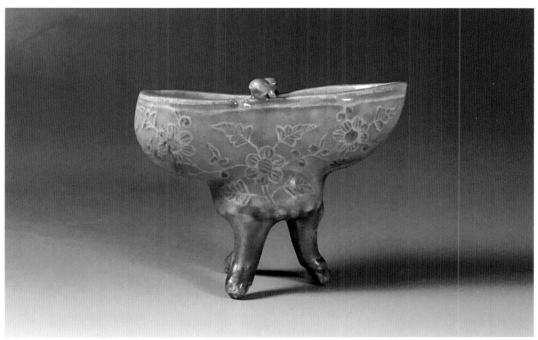

34.

明　龙泉窑刻花双耳鼎式炉

Ding shaped thurible with two standing handles and engraved floral patterns of the Longquan kiln of Ming

通高18.4厘米　口径19厘米　最大腹径22.5厘米　　H:18.4cm　L:22.5cm

直口平唇，颈内束，双立耳，鼓腹，下承三乳足外撇。口部、上腹部饰双线弦纹，颈部饰缠枝牡丹纹，腹部印网格纹，内填卷草纹。胎厚重，施青釉，底部无釉，呈朱红色。配精致红木盖、底座。

（台北著名收藏家张允中先生旧藏）

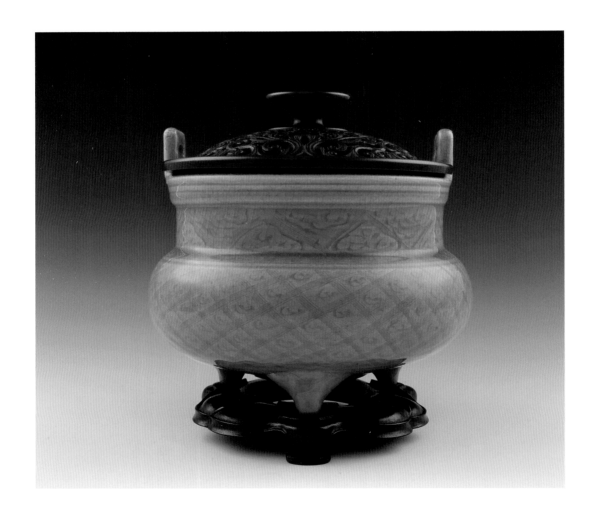

35.

明　龙泉窑骨盆

Basin of the Longquan kiln of Ming

高8厘米 口径18厘米 底径9厘米　H:8cm D:18cm

敞口，圆唇，盆壁斜收，腹中空，环形底。内底刻花卉一朵，内壁饰弦纹、如意祥云纹、水波纹，外壁刻菊瓣纹、弦纹、如意祥云纹。外底有一圆孔，胎灰白，施青釉，釉层开片，外底无釉，呈灰白色。

骨盆亦称"孔明碗、诸葛碗、暖碗"，始烧于北宋。可通过外底圆孔，注入开水，温暖碗内食物。

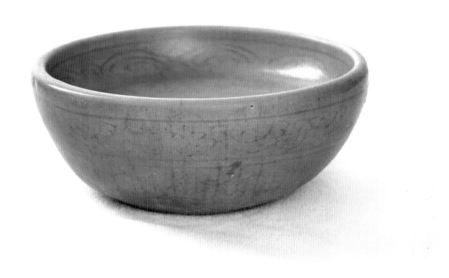

永恒的珍藏

程振墅

书画展品图版目录
Paintings Catalogue

1. 张熊　《墨梅图八屏》
Ink Plum in Eight Screens by Zhang xiong

2. 任伯年　《富贵大吉图轴》
Prosperity and Auspiciousness by Ren Bonian

3. 吴昌硕　《石鼓文轴》
Shiguwen Scroll by Wu Changshuo

4. 吴昌硕　《桃实图》
Peach Fruit by Wu Changshuo

5. 吴昌硕　《天竺图》
Guinea Grass by Wu Changshuo

6. 黄宾虹　《山水图》
Landscape by Huang Binhong

7. 黄宾虹　《江山卧游图四屏》
Landscape of Mountains and Waters
by Huang Binhong

8. 王福厂　《篆书对联》
Seal Character Couplet by Wang Fu'an

9. 弘一　《楷书对联》
Regular Script Couplet by Hongyi

10. 冯超然、吴湖帆　《书画成扇》
Fan of Calligraphy and Painting
by Feng Chaoran and Wu Hufan

11. 贺天健　《高士图轴》
The Noble Recluse Scroll by He Tianjian

12. 徐悲鸿　《立马图》
Standing Horse by Xu Beihong

13. 张大千　《凤凰女图》
Phoenix Girl by Zhang Daqian

14. 丰子恺　《行书七律诗》
Seven-line Poem in Cursive Handwriting
by Feng Zikai

15. 沙孟海　《书法》
Calligraphy by Sha Menghai

16. 费新我　《行书》
Cursive Handwriting by Fei Xinwo

17. 江寒汀　《花鸟图》
Painting of Flowers and Birds by Jiang Hanting

18. 张大壮　《网虾图》
Net Shrimp by Zhang Dazhuang

19. 张大壮　《秋菊图》
Autumn Helenium by Zhang Dazhuang

20. 张大壮　《蔬果图》
Vegetables and Fruits by Zhang Dazhuang

21. 陆抑非　《富贵牡丹图》
Peony by Lu Yifei

22. 来楚生　《行书》
Cursive Handwriting by Lai Chusheng

23. 陆俨少　《峡江帆影图》
Xiajiang Sails by Lu Yanshao

24. 陆俨少　《悬流飞翠图》
Waterfalls and Green Peaks by Lu Yanshao

25. 唐云　《行书》
Cursive Handwriting by Tang Yun

26. 唐云　《花鸟图》
Painting of Birds and Flowers by Tang Yun

27. 唐云　《荷花图》
Lotus by Tang Yun

28. 吴青霞　《鱼乐图》
Merry Fish by Wu Qingxia

29. 谢稚柳　《芙蓉青竹图》
Lotus and Bamboo by Xie Zhiliu

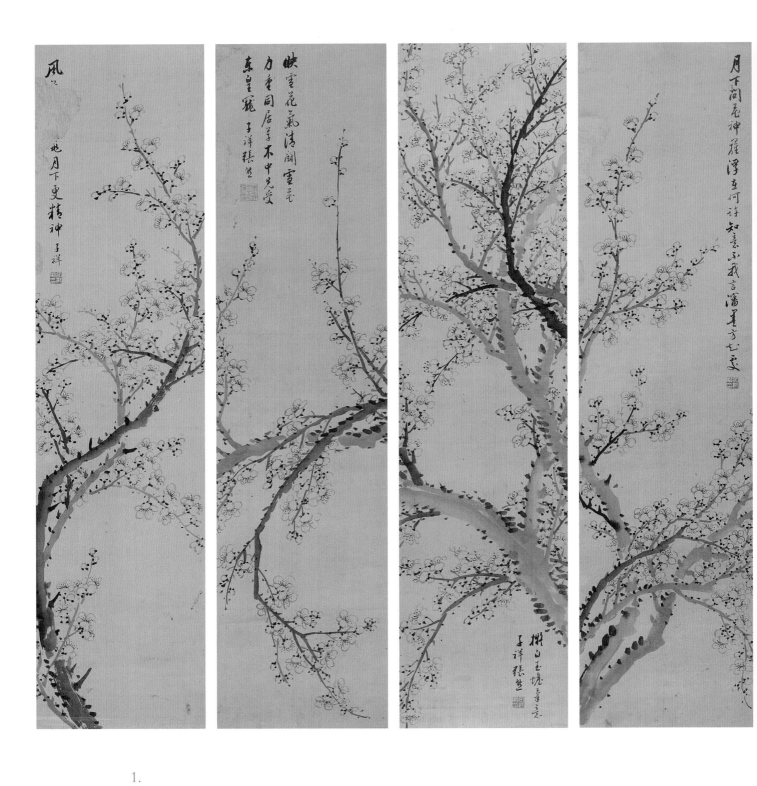

1.

张熊　《墨梅图八屏》

Ink Plum in Eight Screens by Zhang xiong

绢本，水墨，各纵83厘米，横21厘米　　　H:83cm　L:21cm

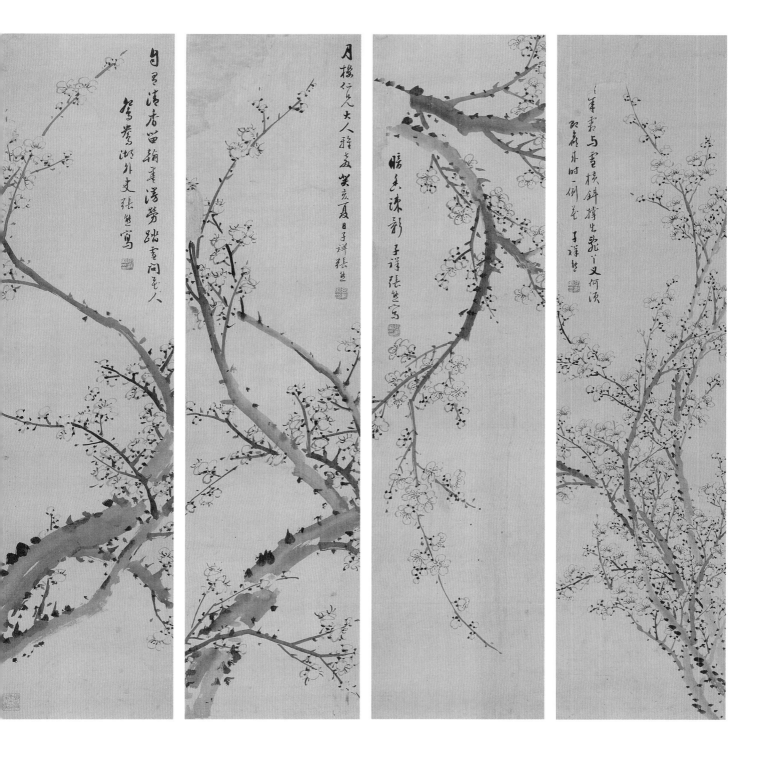

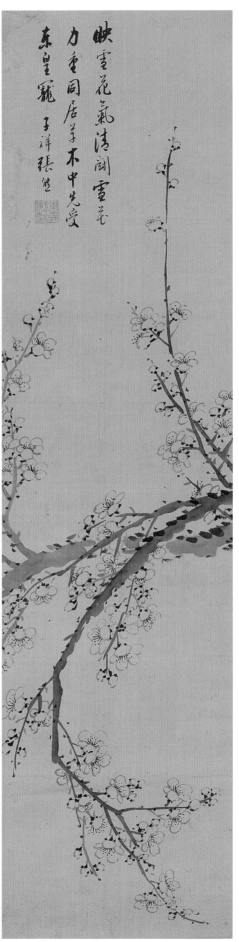

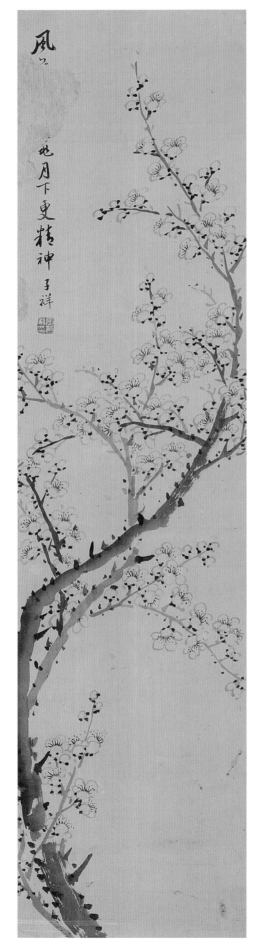

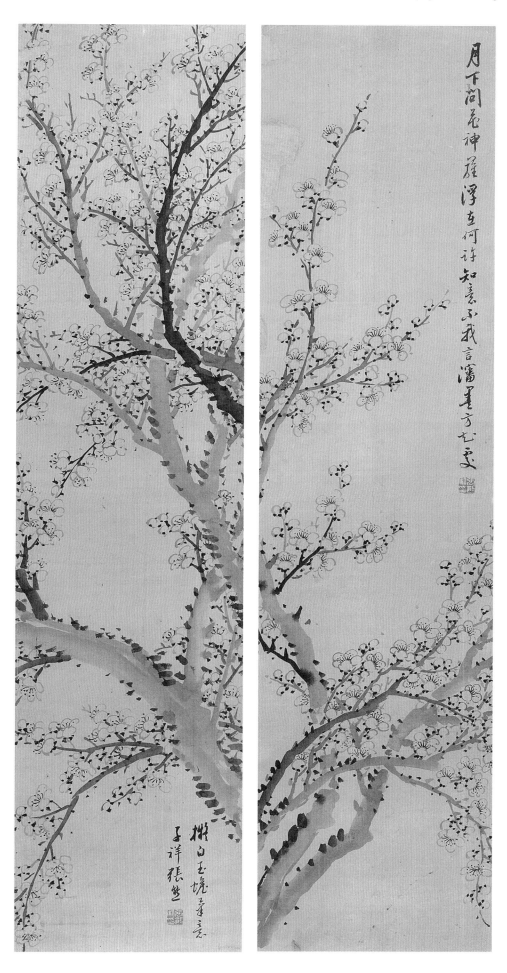

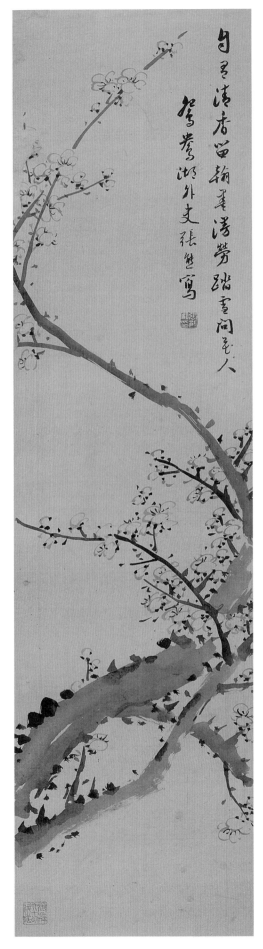
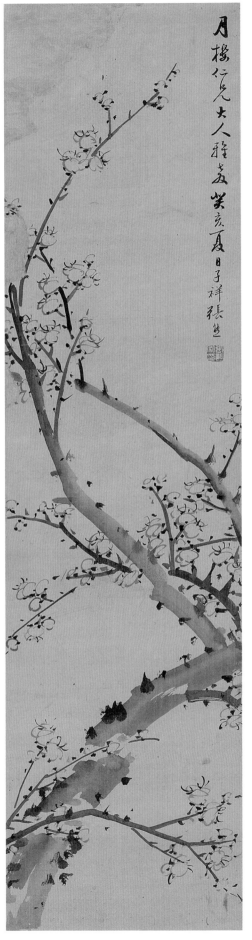

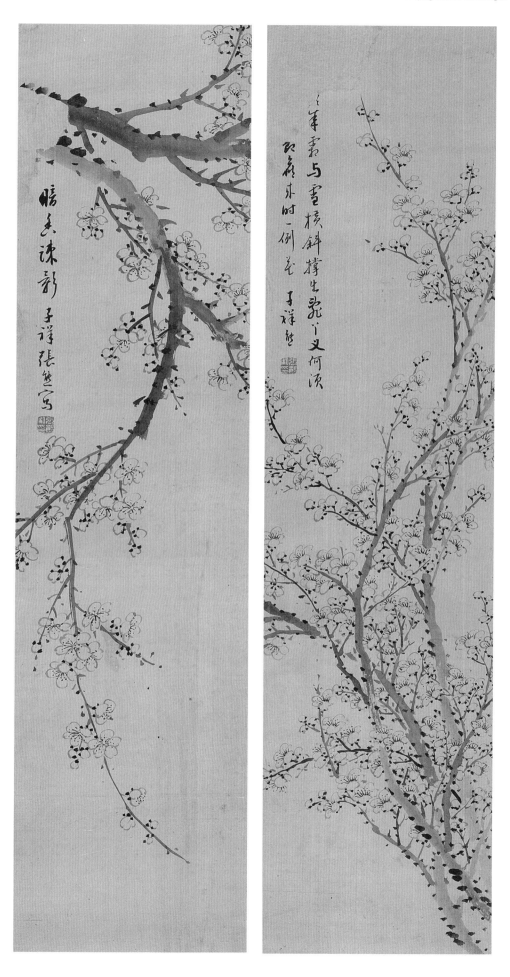

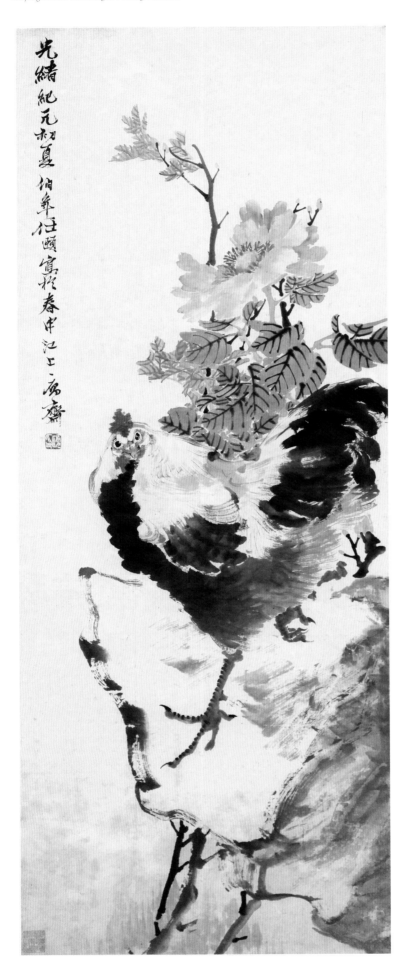

2.

任伯年　《富贵大吉图轴》
Prosperity and Auspiciousness
by Ren Bonian

纸本，设色，纵99厘米，横40厘米
H:99cm L:40cm

著名收藏家钱镜塘旧藏

3.

吴昌硕　《石鼓文轴》

Shiguwen Scroll by Wu Changshuo

纸本，水墨，纵133厘米，横45厘米
H:133cm　L:45cm

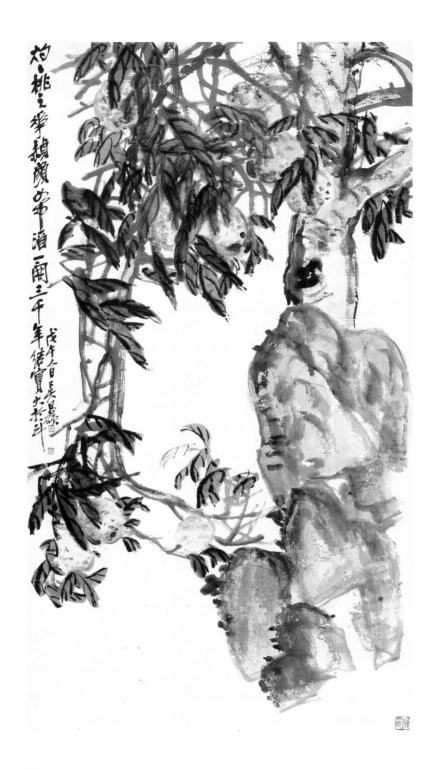

4.

吴昌硕 《桃实图》

Peach Fruit by Wu Changshuo

纸本，设色，纵153厘米，横84厘米　　　H:153cm　L:84cm

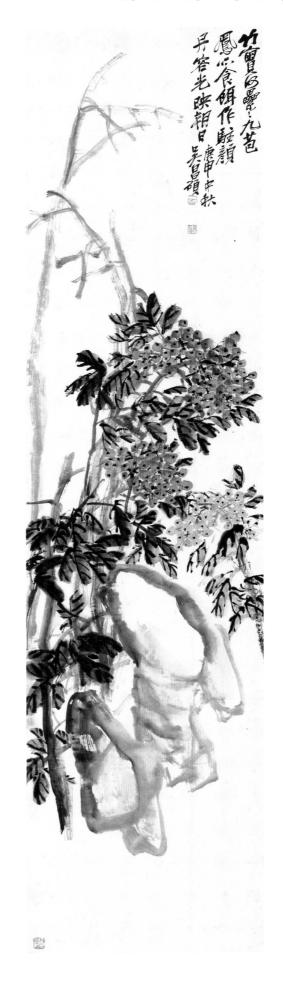

5.

吴昌硕　《天竺图》

Guinea Grass by Wu Changshuo

纸本，设色，纵143厘米，横35厘米
H:143cm　L:35cm

6.

黄宾虹　《山水图》

Landscape by Huang Binhong

纸本，设色，纵153厘米，横84厘米　　　H:153cm　L:84cm

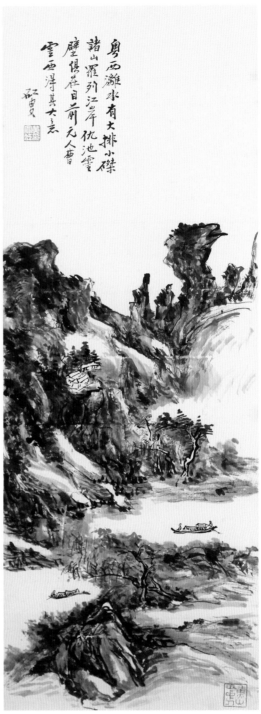

7.

黄宾虹　《江山卧游图四屏》

Landscape of Mountains and Waters by Huang Binhong

纸本，设色，各纵88厘米，横32厘米　　H:88cm L:32cm

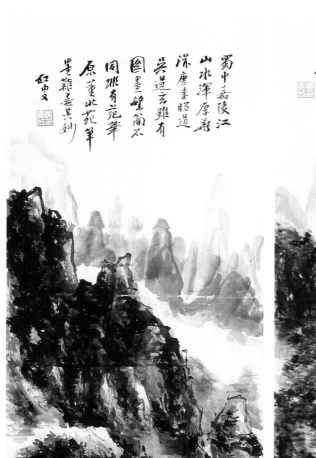

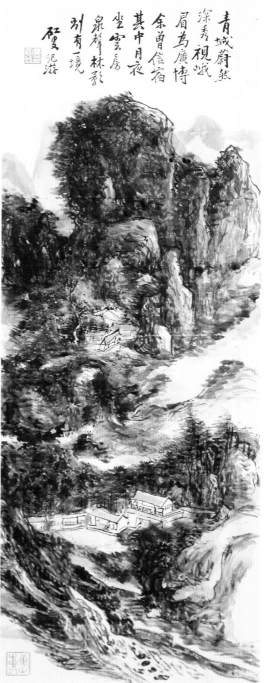

蜀中荔陵江
山水渾厚莽
滌盡李昭道
吳道玄雖有
圖墨二鯨簡太
同琳有苑華
原董此苑筆
墨難嘉其劉
　紅豆又

青城蔚然
深秀視峨
眉為廣博
余曾信宿
其中月夜
坐雲房
泉聲林影
別有一境
賀天健泥游

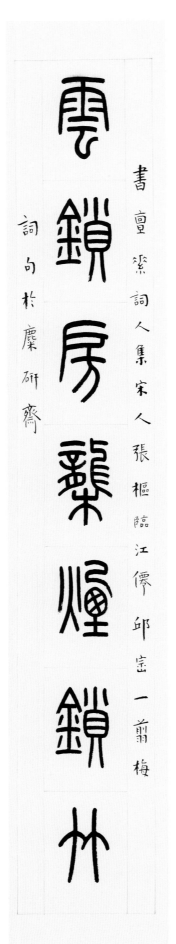

8.

王福厂 《篆书对联》

Seal Character Couplet by Wang Fu'an

纸本，水墨，各纵150厘米，横26厘米

H:150cm L:26cm

晉譯大方廣佛華嚴經初發心菩薩功德品頌集聯

頭盡未來普代法界一切眾生備受大苦

誓捨身命弘護南山四分律教久住神州

後二十手歲次鶉首書暮晉水證浮院沙門勝臂行書

9.

弘一 《楷书对联》

Regular Script Couplet by Hongyi

纸本，水墨，各纵108厘米，横11厘米
H:108cm L:11cm

10.

冯超然、吴湖帆 《书画成扇》

Fan of Calligraphy and Painting by Feng Chaoran and Wu Hufan

成扇，纸本，设色，各纵31厘米，横49厘米　　　H:31cm L:49cm

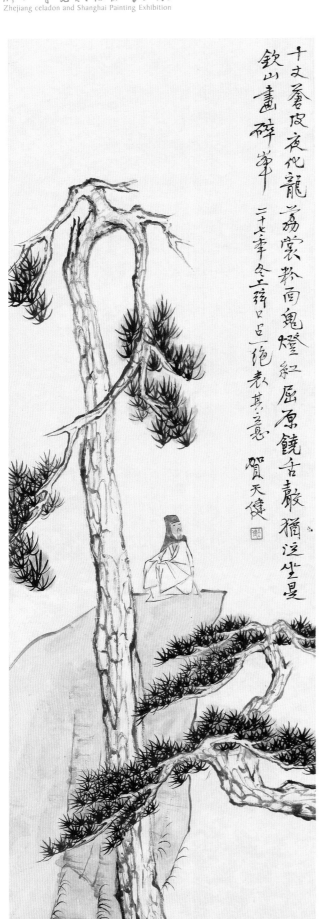

11.

贺天健 《高士图轴》

The Noble Recluse Scroll by He Tianjian

纸本，设色，纵105厘米，横34厘米

H:105cm L:34cm

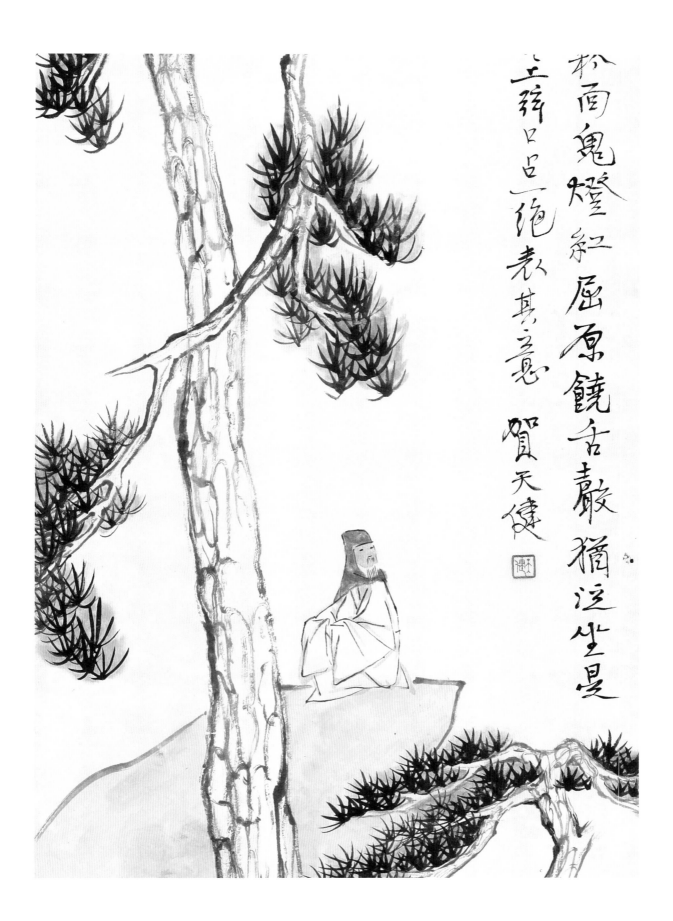

松而鬼燈紅 屈原饒舌巖猶泛坐閒
立禪口占一絕意表其意 賀天健

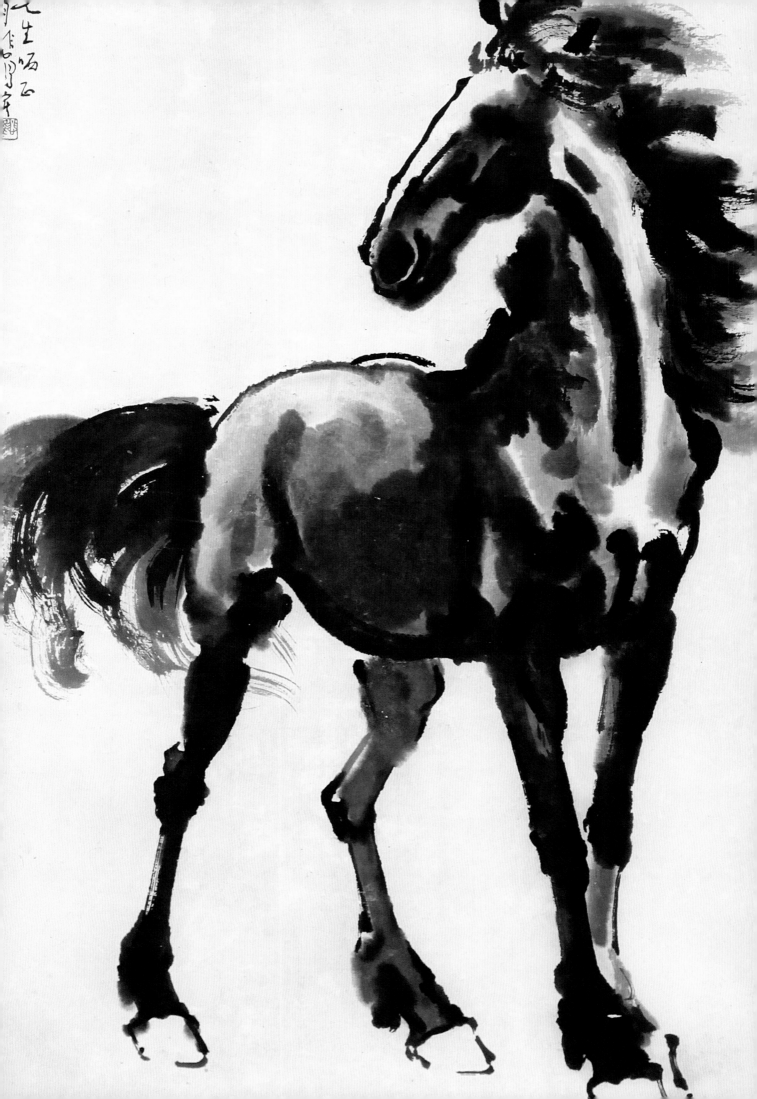

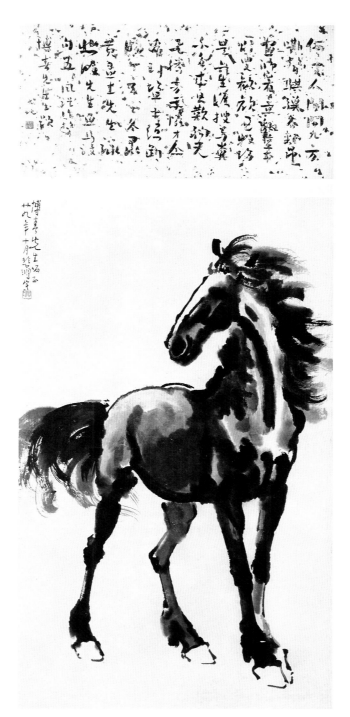

12.

徐悲鸿　《立马图》

Standing Horse by Xu Beihong

纸本，水墨，纵83厘米，横50厘米　　　H:83cm　L:50cm

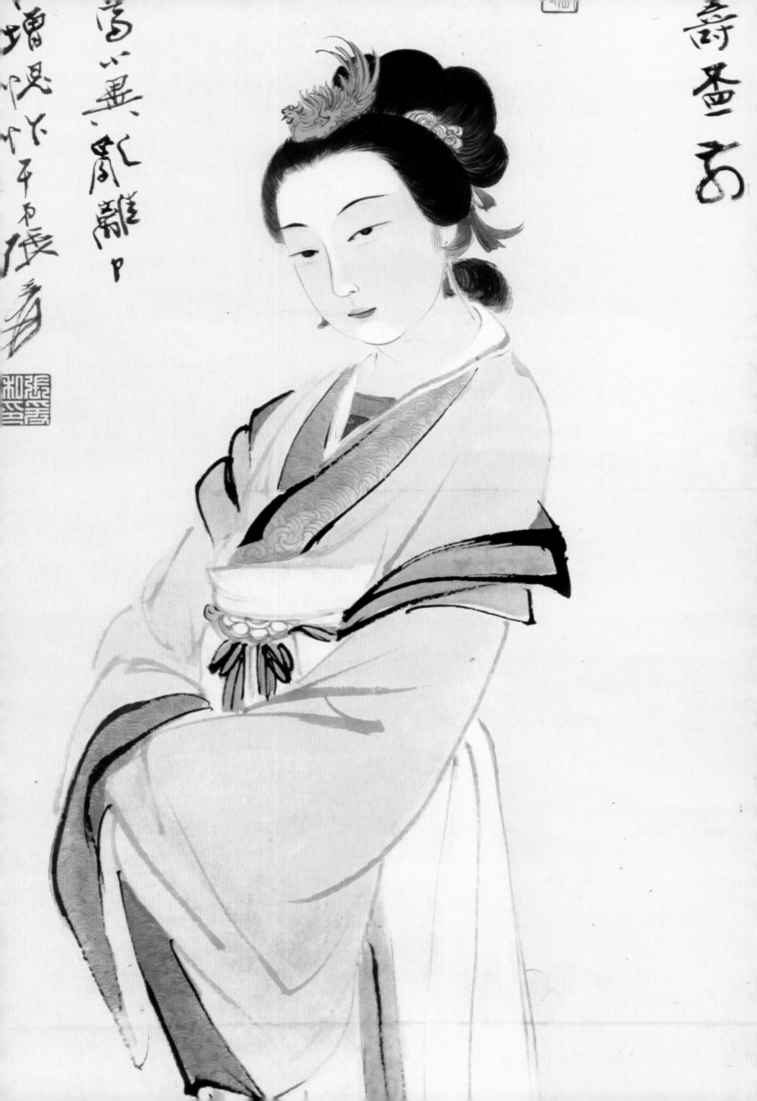

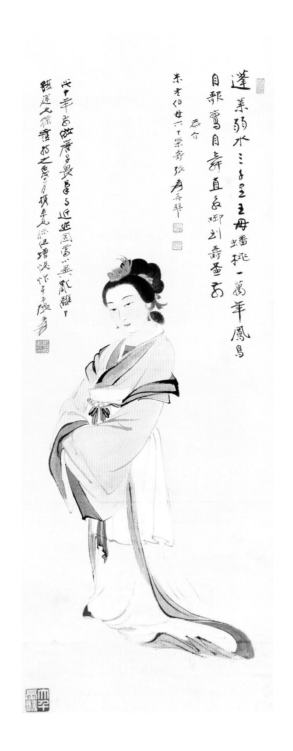

13.

张大千 《凤凰女图》

Phoenix Girl by Zhang Daqian

纸本，设色，纵99.5厘米，横35厘米　　H:99.5cm　L:35cm

澹烟空水對斜暉曲島蒼茫接翠微

上馬嘶看棹去柳邊人歇待船歸數叢

莎草群鷗散萬頃江田一鷺飛泣解來

舟尋花鯷五湖煙水獨忘機

旰彥先生 牧正

乙酉新正萬二日子愷書於閩中蔣氏

14.

丰子恺 《行书七律诗》

Seven-line Poem in Cursive Handwriting by
Feng Zikai

纸本，水墨，纵69厘米，横34厘米
H:69cm L:34cm

15.

沙孟海 《书法》

Calligraphy by Sha Menghai

纸本，水墨，纵181.5厘米，横45.2厘米
H:181.5cm L:45.2cm

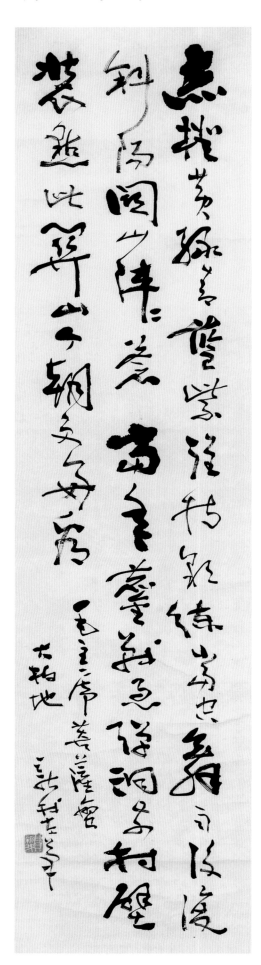

16.

费新我 《行书》

Cursive Handwriting by Fei Xinwo

纸本，水墨，纵138厘米，横39厘米
H:138cm L:39cm

17.

江寒汀 《花鸟图》

Painting of Flowers and Birds by Jiang Hanting

纸本，设色，纵160厘米，横44厘米
H:160cm L:44cm

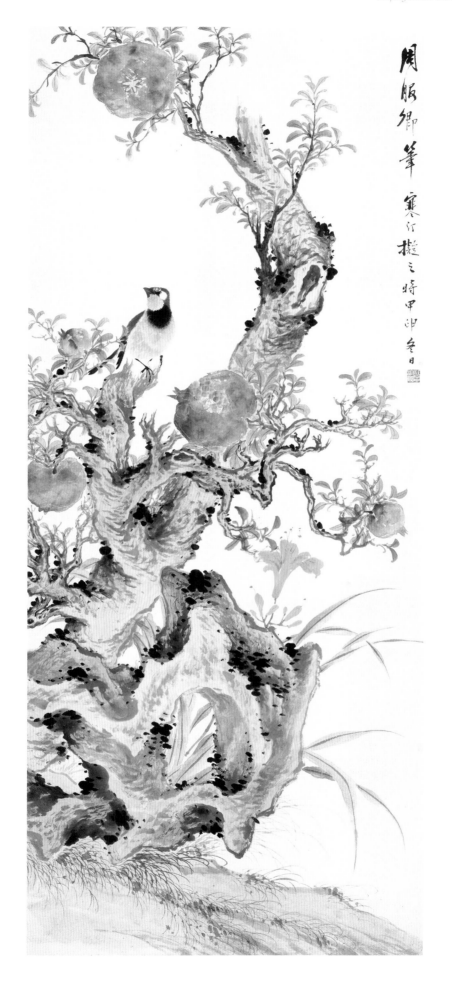

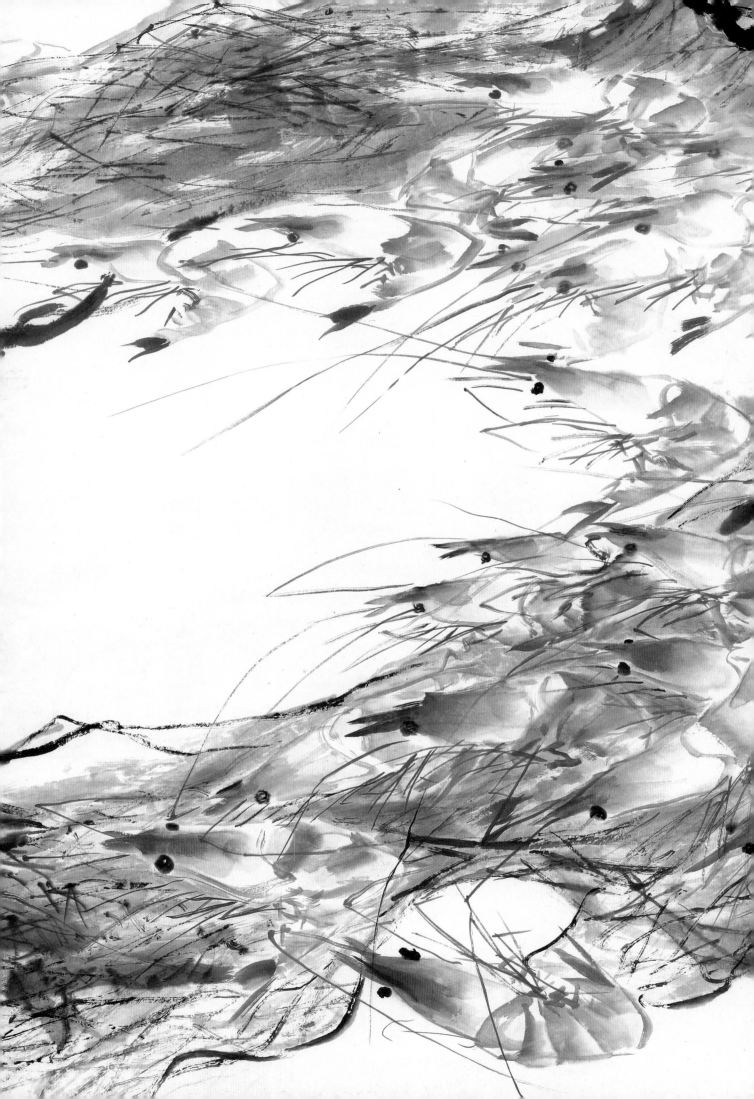

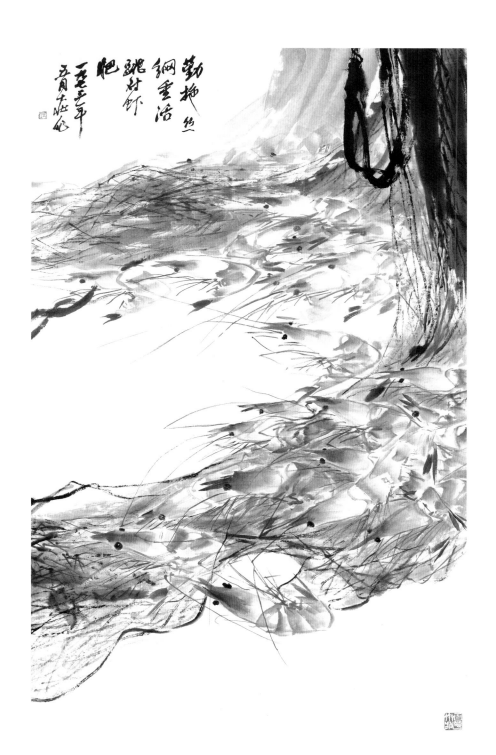

18.

张大壮 《网虾图》
Net Shrimp by Zhang Dazhuang

纸本，设色，纵107厘米，横67厘米　　　H:107cm L:67cm

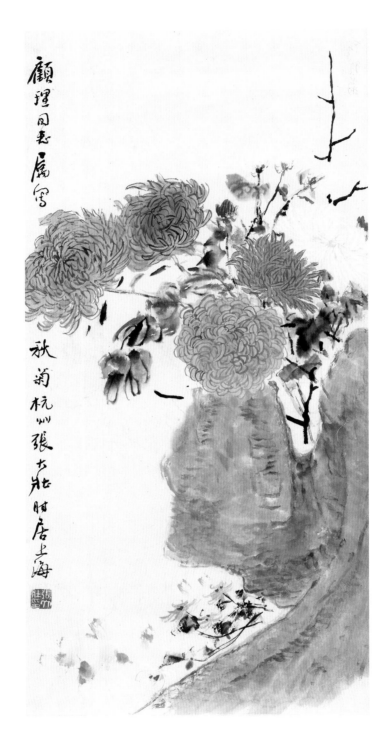

19.

张大壮 《秋菊图》

Autumn Helenium by Zhang Dazhuang

纸本，设色，纵68厘米，横34厘米　　H:68cm　L:34cm

20.

张大壮　《蔬果图》

Vegetables and Fruits by Zhang Dazhuang

纸本，设色，纵68厘米，横30厘米　　H:68cm　L:30cm

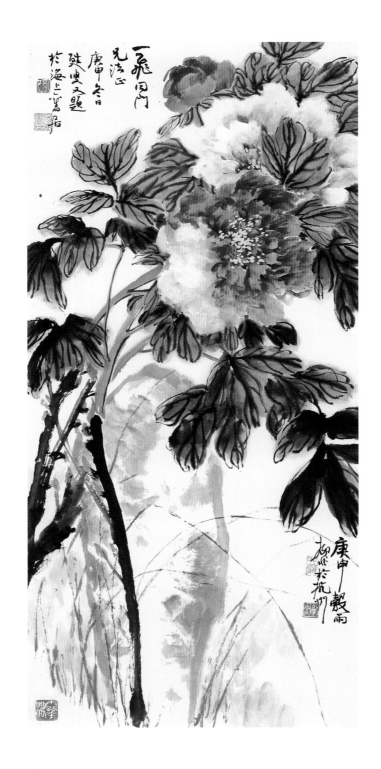

21.

陆抑非 《富贵牡丹图》

Peony by Lu Yifei

纸本，设色，纵97厘米，横45厘米　　H:97cm　L:45cm

千山鸟飞绝，万径人踪灭。孤舟蓑笠翁，独钓寒江雪

柳河东江雪一首为
黑陈井二月志书
一九七四年国萦甡

22.

来楚生 《行书》

Cursive Handwriting by Lai Chusheng

纸本，水墨，纵141厘米，横36厘米
H:141cm L:36cm

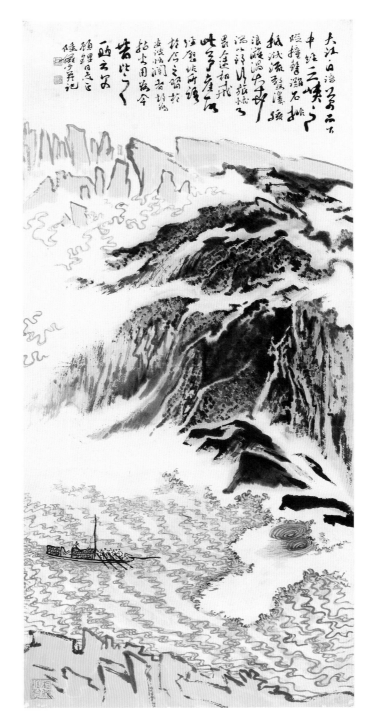

23.

陆俨少　《峡江帆影图》

Xiajiang Sails by Lu Yanshao

纸本，设色，纵98厘米，横46厘米

H:98cm L:46cm

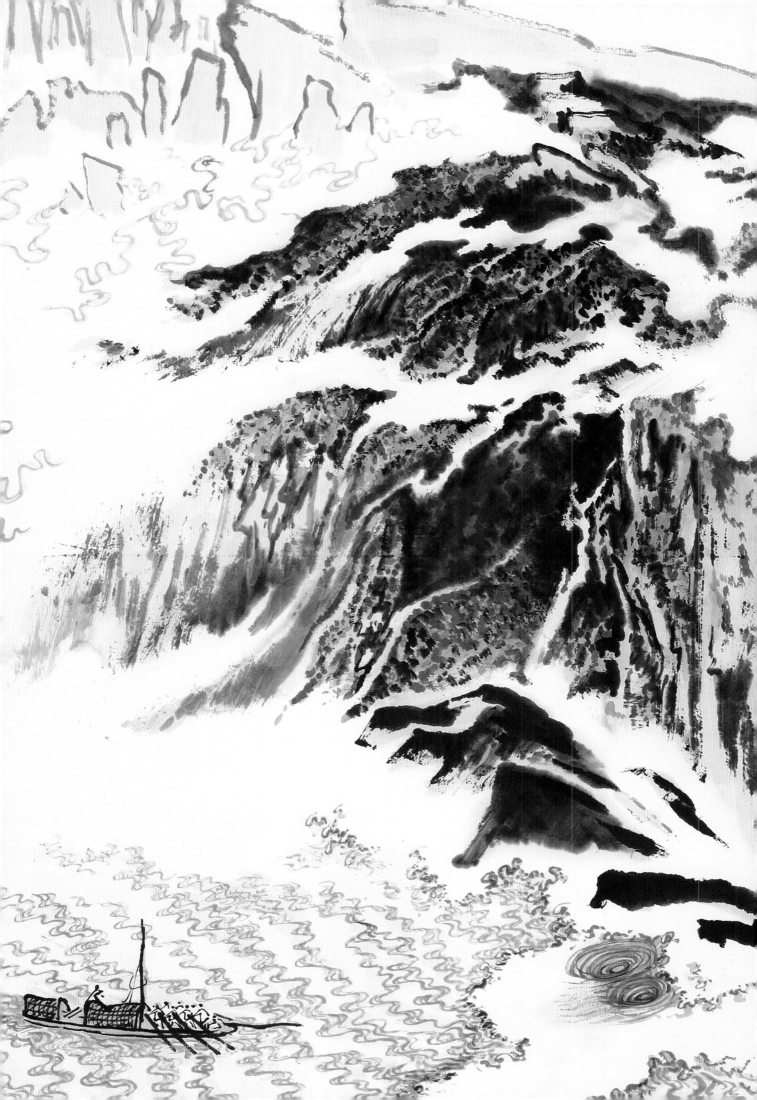

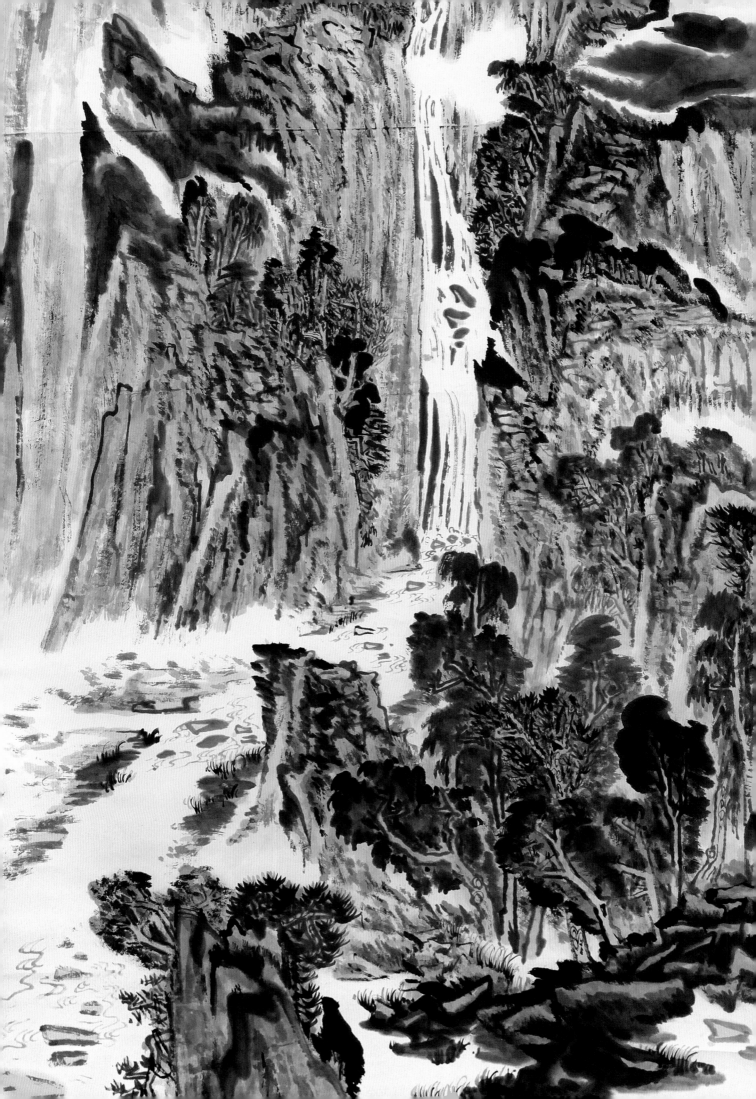

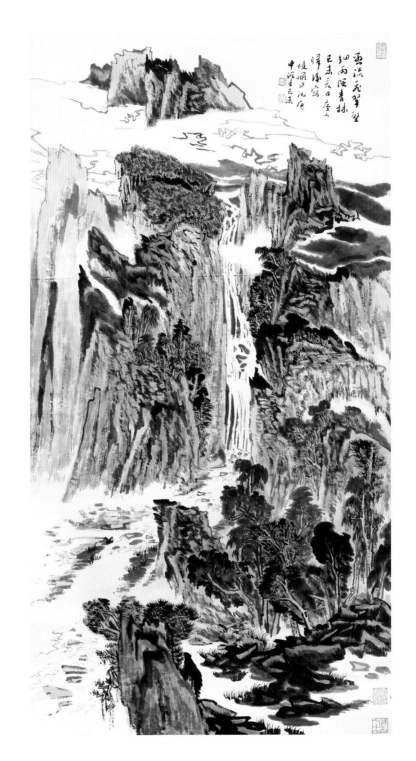

24.

陆俨少 《悬流飞翠图》

Waterfalls and Green Peaks by Lu Yanshao

纸本，设色，纵138厘米，横69厘米　　H:138cm L:69cm

25.

唐云 《行书》

Cursive Handwriting by Tang Yun

纸本，水墨，纵133厘米，横33.5厘米
H:133cm L:33.5cm

26.

唐云 《花鸟图》

Painting of Birds and Flowers by Tang Yun

纸本，设色，纵95厘米，横 48厘米
H:95cm L:48cm

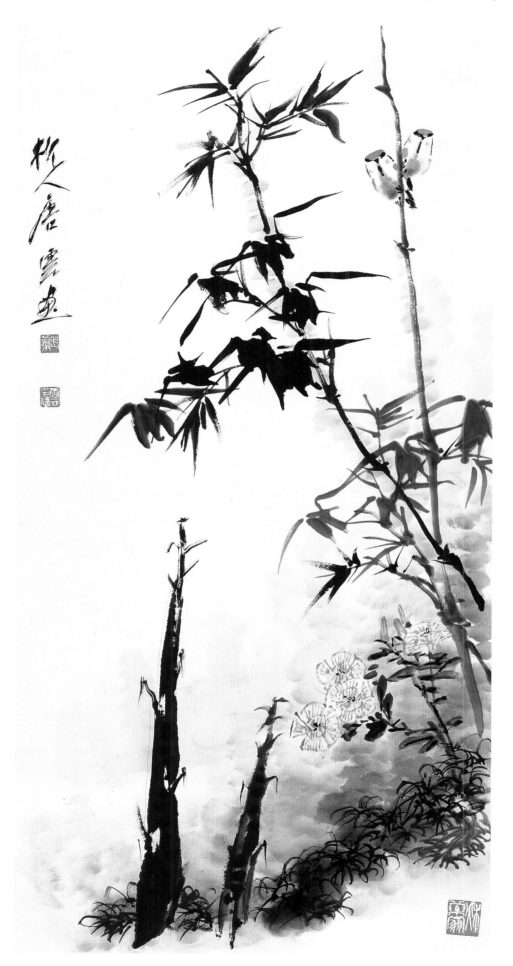

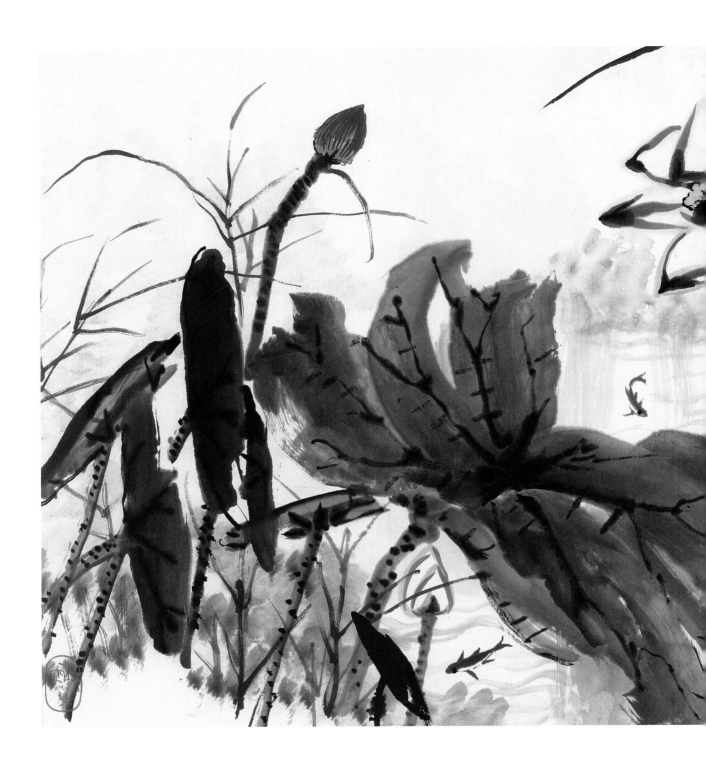

27.

唐云　《荷花图》

Lotus by Tang Yun

纸本，设色，纵67厘米，横136厘米　　H:67cm L:136cm

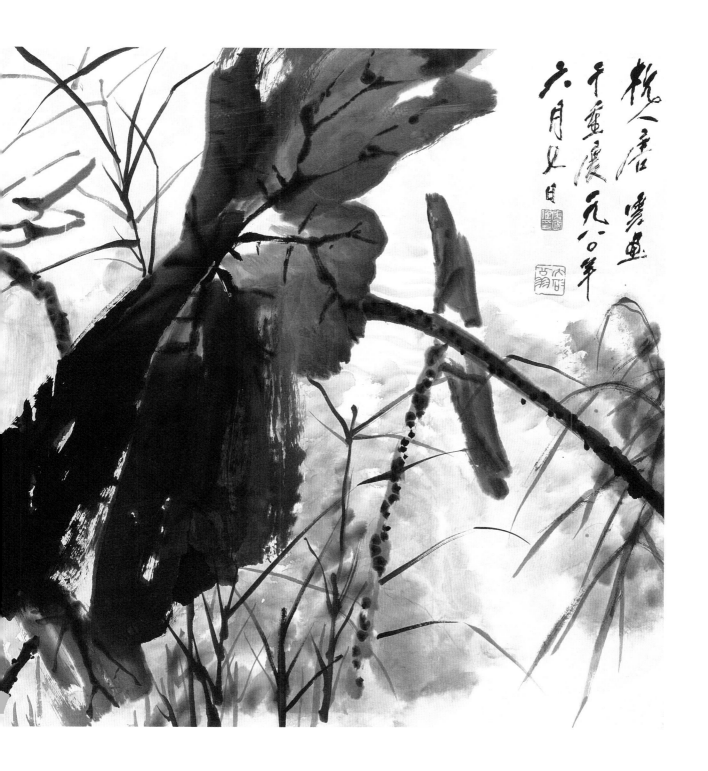

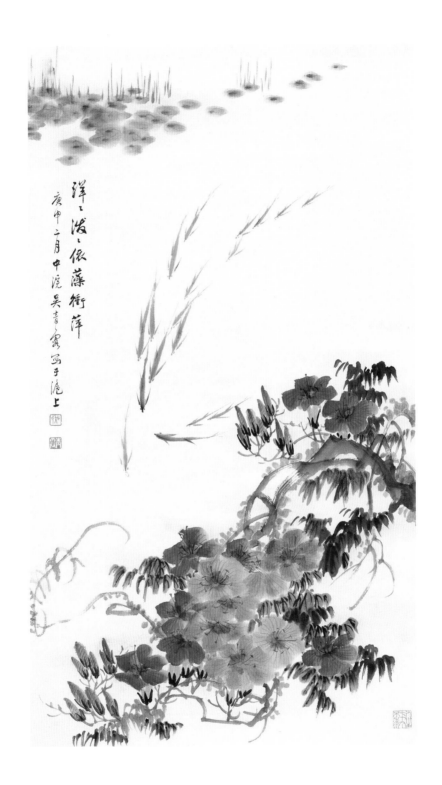

28.

吴青霞　《鱼乐图》

Merry Fish by Wu Qingxia

纸本，设色，纵90厘米，横49厘米　　H:90cm L:49cm

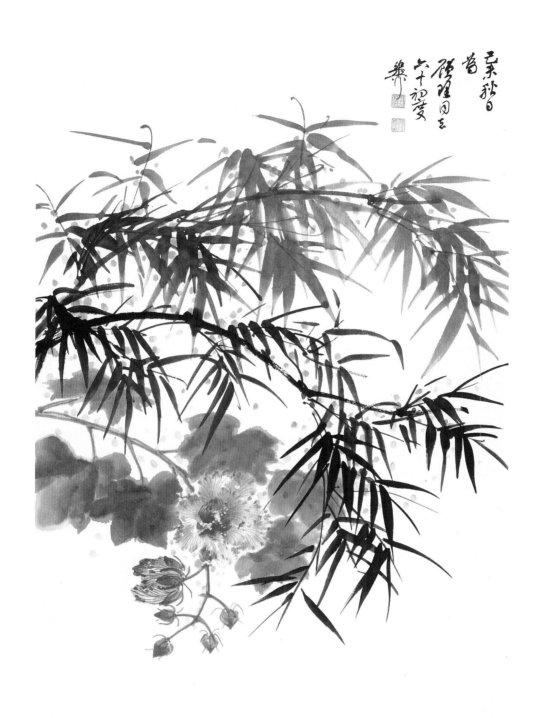

29.

谢稚柳 《芙蓉青竹图》

Lotus and Bamboo by Xie Zhiliu

纸本，设色，纵68厘米，横45厘米　　H:68cm　L:45cm

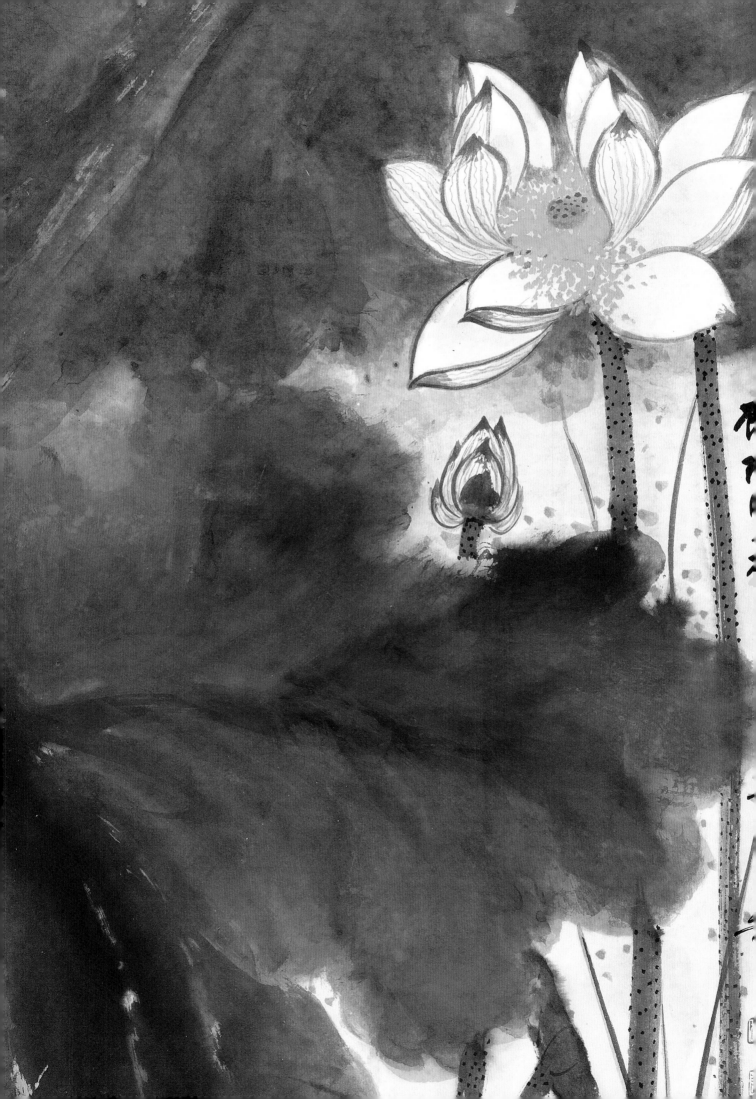

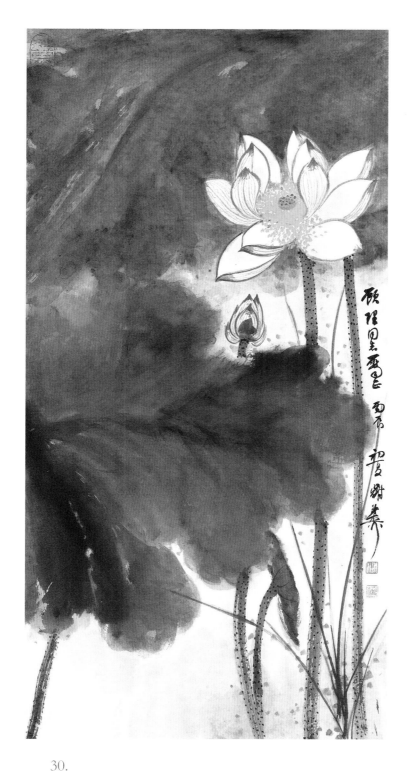

30.

谢稚柳　《荷花图》

Lotus by Xie Zhiliu

纸本，设色，纵77厘米，横38厘米　　H:77cm　L:38cm

尋插紫寒

村堰秋发日

不声中把兰

村声

猿臂于寻插紫垒霄雲端
雞犬見村墟秋兑日变地
銷日涼水声中把芸芸

纯茂月志程教
一九六四年夏 啟功

31.

启功 《行书七律轴》

Seven-line Poem in Cursive

Handwriting Scroll by Qigong

纸本，水墨，纵83厘米，横39厘米
H:83cm L:39cm

32.

应野平 《观瀑图》

View of Waterfall by Ying Yeping

纸本，设色，纵64厘米，横133厘米　　H:64cm L:133cm

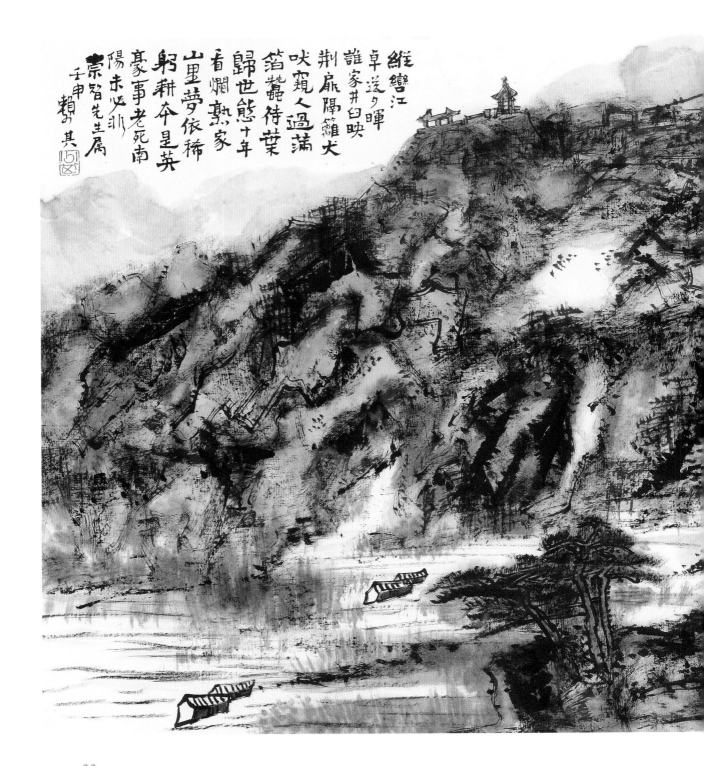

33.

赖少其 《山水图》

Landscape by Lai Shaoqi

纸本，设色，纵68厘米，横134厘米　　H:68cm L:134cm

34.

宋文治　《娄山关风景》

Loushan Guan by Song Wenzhi

纸本，设色，纵132厘米，横63厘米　　　H:132cm L:63cm

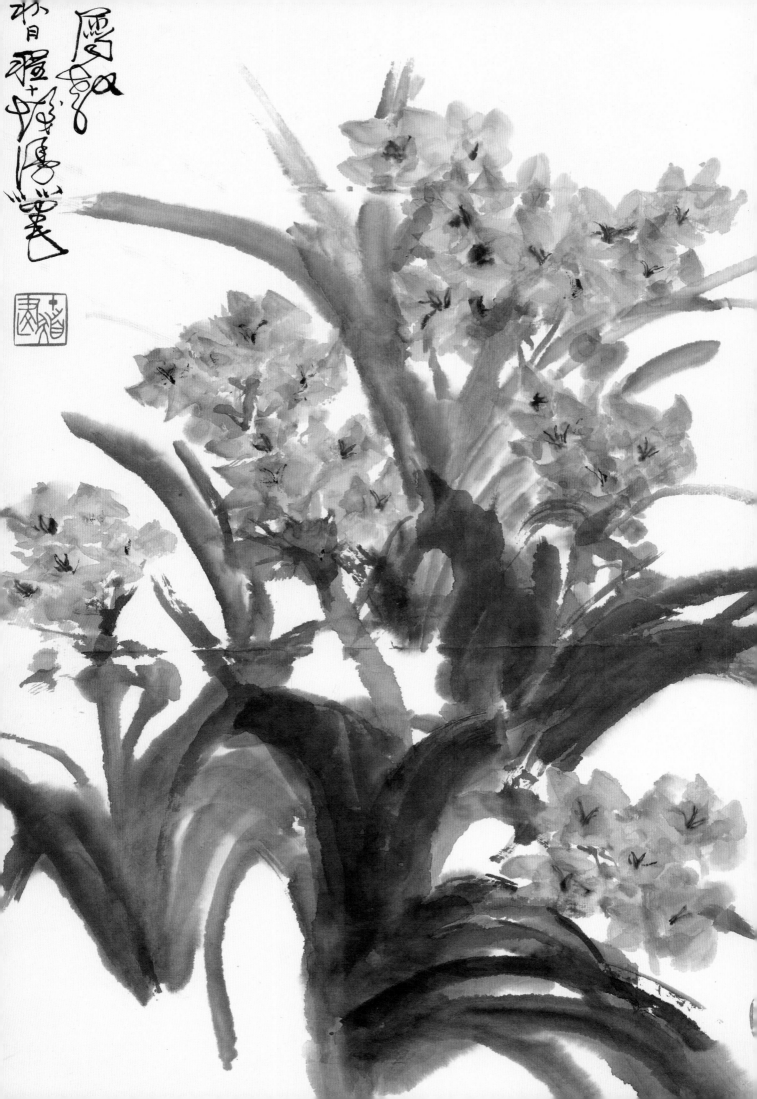

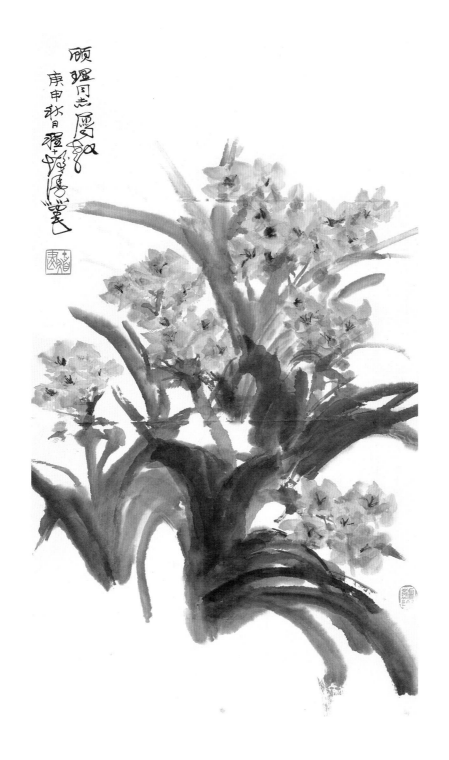

35.

程十发 《花卉》

Flower by Cheng Shifa

纸本，设色，纵88厘米，横47厘米　　H:88cm L:47cm

36.

程十发 《饲鹿图》

Feeding Dear by Cheng Shifa

纸本，设色，纵69厘米，横123厘米　　　H:69cm L:123cm

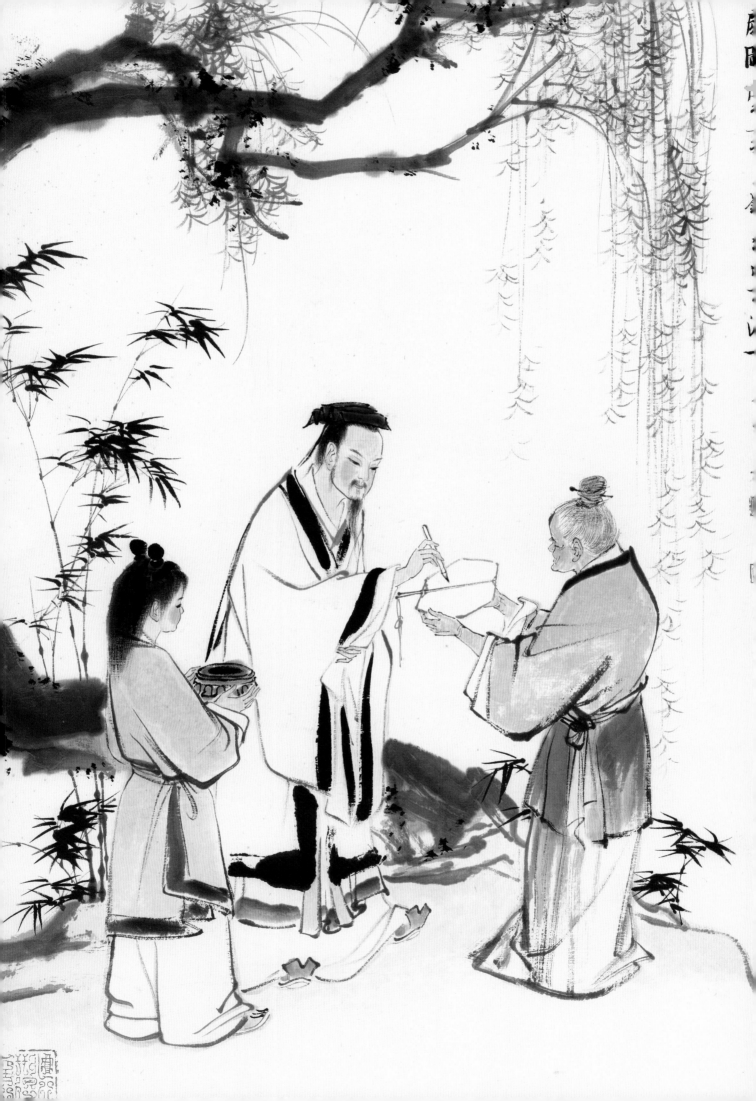

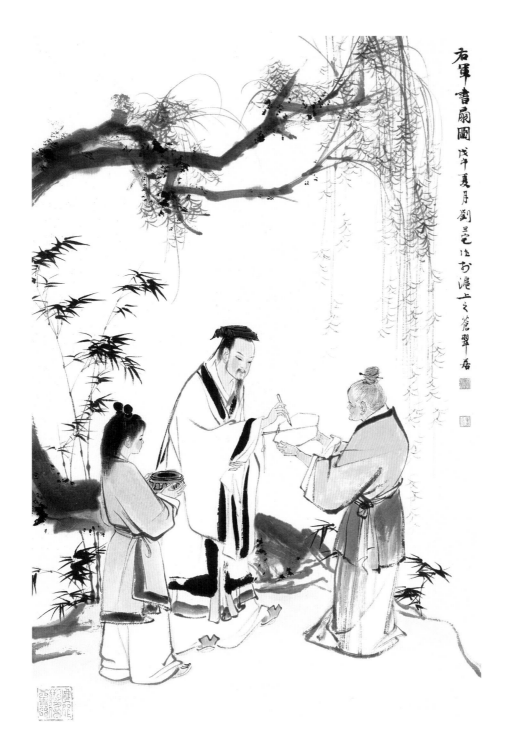

37.

刘旦宅　《右军书扇图》

Wang Xizhi Drawing A Fan by Liu Danzhai

纸本，设色，纵95厘米，横60厘米　　　H:95cm L:60cm

38.

钱行健 《秋树鸲鹆图》

Autumn Tree and Crested Myna by Qian Xingjian

纸本，设色，纵68厘米，横68厘米　　H:68cm　L:68cm

39.

钱行健　《翠竹双雀图》

Bamboo and Double Finches by Qian Xingjian

纸本，设色，纵68厘米，横68厘米　　H:68cm L:68cm

攜幼入室有酒
盈樽引壺觴以
自酌眄庭柯以
怡顏倚南窗以
寄傲審容膝之
易安園日涉以
成趣門雖設而
常關策扶老以
流憩時矯首而
遐觀雲無心以
出岫鳥倦飛而
知還景翳翳以
將入撫孤松而
盤桓歸去來兮

時曷不委心任
去留胡為遑遑
欲何之富貴非
吾願帝鄉不可
期懷良辰以孤
往或植杖而耘
耔登東皋以舒
嘯臨清流而賦
詩聊乘化以歸
盡樂夫天命復
奚疑

陶淵明歸去來辭
歲次庚寅大暑
周慧珺書於海上

40.

周慧珺　《行书归去来兮辞》

Homeward Bound Speech in Cursive Handwriting by Zhou Huijun

纸本，水墨，各纵36厘米，横35厘米　　　H:36cm　L:35cm

归去来兮田园
将芜胡不归既
自以心为形役
奚惆怅而独悲
悟已往之不谏
知来者之可追

实迷途其未远
觉今是而昨非
舟摇摇以轻飏
风飘飘而吹衣
问征夫以前路
恨晨光之熹微

乃瞻衡宇载欣
僮仆欢迎

请息交以绝游
世与我而相违
复驾言兮焉求
悦亲戚之情话
乐琴书以消忧
农人告余以春

及将有事于西
畴或命巾车或
棹孤舟既窈窕
以寻壑亦崎岖
而经邱木欣欣
以向荣泉涓涓

载奔僮仆欢迎

而姑流羡万物
之得时感吾生

歸去來兮田園將蕪胡不歸既自以心為形役奚惆悵而獨悲悟已往之不諫知來者之可追

實迷途其未遠覺今是而昨非舟摇摇以輕颺風飄飄而吹衣問征夫以前路恨晨光之熹微

乃瞻衡宇載欣
載奔僮僕歡迎
稚子候門三逕
就荒松菊猶存
攜幼入室有酒
盈樽引壺觴以

自酌眄庭柯以
怡顏倚南窗以
寄傲審容膝之
易安園日涉以
成趣門雖設而
常關策扶老以

流憩時矯首而遐觀雲無心以出岫鳥倦飛而知還景翳翳以將入撫孤松而盤桓歸去來兮

請息交以絕游世與我而相遺復駕言兮焉求悅親戚之情話樂琴書以消憂農人告余以春

及將有事於西

疇或命巾車或

棹孤舟既窈窕

以尋壑亦崎嶇

而經邱木欣欣

以向榮泉涓涓

而始流羨萬物

之得時感吾生

之行休已矣乎

寓形宇內復幾

時曷不委心任

去留胡為遑遑

歈俜之富貴非吾願帝鄉不可期懷良辰以孤往或植杖而耘耔登東皋以舒嘯臨清流而賦詩聊乘化以歸盡樂夫天命復奚疑

陶淵明歸去來辭

歲次庚寅大暑

周慧珺書於海上

画家简介
Artist introduction

张熊（1803—1886）

又名张熊祥，字寿甫，亦作寿父；号子祥，晚号祥翁，别号鸳湖外史、鸳湖老者、西厢客，别署清河伯子、鳔参军，室名银藤花馆。秀水（今浙江嘉兴）人。

最擅长画花卉，尤其善于画大幅的牡丹，屏山巨幛；花鸟、草虫、蔬果、人物、山水都很有功力。花鸟画初宗恽南田，后自成一家。色艳而不俗，作品雅俗共赏，富于时代气息，极受社会称赞，带动了一批画家，时称"鸳湖派"。与任熊、朱熊合称"海上三熊"。

任伯年（1840—1896）

初名润，字次远，号小楼，后改名颐，字伯年，别号山阴道上行者、寿道士等，以字行，浙江山阴航坞山（今杭州市萧山区瓜沥镇）人。

任伯年的绘画继承传统，融汇诸家之长，吸收了西画的速写、设色诸法，形成自己丰姿多采、新颖生动的独特画风。主要成就在于人物画和花鸟画方面，往往寥寥数笔，便能把人物整个神态表现出来，着墨不多而意境深远，其线条简练沉着，有力潇洒。与吴昌硕、蒲华、虚谷齐名为"清末海派四杰"。

吴昌硕（1844—1927）

名俊卿，字昌硕，又字苍石，别号缶庐、苦铁，又署老缶、大聋，七十岁以后字行，浙江安吉人。

吴昌硕是晚清著名画家，书法家，篆刻家，为"后海派"中的代表，杭州西泠印社首任社长。书法以石鼓文最为擅长，用笔结体，一变前人成法，力透纸背，独具风骨。篆刻初从浙、皖诸家入手，后专攻汉印，也受邓石如、吴让之、赵之谦等人的影响，上溯秦汉印，不蹈常规，钝刀硬入，朴茂苍劲，前无古人，成为一代宗师。自称三十学诗，五十学画。画初从赵之谦以及石涛、八大、陈淳、徐渭，运以金石书法入画。笔墨坚挺，气魄厚重，色彩浓郁，结构突兀，一笔一画，一枝一叶，无不精神饱满，有金石气。名满天下，日本人尤为崇拜，为之铸铜像，置西泠社中。著有《缶庐印存》《吴昌硕画集》多种。

黄宾虹（1865—1955）

原名懋质，改名质，字朴存、朴人，亦作朴丞、劈琴，1918年更字宾虹，别署予向、虹叟、黄山山中人等,室名宾虹草堂、滨虹草堂、佩训堂、片石居、青照台、水上鸿飞馆等，原籍安徽歙县，出生于浙江金华。

专攻山水，以新安派为宗，用笔如作篆籀，遒劲有力，六十岁以前是典型的"白宾虹"，其画作中年时苍浑清润，晚年尤精墨法，并在浓、焦墨中兼施重彩。所作画斑斓古艳，浑厚华滋，意境幽深。所谓"黑、密、厚、重"的画风，正是他逐渐形成的显著特色，这一显著特色也使中国的山水画上升到一种新的境界。间画花鸟草虫，亦奇崛有致，工篆籀及行书，古拙朴茂，饱含金石气。亦善刻印，宗秦汉。

王福厂（1879—1960）

名禔，初名寿祺，七十岁后自号持默老人，字维季，号福厂，浙江杭州人。因喜收集印章，自称印备，室名麋研斋。现代著名书法家、金石家。

工书，凡钟鼎、籀隶无不能。初从秦汉入手，旋深邃于浙派，兼及明清各家。前期创作面目众多，既有深厚苍劲如小松、曼生者，又有稳健茂密如让翁、悲庵者。四十岁以后，博采众长而逐渐形成自己的面貌，白文醇厚蕴藉，朱文秀逸圆劲，特别是铁线篆，凝练委婉，如洛神临波，嫦娥御风。王氏刻侧款，书体随印面字义而变，尽洗靡曼，独标清丽，集绵渺之思，有韶倩之致，书法造诣极深。

清末与丁仁等创设西泠印社，1920年由唐醉石推荐到北京，与唐氏一同供职于国民政府印铸局。1920年代即名震京华，王禔篆刻受到极大推崇，"中华民国国民政府印"及五院印铸，皆为王禔所篆。

弘一（1880—1942）

俗名李叔同，天津人。中国新文化运动的前驱，卓越的艺术家、教育家、思想家、革新家，是中国传统文化与佛教文化相结合的优秀代表，中国近现代佛教史上最杰出的一位高僧，又是国际上声誉甚高的知名人士。

他在音乐、美术、诗词、篆刻、金石、书法、教育、哲学、法学、汉字学、社会学、广告学、出版学、环境与动植物保护、人体断食实验诸方面均有创造性发展。在多个领域，开中华灿烂文化艺术之先河。他把中国古代的书法艺术推向了极至，"朴拙圆满，浑若天成"。他的书法早期脱胎魏碑，笔势开张，逸宕灵动，后期则自成一体，冲淡朴野，温婉清拔，特别是出家后的作品，更充满了超凡的宁静和云鹤般的淡远，这是绚烂至极的平淡、雄健过后的文静、老成之后的稚朴。

冯超然（1882—1954）

名迥，字超然，号涤舸，别署嵩山居士，江苏常州人。

早年精仕女，晚年专攻山水，工行草篆隶，偶刻印。山水师法"四王"，上追元人神韵，笔墨醇雅洒脱。花卉、人物，取法仇英、唐寅，神形兼备。善书法、能制印，通诗词。与吴湖帆、吴待秋、赵叔孺并称"海上四大家"；与吴湖帆、吴待秋、吴子深在上海画坛有"三吴一冯"之称，为沪上画坛之大家。

贺天健（1891—1977）

原名骏，字炳南，别名健叟，别署健父、阿难等，江苏无锡人。

幼年喜欢绘画，早年通过实地写生，领悟画理，善用水墨，层层尽染，沉厚匀满，设色讲究层次，多用复色。尤长于青绿山水。他的山水画功力深厚，法度谨严，出入传统画法，颇得"宋人格律，元人笔意"，而能自创新境。画风崇尚清代吴渔山、梅瞿山，并演变而自成一格。

出版有《贺天健画集》《贺天健山水册》等，著有《学山水画过程自述》一书。

吴湖帆（1894—1968）

名倩，本名万，又号倩庵，字通骏、东庄，别署丑簃、翼燕，书画署名湖帆，斋名梅景书屋。江苏苏州人，与冯超然、吴待秋、吴子深在上海画坛有"三吴一冯"之称，为沪上画坛名家，集绘画、鉴赏、收藏于一身。

他擅画没骨荷花，婀娜绰约，创有新格。山水画风秀丽丰腴，清俊雅逸，设色深具烟云缥缈、泉石洗荡之致，在传统技法上有发展，初从清初"四王"入手，继对明末董其昌下过一番功夫，画风丕变，受宋董源、巨然、郭熙等影响，骨法用笔，渐趋凝重。

徐悲鸿（1894—1953）

原名寿康，别署神州少年、江南布衣、江南贫侠、黄扶、东吴王孙，室名应无庸议斋、无枫堂，江苏宜兴屺亭镇人。

书法曾师从康有为，学北碑及造像石刻，所作行楷，结体似疏时茂，笔画婀娜而含刚劲；喜作行草，超脱奔放，转折有度，调高韵远。绘画倡导中西结合，融会古今，所作人物、山水、花卉、鸟兽无不落笔有神，尤擅长画马，冠绝古今，是中国现代美术的奠基者。

1949年后任中央美术学院院，1953年因病去世，夫人廖静文女士将他的一生节衣缩食收藏的唐、宋、元、明、清及近代著名书画家的作品1200余件，图书、画册、碑帖等一万余件，全部捐献给国家。次年，徐悲鸿故居被辟为徐悲鸿纪念馆，集中保存展出其作品，周恩来总理亲自题写"悲鸿故居"匾额。

丰子恺（1898—1975）

原名润，浙江崇德石门湾人。我国现代著名画家、散文家、美术教育家、音乐教育家、漫画家、书法家、翻译家，是一位多方面卓有成就的文艺大师。

早年曾从李叔同学习绘画、音乐。绘画风格独特，注重小、巧、精、秀、拙，表现出真情、真趣，若孩童般的天真、自然。作品内涵深刻，耐人寻味，取材多是人世间的辛酸事，作品影响很大，深受人们的喜爱。

历任上海文史馆馆员、中国美术家协会上海分会副主席、中国美术家协会常务理事、上海市对外文化协会副会长、上海市文联副主席、全国政协委员、上海中国画院院长、中国美术家协会上海分会主席，上海文学艺术界联合会副主席等。

张大千（1899—1983）

名爰，字季爰，法号大千，别署大千居士、下里巴人、弘丘子，斋名大风堂、摩耶精舍，四川内江人，祖籍广东番禺。

早年留学日本，曾任南京中央大学美术系教授。1940年代初，赴敦煌莫高窟研究，临摹壁画三年，其画以山水、花卉、人物最胜，晚年尤喜以泼彩画荷花，最为传神。书法早年拜李瑞清、曾熙为师，学北碑，得《郑文公碑》《瘗鹤铭》笔法，所作豪放洒脱，极富神采。篆刻亦能己意出之。

张大千是20世纪中国画坛最具传奇色彩的国画大师，无论是绘画、书法、篆刻、诗词都无所不通。他与兄张善孖创立"大风堂派"，是20世纪中国画坛最具传奇色彩的泼墨画工。特别在山水方面卓有成就。画风工写结合，重彩、水墨融为一体，尤其是泼墨和泼彩，开创了新的艺术风格。

沙孟海（1900—1992）

又名文若，字孟海，中年后以字行；号石荒、沙村、决明、兰沙等。浙江鄞县人，中国当代书坛巨擘，现代高等书法教育的先驱之一。

早年从冯君木学古典诗文，从吴昌硕习书法、篆刻。其书法远宗汉魏，近取宋明，于钟繇、王羲之、欧阳询、颜真卿、苏轼、黄庭坚诸家，用力最勤，且能化古融今，形成自己独特书风。兼擅篆、隶、行、草、楷诸书，所作榜书大字，雄浑刚健，气势磅礴。学问渊博，于语言文字、文史、考古、书法、篆刻等均深有研究。

历任浙江省文物管理委员会常务委员，浙江省博物馆名誉馆长，中国书法家协会副主席，浙江省书法家协会主席，西泠印社社长，西泠书画院院长，浙江考古学会名誉会长等职。

费新我（1903—1992）

学名斯恩，字省吾，别名立千、立斋，后改名新我。浙江湖州人。我国现代著名的书画家，也是最杰出的左笔书法家。

擅长中国画、书法，精于行草书，它的作品结字十分严谨，线条干净利落，章法错落有致，运笔极富节奏感和韵律。

任江苏省国画院一级画师、中国美术家协会会员、中国书法家协会理事、中国书法家协会江苏分会顾问、苏州市武术协会名誉主席、湖州书画院名誉院长等。

江寒汀（1903—1963）

原名荻，学名赓元，又名鸿、上渔，笔名江鸿、石溪，别署寒汀居士。江苏常熟人。

擅画花鸟，早年清隽秀丽，显江南水乡之灵气，中晚年笔墨趋向豪放苍劲、气息酣畅。1960年应周恩来总理邀请为人民大会堂绘制巨幅《红梅图》。与唐云、张大壮、陆抑非并称海上"四大花旦"。

曾任教于上海美术专科学校。为中国美术家协会会员、上海美术家协会理事、上海中国画院画师。

张大壮（1903—1980）

原名颐，又名心源，字养庐，别署富春山人，浙江杭州人。章太炎外甥。花卉受业于山阴李汉青，山水受业于杭县汪洛年，擅画花卉、鱼虾、瓜果。与唐云、陆抑非、江寒汀被合称海上花鸟画"四大花旦"。

曾为上海中国画院画师、上海美术家协会会员。

来楚生（1903—1975）

原名稷勋，号然犀，书斋名有然犀室、安处楼。浙江萧山人。曾任西泠印社副社长。

其画清新朴茂、笔墨简练、格调隽逸，在现代花鸟画坛上独树一帜。书法拙中寓巧，草书和隶篆最为人称道。篆刻远师秦汉，近踵吴熙载、赵之谦、吴昌硕、齐白石等大家，而能不落前人窠臼，自出新意，开创了一代印风。其肖形印更是融汉画像、古肖形印为一炉，在印坛上冠绝古今，无出其右。

陆抑非（1908—1997）

名翀，字抑非，号非翁、苏叟。江苏常熟人。著名中国画家、艺术教育家。早年师从李西山、陈加庵，后为吴湖帆入室弟子。擅长花鸟画，初擅工笔重彩，后吸取明清徐青藤、陈白阳以及石涛、八大等画法，墨彩兼施，画风气势张开，灵气盎然。为海上花鸟画四大名家之一。

曾为中国美术学院教授，中国美术家协会会员，中国书法家协会会员，浙江画院顾问，西泠书画院副院长，上海中国画院画师等。

陆俨少（1909—1993）

学名学祖，又名砥，号宛若。上海嘉定县南翔镇人。

1926年考入无锡专科学校，1927年拜冯超然为师，并与吴湖帆相识，此前大部分作品是对古代传统的消化和吸收。他途径三峡的经历，引发创新意识，开始将以前局部改造传统转换为有意识地建立个人风格。陆俨少通过各种笔墨技法之探讨，终于在自己的作品中突破地进入了新的表现层次：勾云、勾水、大块留白、墨块等特殊技法。

曾任上海中国画院画师、浙江画院院长等。

唐云（1910—1993）

字侠尘，别号药城、药翁、老药、大石翁等。浙江杭州人。

擅长花鸟，少年时期主要临摹《芥子园画谱》及古代名画和画册成才，后迁居上海，在新华艺专、上海美专教授中国画，能书会诗，为海上花鸟画"四大花旦"之一。作品广被国内外博物馆、美术馆收藏。

曾为中国美术家协会理事、上海美术家协会副主席、上海书法家协会名誉理事、西泠印社理事、上海市文物保管委员会委员、上海中国画院名誉院长。

吴青霞（1910—2008）

女。学名德舒，号龙城女史，别署篆香阁主。江苏常州人。

幼喜绘画，熟谙宋元明清各派绘画技法，笔墨挺劲流畅，色彩明洁秀丽，工写兼备，生动传神。擅长山水、人物、花鸟，尤擅画鲤鱼、芦雁，有"鲤鱼王"之称。书法学"二王"，潇洒别致。

曾为美术家协会会员、上海美术家协会理事、意大利欧洲学院院士、上海中国画院画师、上海市文史研究馆馆员、上海师范大学教授。

谢稚柳（1910—1997）

初名稚，斋名鱼饮溪堂、杜斋、烟江楼、苦篁斋、壮暮堂。江苏常州人。

山水、人物、花卉、翎毛、走兽无不精湛。初攻花鸟，倾心陈老莲，后跨越明清，山水、花鸟均直入宋元。人物宗法晋唐，书法糅以张旭草法，以行草闻名。1980年代出任全国书画鉴定小组组长，多次赴海外讲学交流。

曾为中国美术家协会理事、上海美术家协会顾问、中国画研究院院务委员、上海博物馆顾问、中国书法家协会常务理事、上海书法家协会主席。

应野平（1910—1990）

原名端俊，改名俊，笔名野苹。浙江宁海人。幼承家学，专攻山水，在传统画法上又渗入西画画法，并擅书法、工诗词、精画论。曾为中国美术家协会会员、中国美术家协会上海分会常务理事、上海书法家协会名誉理事、上海中国画院画师、上海文史馆馆员。

启功（1912—2005）

字元白，也作元伯，号苑北居士，雍正皇帝的第九代孙。

他著作丰富，通晓语言文字学，甚至对已成为历史陈迹的八股文也很有研究。他做得一手好诗词，同时又是古书画鉴定家，尤精碑帖之学。

曾任北京师范大学副教授、教授，中国人民政治协商会议全国委员会常务委员，国家文物鉴定委员会主任委员，中央文史研究馆馆长，博士研究生导师，九三学社顾问，中国书法家协会名誉主席，世界华人书画家联合会创会主席，中国佛教协会、故宫博物院、国家博物馆顾问，西泠印社社长。

赖少其（1915—2000）

一作少麟，斋号木石斋。广东普宁人。

擅长版画、中国画。他独创的"以白压黑"技法，奠定了新徽派版画的主要创始人的地位。他的书风朴拙奇崛，道劲浑厚。

曾为华东美术家协会党组书记、安徽美术家协会主席、中国版画家协会副主席、上海美术家协会副主席、广东美术家协会名誉副主席、安徽省政协副主席、全国政协委员等。

宋文治（1919—1999）

室名松石斋。江苏太仓人。

早年师从张石园学山水，后得吴湖帆、陆俨少指教。1941年考入苏州美术专科学校上海分校。1960年代始致力于中国画创作。所作笔墨雄健，气势宏大，意境深远，自具风貌。作品多次入选国内外大型美术作品展及在多种专业报刊上发表，或被美术馆、博物馆等收藏。

曾任江苏省国画院副院长、中国美术家协会理事、江苏省美术家协会副主席。

程十发（1921—2007）

名潼，斋名曾用步鲸楼、不教一日闲过斋、三釜书屋、修竹远山楼。上海松江人。"上海市文学艺术杰出贡献奖"获得者。

擅画人物、山水、花卉、鸟兽等，山水画大气磅礴，花鸟走兽精工传神，人物画自成一格，被称为"程家样"。在连环画、年画、插画、插图等方面均有造诣。工书法，善将草、篆、隶融为一体。

曾任上海中国画院院长、中国美术家协会理事、上海美术家协会副主席、中国文联委员、上海文联委员。

刘旦宅（1931—2011）

原名小粟，又名浑。浙江温州人。

擅人物，兼花鸟，取法汉唐人物、宋元山水及陈老莲和八大之花鸟，广泛吸取古人之长而融会贯通。工写兼长，创作多取古典题材及历史人物，造型清俊，情思横逸，秀拙相蕴。作品多次入选国内外大型美术作品展览及在多种专业报刊上发表，多次被美术馆、博物馆、艺术馆收藏。所绘《红楼梦十二金钗》邮票，曾获1981年全国邮票最佳奖。1985年获中国奥林匹克委员会颁发的《中国体育美术展览》荣誉奖。

曾为中国美术家协会会员、上海美术家协会理事、上海中国画院画师、上海师范大学美术学院名誉院长。

钱行健（1935—2010）

室名不息斋。江苏无锡人。

曾从名士袁容舫先生攻习山水、花卉、文学及诗词。1954年师从上海著名画家江寒汀专攻花画。出版有《百鸟园》《钱行健画集》等，国内外各种出版物百余种，其中论述艺术的文字共约十余万字。

曾为中国美术家协会会员、上海美术家协会会员、上海外国语大学艺术副教授、上海书画院特聘画师。

后记

　　浙江青瓷与海派书画虽然是受时空区隔独立发展的两门艺术，却都凝聚着吴越之地精致典雅、包容开放的审美观和价值取向。二者皆是对传统的突破创新，都在保持自身特点的同时广泛吸收其他地区、国家的美学元素，是中华民族艺术史上瑰丽无比的两朵奇葩。

　　此次展览由杭州博物馆和上海君苑文化发展有限公司联合举办，展出了具有代表性的浙江青瓷和海派书画作品百余件并各精选四十件辑合成图录以飨读者。两相对比，充分展现了浙江青瓷与海派书画的影响、发展，引领观众体验了一场吴越、古近交融的美学之旅。

　　蔡和璧女士和江宏先生为本书作了序，浙江省文物考古研究所为本次展览提供了部分展品。在此，谨向为本次展览倾注热情，给予鼎力支持的各方同仁表达诚挚的敬意和由衷的感谢！

　　由于展览筹备时间有限，仓促之中难免疏漏，对于展览中存在的问题与不足之处欢迎业界同仁和观众给予指正。

编者

2017年9月26日

Epilogue

As two independent categories of art developed in different space and time, Zhejiang Celadon and Shanghai Painting and Calligraphy are the embodiment of the sophisticated and inclusive aesthetics and values of Wu and Yue area. They both represent a breakthrough and innovation in tradition and are two precious treasures in the history of Chinese art which extensively absorb the aesthetic elements of other regions and countries while maintaining their own characteristics.

The exhibition is jointly organized by Hangzhou Museum and Shanghai Junyuan Cultural Development Co., Ltd. during which more than 100 pieces of works of Zhejiang Celadon and Shanghai Painting and Calligraphy will be on display and an album out of 40 selected pieces will be produced. The co-exhibition fully demonstrates the impact and development of Zhejiang Celadon and Shanghai Painting and Calligraphy and brings the audience a rare aesthetic experience integrating Wu and Yue cultures in ancient and modern times.

I would like to extend our sincere thanks to Mr. Cai Hebi and Mr. Jiang Hong for writing the preface to this book and Zhejiang Provincial Institute of Cultural Relics and Archeology for contributing part of the exhibits for this exhibition. Besides, our heartfelt gratefulness goes to those who have devoted their passion and given full support to this exhibition.

As the preparation time is limited, there are inevitably aspects needing improvement. Therefore, all candid comments and criticism from our peers and the audience will be greatly appreciated.

Editor
September 26, 2017

图书在版编目（ＣＩＰ）数据

浙江青瓷与海派书画展精选 / 杭州博物馆编. -- 上

海：上海书画出版社，2017.9

ISBN 978-7-5479-1628-5

Ⅰ．①浙……　Ⅱ．①杭……　Ⅲ．①青瓷(考古)－作品集－

中国－现代②汉字－法书－作品集－中国－现代③中国画

－作品集－中国－现代　Ⅳ．①J527②J222.7

中国版本图书馆CIP数据核字(2017)第228634号

浙江青瓷与海派书画展 精选

Zhejiang celadon and Shanghai Painting Exhibition Selections

杭州博物馆　编

主　　编　　杜正贤、沃明东
编　　委　　刘春蕙、余洪峰、黄燕、王伟民、翁周明
策　　划　　贺敏敏
展品提供　　上海君苑文化发展有限公司、浙江省文物考古研究所
责任编辑　　黄坤峰
审　　读　　陈家红
技术编辑　　包赛明
装帧设计　　贺敏敏、顾毅
出版发行　　上海世纪出版集团
　　　　　　　上海书画出版社
地　　址　　上海市延安西路593号　200050
网　　址　　www.ewen.co
　　　　　　　www.shshuhua.com
E-mail　　shcpph@163.com
经　　销　　各地新华书店
印　　刷　　上海雅昌艺术印刷有限公司
开　　本　　889×1194　1/8
版　　次　　2017年9月第1版　2017年9月第1次印刷
印　　张　　26
书　　号　　ISBN 978-7-5479-1628-5
定　　价　　298元

若有印刷、装订质量问题，请与承印厂联系